Nikon®

Creative
Lighting System

Digital **Field Guide**

Third Edition

Nikon®
Creative
Lighting System
Digital Field Guide
Third Edition

Benjamin Edwards

WILEY

John Wiley & Sons, Inc.

Nikon® Creative Lighting System Digital Field Guide, Third Edition

Published by
John Wiley & Sons, Inc.
10475 Crosspoint Boulevard
Indianapolis, IN 46256
www.wiley.com

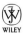
WILEY

About the Author

Benjamin Edwards is a wedding, portrait, and humanitarian photographer based out of Bend, Oregon, where he and his wife, Lauren, operate Benjamin Edwards Photography. Benjamin previously worked on *Kevin Kubota's Lighting Notebook: 101 Lighting Styles and Setups for Digital Photographers* (also published by John Wiley & Sons, Inc.).

He has been featured in the September 2009 issue of *Photo District News* magazine and on *Framed*, a web-based series for photographers. Benjamin also won a Hollywood Film Festival award in 2009 for his short film, *Cry Out for Congo*, and has been recognized as a Photoflex Pro Showcase Member.

Credits

Senior Acquisitions Editor
Stephanie McComb

Project Editor
Amanda Gambill

Technical Editor
Jeff Wignall

Copy Editor
Marylouise Wiack

Editorial Director
Robyn Siesky

Business Manager
Amy Knies

Senior Marketing Manager
Sandy Smith

Vice President and Executive Group Publisher
Richard Swadley

Vice President and Executive Publisher
Barry Pruett

Senior Project Coordinator
Kristie Rees

Graphics and Production Specialists
Jennifer Mayberry
Mark Pinto

Quality Control Technicians
Jessica Kramer
Lauren Mandelbaum

Proofreading and Indexing
Laura Bowman
Estalita Slivoskey

For my Parker. I know you'll change the world.

Acknowledgments

I've learned that the best things in my life and business have been the result of being surrounded by exceptional people. For their creativity, support, and love, I thank:

Lauren Edwards, you're simply my better three-quarters and our partnership in life is truly divine. Without you, I couldn't do what *we* do.

My boys, you're shining lights in my life. Thanks for letting Daddy work a few weekends.

Kevin Kubota, you're my creative, collaborative partner, a source of inspiration, and my best friend. Thank you for showing me all that you have, and for showing photographers and *normal* people everywhere that to give back isn't to empty one's self, but rather to fill oneself.

Tiffany Lausen, everyone needs a Tiffany in his or her life. Your creative support and energy have been a true blessing.

Stephanie and Amanda at Wiley, thank you for being here for me and answering the onslaught of questions.

Photoflex, thank you for your continued support and for making stellar gear.

Nikon, the best.

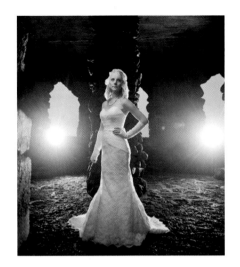

Contents

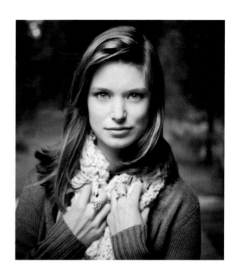

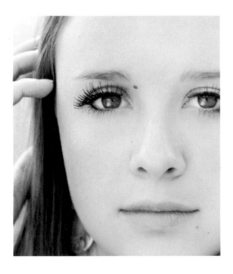

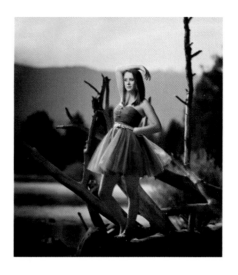

CHAPTER 4
Advanced Wireless Lighting 113

CHAPTER 5
Setting Up a Portable Studio 125

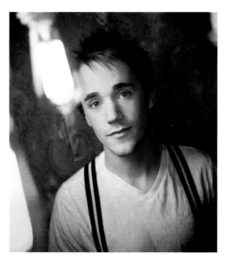

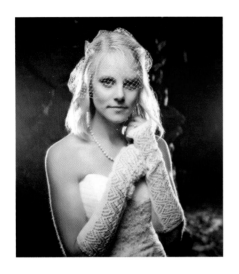

CHAPTER 6
Advanced Flash Techniques 145

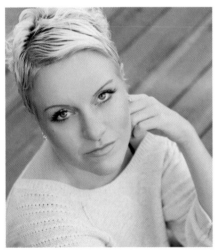

CHAPTER 7
Flash Techniques for Portrait
Photography 159

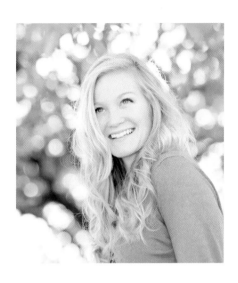

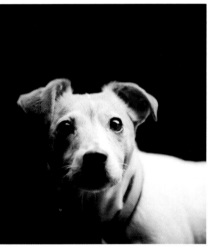

Introduction

From its origin in the Greek language, the word *photography* literally means *painting (or writing) with light*. It's fairly safe to say that if you were to remove light altogether from the photography equation, you'd have a difficult time capturing the perfect picture. You could also say that the addition of light, or the ability to create it quickly and efficiently, could go a long way in helping you create your very own masterpiece.

When Nikon introduced the Creative Lighting System (CLS) in 2004, it was mostly overlooked. The industry was focused on the rapidly changing advancement of digital SLR (dSLR) cameras — more specifically, how many megapixels could be jammed into a new generation of image sensors. This was a shame because the Nikon CLS was the most amazing development in creative photography in decades. The ability to completely control the output of multiple lights, *and* do it wirelessly with full Through-the-Lens (TTL) metering was a true breakthrough.

The popularity of the Nikon CLS has grown exponentially in recent years as more people are becoming interested in off-camera, photographic lighting. With the SB-400, SB-700, SB-900, and SB-910, no other company comes close to offering such a multitude of tools for specific lighting needs.

The main features of the CLS are its ability to get the flashes off of the camera and control them wirelessly. Nikon refers to this as Advanced Wireless Lighting (AWL). Simply put, when the flash is on top of your camera (or even attached to a flash bracket) your freedom to place the light source exactly where you want it is limited. AWL eliminates these restrictions.

With the CLS, you can direct and modify all of the light from your camera. This gives you the ability to create images full of depth and dimension, with far greater ease than with traditional studio strobes, and at a much lower cost to both your wallet and your back.

The Evolution of the Nikon Creative Lighting System

Nikon introduced wireless Speedlight control in 1994 with the SB-26 Speedlight. This flash incorporated a built-in optical sensor that enabled you to trigger the flash with the firing of another flash. While this was handy, you still had to meter the scene and manually set the output level on the SB-26.

With the release of the SB-28 in 1997, Nikon omitted the built-in optical sensor. You could still do wireless flash, but you needed to buy the SU-4 wireless sensor. Wireless flash still had to be manually set because the pre-flashes used by the Through-the-Lens (TTL) metering system caused the SU-4 to fire the speedlight prematurely.

In 1999, Nikon released the SB-28DX. This flash was made to work with Nikon's emerging line of dSLRs. The only difference from the SB-28 was the metering system — the film-based Through-the-Lens (TTL) metering was replaced by Digital Through-the-Lens (dTTL) metering. This metering system compensated for the lower reflectivity of a digital sensor as opposed to film's highly reflective surface. (Don't worry; there won't be a test on this at the end of the book.)

In 2002, Nikon replaced the SB-28DX with the SB-80DX. The changes were minimal — more power, a wider zoom, and a modeling light. It also brought back the wireless optical sensor. Before, although you could use this speedlight wirelessly, you still had to set everything up on the flash.

When 2004 rolled in, Nikon revolutionized the world of photographic lighting with the SB-800, the first flash to be used with the new Creative Lighting System. The first camera to be compatible with the CLS was the D2H. Using the D2H with multiple SB-800s enabled you to control the speedlights individually by setting them to different groups — all of which were metered via pre-flashes and could be adjusted separately.

With the introduction of the D70 (and, later, the D70s and D200), users could now control any number of off-camera speedlights with the camera's built-in flash. Of course, using this had some drawbacks. With the D70s, you could control only one group of speedlights. The D200 could control only two. Even so, it was remarkable. Prior to this, you could never use a speedlight off-camera while retaining the function of the intelligent Through-the-Lens (i-TTL) metering. Today, all Nikon dSLR cameras are CLS-compatible, but not all of them allow you to control the lighting with the built-in flash. However, any of them can be used with a speedlight acting as a Commander to control any number of off-camera speedlights.

Eventually, Nikon augmented the CLS line with a little brother for the SB-800: the SB-600. While lacking some of the features of the SB-800, such as the ability to control speedlights and no PC terminal, it's still an amazing little flash.

Nikon also released a couple of kits for macro photography lighting: The R1 and the R1C1. The R1 Macro Lighting Kit includes two SBR-200s, which are small wireless speedlights. They can be mounted directly to the lens via an adapter. You can also purchase the SBR-200 separately, which enables you to use as many lights as you want. The R1C1 Kit is essentially the same, except that it includes an SU-800 Commander unit. The SU-800 is a wireless transmitter that allows you to control groups of flashes (just like the SB-800, but without a visible flash).

Nikon has rounded out the CLS with the bare-bones SB-400 (2006), the efficient SB-700 (2010), and the flagship models, the SB-900 (2008) and the SB-910 (2011). The newer models offer the photographer the ultimate Creative Lighting System. With great attention to detail and ergonomics, and enhanced user-interfaces, never before have so many features been so easy to access.

Released in late 2011, the SB-910 is the culmination of years of research and design. With a faster recycle time (2.5 to 3 seconds, depending on battery use), an improved Thermal cut-out feature, and a multipoint AF-assist Illuminator that now covers the field of view of a 17-135mm lens with 51 focus points (39 focus points for a 24-135mm lens), the SB-910 is the new CLS workhorse.

What's in This Book?

While I certainly recommend that you read your camera and flash manual at least once, most of us find the best use for an owner's manual is as a sleep aid. Technically written and devoid of user experiences, manuals leave out the parts like, "Oh yeah, this works sometimes, but when it doesn't, try this." That's where this Field Guide becomes your best friend.

This book does include the nuts and bolts information usually included in a standard manual. However, it also covers tips and advice. It also includes sample images and setup diagrams that explain how a shot was created using the Nikon CLS.

Finally, some photographers may be so intimidated by off-camera lighting, that they shoot only in available light. That's fine if it's your passion, but what happens when there isn't any light available? Creative, off-camera lighting takes a bit of time and practice to master, but it *can* be done — I'm proof of that.

This book will assist you throughout the learning process, but it won't do the work for you. It's important that you take the information contained in these pages and put it into practice. Find a willing model (anyone that will hold still for you will do) and experiment. Also, remember that mistakes are only little markers on the road to success.

With a newfound appreciation for the Nikon Creative Lighting System and an understanding of Advanced Wireless Lighting, you'll be well on your way to a new season of creative photography.

Are you ready?

Quick Tour

Any photographer who uses a camera with a built-in flash usually realizes very quickly the limitations these little light sources present. While a built-in or pop-up flash may serve well in a pinch, adding one or more speedlights to your photographic arsenal enhances your capabilities well beyond those that a built-in flash can provide.

Speedlights are not only useful in low-light situations. The benefits range from using fill flash in direct sunlight (which I cover later in the book) to completely lighting a subject in the studio.

The SB-910 and SB-700 are great for quick snapshots, but they can also be configured for complex wireless, multi-flash photo shoots. So, get ready: you are about to explore the world of the Nikon speedlights and the Nikon Creative Lighting System (CLS).

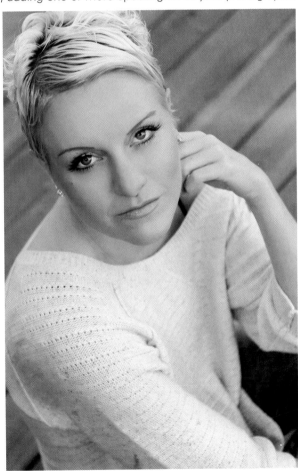

Right out of the box, you can use a speedlight to capture dramatic portraits like this one.

Getting Started

If you want to get up and running quickly with your Nikon speedlight, all you really need to do is insert the batteries, attach it to your camera (it's a starting point; you'll get that speedlight off your camera soon), and then turn both the speedlight and the camera on. While you may not shoot any album covers this way, you'll be amazed at the quality of flash photos you can take with the speedlight as soon as you take it out of the box, whether it's the entry-level SB-400 or the top-of-the-line SB-910.

The *Nikon Creative Lighting System Digital Field Guide* assumes that you are familiar with your camera's settings and modes. If you're unsure about certain settings, consult the owner's manual or the appropriate *Digital Field Guide* for your camera.

Attaching the speedlight is quite easy:

1. **Turn off the camera and speedlight.** Turning off the equipment reduces any risk of short circuits when attaching different electronic devices.

2. **Unlock the mounting-foot locking lever on the speedlight.** Move the mounting-foot locking lever to the left — its unlocked position.

3. **Attach the speedlight to your camera.** Slide the speedlight foot into the camera's hot shoe. Turn the mounting-foot locking lever to the right to lock the speedlight in place.

4. **Turn on your camera.**

5. **Turn on your speedlight.** The On/Off switch is located on the back panel.

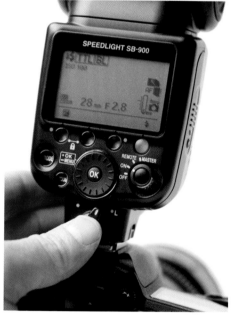

QT.1 **Slide the speedlight foot into the hot shoe and lock the mounting foot.**

Nikon speedlights accept alkaline, lithium, or rechargeable NiMH AA batteries.

After your speedlight is attached with the flash head in the horizontal position, and the camera and speedlight are turned on, you can reposition your flash head if you want. Repositioning the flash head allows you to use *bounce flash*. This technique bounces the light from the flash off of a nearby surface (typically the ceiling or a wall) to diffuse it.

 For more information on bounce flash, see Chapter 3.

Taking Your First Photos with a Speedlight

Once the speedlight is attached to the camera and both are turned on, the speedlight defaults to *Through-the-Lens* (TTL) metering. This means that the camera reads the light levels through the lens and sets the flash level output from the data that it receives. Nikon refers to its proprietary metering systems as *i-TTL*.

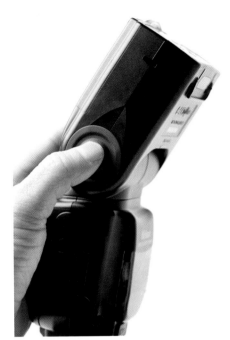

QT.2 Reposition the flash head for bounce flash.

 Through-the-Lens (TTL) metering is covered in more detail in Chapter 2.

There are two types of Through-the-Lens metering available with all current CLS-compatible speedlights:

▶ **TTL BL.** This means that the camera is taking a reading of the entire scene and attempting to balance the light from the flash with the ambient lighting. This is generally the best setting to use as it tends to yield the most natural-looking results. When the camera meter (⬛) is set to Matrix metering (⬛), TTL BL is the default TTL setting.

▶ **Through-the-Lens (TTL).** When the camera's metering mode (⬛⬛) is set to Center-weighted (🔘) or Spot metering (⬚), the camera switches to a straight Through-the-Lens metering system. The camera meters for the subject only and doesn't take into account the ambient lighting. This can sometimes cause your background to be under- or overexposed, depending on the lighting situation.

For this Quick Tour, I'm using the TTL BL mode. To begin, set your camera to Aperture Priority (**A**), Matrix metering mode (⬛⬛), and use the speedlight's default TTL BL mode. This mode produces great results and you don't have to do anything but press the Shutter Release button — a great starting point.

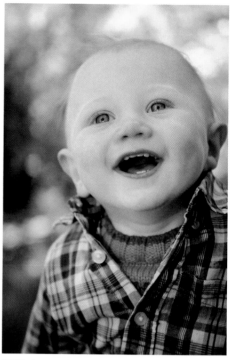

QT.3 **An outdoor portrait taken with an SB-900 speedlight to add some fill flash.**

 Speedlights aren't just for shooting in dim light. If you use one outside in bright light, it can fill in harsh shadows and give your images a more natural look.

Taking photos with a speedlight using Nikon Through-the-Lens (TTL) or TTL BL metering is just as easy as taking photos without a flash. It can also yield better results than relying solely on available light, such as the sun, which can often be high in contrast and not very flattering to the subject. Just focus and shoot. The camera makes all of the adjustments for exposure and it also adjusts the *flash head zoom* for you. The flash head zoom is a speedlight feature that adjusts the flash to match the focal length of the lens you're using. Don't be concerned if you don't completely understand how TTL BL works or why the flash zoom is important — you will in good time. In the meantime, this Quick Tour is meant to help you get started with flash photography and become more comfortable with your flash equipment.

 If your speedlight comes with a diffusion dome, use it. This simple device softens the light for a more pleasing effect. For best results, position the flash head at a 60-degree angle.

For some people, just attaching the flash and using the TTL BL mode may be enough for one day. If that's you, don't be afraid to put the book down for a bit and practice. See where TTL BL works well, and don't be surprised if you find some limitations — this book will be here when you're ready to discover the solutions to those limitations.

QT

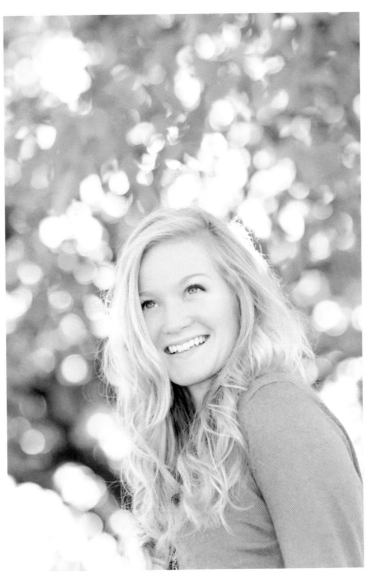

QT.4 This portrait was taken in the shade using the supplied SW-13H Diffusion Dome on the SB-900.

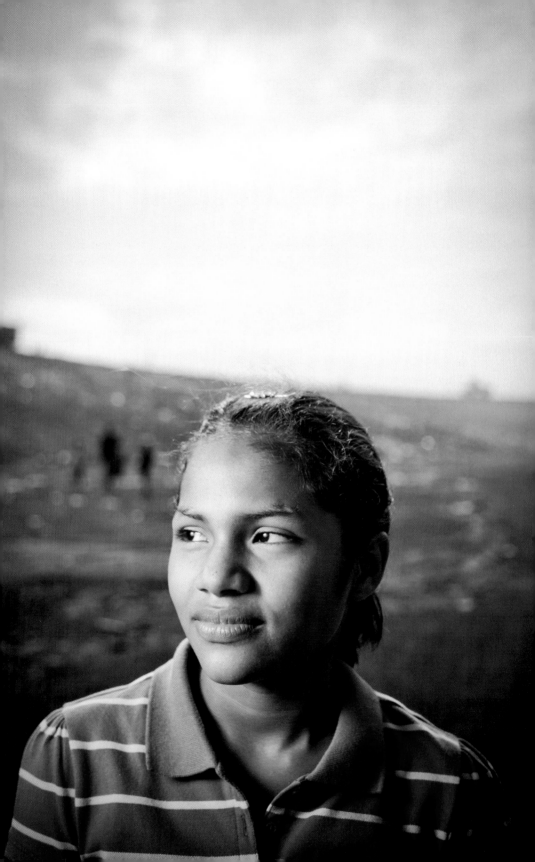

Exploring the Nikon Creative Lighting System

Like most sophisticated pieces of camera equipment, a speedlight is a complicated device with many different parts and features. To get the most out of yours, it helps to be familiar with all of the moving parts. In this chapter, I dissect each speedlight and explain what each button, switch, dial, and lever does. I also cover some of the accessories and current cameras that can be used with them. By the end of this chapter, you should be familiar with all of the different accessories and terminologies that pertain to your Nikon Speedlight.

The Nikon Creative Lighting System (or CLS) basically consists of two components: A CLS-compatible camera and a speedlight. This is just the beginning, however, because the CLS is a completely modular system that can also be comprised of a camera and multiple speedlights functioning as Commanders and/or Remotes.

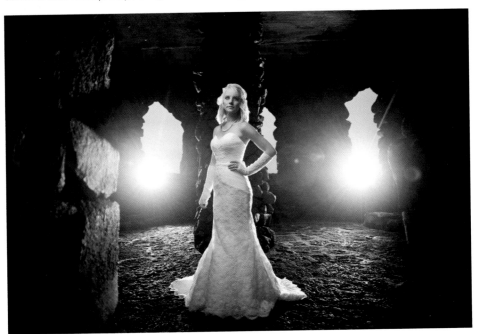

The Nikon Creative Lighting System can add flare to your images.

Main Features and Functions

Nikon has designed its Creative Lighting System with features and functions that anyone can take advantage of, whether you're new to photography or a seasoned professional. Once you understand the different components of the Nikon CLS and how the features can work for you, you unlock a whole new world of creative opportunities.

The main features and functions of the Nikon Creative Lighting System are as follows:

▶ **i-TTL/i-TTL BL.** This is the most advanced Nikon flash metering system. It uses pre-flashes fired from the speedlight to determine the proper flash exposure. The pre-flashes are read by a 1005-pixel RGB metering sensor. The information is then combined with the information from matrix metering, which is a reading of how much available light is falling on the subject. The speedlight uses this information to decide how much flash exposure is needed (i-TTL) or to balance the flash output and ambient light for a more natural-looking image (i-TTL BL). All CLS-compatible cameras can use this function when attached to any of the CLS speedlights. The built-in flash also uses i-TTL technology.

▶ **Advanced Wireless Lighting (AWL).** This is probably the most exciting and useful feature of the CLS. In fact, it's likely the main reason you bought this book. AWL allows you to control up to three groups of flashes. This gives you a total of four groups if you use the built-in flash or an SB-700, SB-900, or SB-910 Speedlight in the hot shoe as a Commander. You can control an unlimited number of speedlights assigned to each group with a single Commander, which can be a built-in flash or an SB-700, SB-900, SB-910, or SU-800. This option is available on all cameras when using an SB-700, SB-900, SB-910, or SU-800 as a Commander with another speedlight as a Remote. Cameras with a built-in flash that acts as a Commander can also use this feature.

▶ **Auto FP High-Speed Sync.** This feature allows you to use a shutter speed that's faster than the rated sync speed for your camera. This is achieved by firing a series of low-power flashes during the exposure. You can use this feature to add fill flash to an action shot that requires a fast shutter speed. It's also handy when using a fill flash on an outdoor portrait that requires a wide aperture, which necessitates a fast shutter speed and gives a shallower depth of field, isolating the subject from the background. Keep in mind that this feature is not available with all camera bodies.

 For more information on sync speed, see Chapter 3.

▶ **Flash Value Lock (FV Lock).** This feature enables you to lock the flash exposure to maintain a consistent exposure over a series of images. When you enable the

FV Lock, the camera fires the pre-flash to get the correct flash exposure reading. This reading is then locked, giving you the opportunity to recompose the shot without causing the flash output level to change, or to wait for just the right moment or expression. You essentially make the pre-flash several seconds, as opposed to milliseconds, before the exposure. Because flash exposure is mea-sured at the center of the frame, this feature can also be used to ensure proper flash exposure when recomposing a shot (such as a portrait subject) to place the subject off-center. In most cases, the FV Lock must be assigned to a Function button (**Fn**) using the camera's Custom Settings Menu (✐). Note that this feature isn't needed when both your camera and speedlight are in Manual mode (**M**). This feature is not available on the D3000, D3100, D5000, or D5100.

▶ **Multi-area AF-assist Illuminator.** The SB-700, SB-900, SB-910, and SU-800 have a built-in LED that projects an array onto your subject when shooting in low light. This assists the camera's AF system in acquiring focus on a subject. This feature works with all camera and flash combinations. Note that the AF-assist Illuminator does not function when the camera is in Continuous AF or Manual focus.

▶ **Flash Color Information Communication.** As the flash duration changes, the color temperature of the flash output changes as well. Longer flash durations are required for bright output and cause the color temperature to become a little cooler. The opposite is true for shorter-duration flashes — the color temperature tends to get warmer. When you set your camera to Auto white balance (**A**), the speedlight communicates this information to your camera, which allows it to compensate for the color shift. This can be more accurate than simply setting your camera to Flash white balance (**⚡**), which is fixed at 5500K. This feature is available with all camera and flash combinations. Keep in mind that the camera white balance (**WB**) must be set to Auto (**⚞**) for this feature to be enabled.

Depending on your camera and speedlight combination, not all of these features may be available. Certain cameras, especially the entry-level models, don't allow the use of some of the Nikon CLS features, such as Auto FP High-Speed Sync and FV Lock. Your camera must be CLS-compatible in order to take advantage of any of these features. Here is a list of CLS-compatible cameras as of this writing:

▶ **D3s**

▶ **D3x**

▶ **D4**

▶ **D90**

▶ **D300s**

▶ **D700**

▶ **D800**

- ▶ **D3000**
- ▶ **D3100**
- ▶ **D5000**
- ▶ **D5100**
- ▶ **D7000**
- ▶ **F6**

Understanding DX and FX Sensors

Nikon offers two different sensor sizes within their line of dSLR cameras: DX and FX. The DX format is approximately 24 × 16mm, while the FX is 36 × 24mm. (SLR camera lenses were designed around the 35mm film format.)

Photographers use lenses of a certain focal length to provide a specific field of view. The *field of view*, also called the angle of view, is the amount of the scene that is captured in the image. The angle of view is usually described in degrees. For example, when a 16mm lens is used on a 35mm camera, it captures almost 180 degrees (horizontally) of the scene, which is quite a bit. Conversely, when using a 300mm focal length, the field of view is reduced to a mere 6.5 degrees horizontally. The field of view was previously consistent from camera to camera because all SLRs used 35mm film, which had an image area of 24 × 36mm.

With the advent of digital SLRs, the sensor was made smaller than a frame of 35mm film to keep costs down because sensor production was expensive. This sensor size was called APS-C or, in Nikon terms, the DX format. The lenses used with the DX format have the same focal length they've always had, but because the sensor doesn't have the same amount of area as the film, the field of view is effectively decreased. This causes the lens to provide the field of view of a longer, focal-length lens when compared to 35mm film images.

Fortunately, the DX sensors are a uniform size, thereby supplying consumers with a standard to determine how much the field of view is reduced on a DX-format dSLR with any lens. The digital sensors in Nikon DX cameras have a 1.5X crop factor. This means that to determine the equivalent focal length of a 35mm or FX camera, you simply multiply the focal length of the lens by 1.5. Therefore, a 28mm lens provides an angle of coverage similar to a 42mm lens, a 50mm lens is equivalent to a 75mm lens, and so on.

The SB-700 was designed to cover the full-frame format, so, although the widest setting shown is 14mm, it allows coverage for a 10mm lens on a DX format (10 × 1.5 = 15mm) dSLR.

 The Nikon COOLPIX P7000 and P7100 are equipped with a hot shoe for an accessory speedlight. Although they can accept the SB-400, SB-700, SB-900, and SB-910 speedlights, they aren't CLS-compatible. They use i-TTL metering but cannot perform any Advanced Wireless Lighting or other CLS functions.

Anatomy of the Speedlight

For the most part, speedlights are all pretty similar, and some parts are the same on all of them. The higher up the product line you go, the more expensive they become, and the more features, switches, and dials you find.

Although some speedlights, such as the SB-700, SB-900, and SB910, seem to have more dials and buttons, it's pretty easy to master the controls once you know what each one does. That's where this chapter comes in. In this section, I cover each part of the speedlight and what it does so that — when it comes time to master the settings and modes — you are familiar with the layout of your speedlight and know right where to put your fingers.

SB-R200

Roughly the same size as its sibling, the SB-400, the SB-R200 is the foundation of the R1 and R1C1 macro kits. It's comprised of the following parts:

▶ **Adjustable flash head.** The flash head contains the business part of your speedlight — the *flashtube*. Simplified, the flashtube is a sealed glass tube that contains xenon gas and electrodes that pass a high-voltage electric charge through the gas, making it light up very brightly for a relatively brief duration. The flash has a lens coverage of 24mm: 60 degrees vertical and 78 degrees horizontal.

▶ **TTL cord terminal.** This terminal allows you to connect the SB-R200 to the SU-800 Commander when using a camera that is not CLS-compatible.

▶ **Mounting-foot/Mounting-foot locking lever.** This attaches the SB-R200 to the SX-1 Attachment Ring. When the speedlight is in position, slide the lever to the locked position to ensure safe attachment to the SX-1 Attachment Ring.

▶ **Target light button.** Pressing this causes the SB-R200 to emit a modeling light, enabling your camera to focus more quickly and with greater accuracy.

▶ **Battery chamber.** Sliding back the cover located under the On/Off switch reveals the chamber in which you install a single CR123 battery.

▶ **On/Off switch.** Sliding this switch turns the speedlight on or off. Be sure it is switched to Off before attempting to mount the SB-400 to your camera. This will prevent any accidental damage that could be caused by electrical charges between the contacts.

▶ **Ready light.** When this light is green, your SB-R200 is charging. When the light is red, your speedlight is fully charged and ready to fire at full power. This may seem backwards, so just think of it like this: green is *getting* ready, red is *ready*.

▶ **Channel select dial.** This dial allows you to select the channel on which the Commander (an SB-700, SB-900, SB-910, SU-800, or pop-up flash) exchanges data with the SB-R200.

▶ **Group select dial.** This dial allows you to change the group within which the SB-R200 is placed.

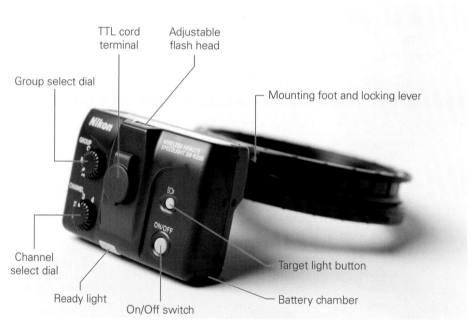

1.1 The SB-R200 attached to the SX-1 Attachment Ring. This is the king of the macro world but it's also useful for other CLS applications.

SB-400

The SB-400 is the simplest speedlight to use. For its diminutive size, this little flash is a powerhouse. Here is a list of the parts found on the SB-400:

▶ **Tilting flash head.** The flash head of the SB-400 can be tilted vertically to execute a bounce flash. You can point it straight ahead horizontally, or tilt it vertically at a 60-, 75-, or 90-degree angle. It is optimized for 18mm coverage with a DX camera and 28mm coverage with an FX camera.

For more information on bounce flash, see Chapter 3.

▶ **Battery chamber.** Sliding the cover toward the back of the SB-400 opens the battery chamber where you install two AA batteries.

▶ **On/Off switch.** Slide this switch to turn the speedlight on or off. Be sure it is switched to Off before attempting to mount the SB-400 to your camera. This will prevent any accidental damage that could result from electrical charges between the contacts.

▶ **Mounting-foot locking lever.** Move this lever to the right to lower the mounting pin, which locks the SB-400 in place in the camera's hot shoe.

▶ **Ready light.** When this is on, your SB-400 is fully charged and ready to fire at full power. The light also blinks as a warning if there is a problem with the speedlight or the camera to which it is attached, as follows:

 • **3 seconds at 4 Hz.** If, immediately following your shot, the ready light blinks at this frequency, your image may be underexposed. Adjust your ISO setting higher, open your aperture (⊘), or move closer to the subject to increase the exposure.

 • **40 seconds at 2 Hz.** When the ready light blinks at this frequency, the batteries are nearly depleted, and need to be replaced or recharged.

 • **1/2 second at 8 Hz.** When the ready light repeatedly flashes at this rate, the SB-400 is attached to a non-CLS-compatible camera and cannot be used.

 • **Repeatedly at 1 Hz.** When the ready light is repeatedly blinking once per second, the SB-400 is overheated and should be allowed to cool down before shooting more flash exposures.

▶ **Mounting foot.** This slides into the hot shoe on top of your camera. The mounting foot has contacts that convey the flash information between the camera and the speedlight.

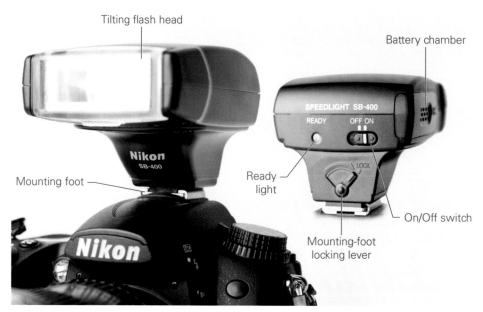

1.2 The SB-400 may look harmless, but it has it where it counts.

SB-700

From time to time, Nikon updates a model, such as the SB-600, and chooses not to discontinue it right away. The SB-700 is an evolutionary model that, coming after the SB-600 in sequence, inherits and improves upon many of the SB-600 features. Nikon also integrated many features on the SB-900 and SB-910, making certain options more accessible. Perhaps for marketing and differentiating purposes, Nikon chose to leave the PC sync terminal off of the SB-700. However, this only affects those wishing to use a third-party triggering device, such as some variety of Pocket Wizard or other trigger that relies on the PC terminal. Here are the functions for the SB-700:

▶ **Zooming/tilting flash head.** This is where the flashtube is located. Inside is a mechanism that moves the flashtube back and forth behind the speedlight lens, providing flash coverage for lenses of different focal lengths. The zooming flash head allows the speedlight to conserve energy by focusing the flash output on the appropriate area. The flash head is adjustable — you can tilt it upward to 45,

60, 75, or 90 degrees, or down-ward to 7 degrees. You can also move it 180 degrees horizontally to the right or left.

▶ **Flash head rotating-angle scale.** This scale enables you to see at which angle the flash head is set when turned horizontally left or right. The scale markings include 30, 60, 90, 120, 150, and 180 degrees.

▶ **Mounting foot.** This foot slides into the hot shoe on your cam-era body and locks down with a lever. The hot-shoe mounting foot has electronic contacts that enable the camera and speed-light to communicate flash out-put, as well as white balance information.

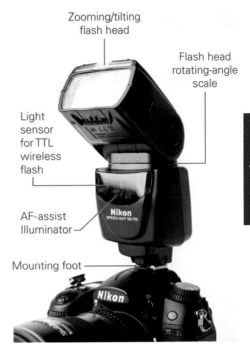

1.3 The SB-700.

▶ **AF-assist Illuminator.** This fea-ture emits an LED array to provide additional contrast. It helps you achieve focus in low-light situations.

▶ **Light sensor for TTL wireless flash.** This sensor reads signals from Commander units, enabling wireless flash.

▶ **Bounce card.** As with other speedlights, pulling out the bounce card on the SB-700 redirects some of the light forward and allows you to add a highlight in your subject's eyes. This gives the eyes a brighter, livelier appearance.

▶ **Wide flash adapter.** This built-in diffuser enables you to use the speedlight with a lens as wide as 8mm (DX) or 12mm (FX) without having light falloff at the edges of the image. The diffuser spreads the light out a bit, giving you a more even, softer illumination with wide-angle lenses.

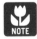
NOTE

The SB-700 recognizes whether an FX or DX camera is attached to it, and adjusts the flash head for the appropriate format.

▶ **Filter detector.** The sensor detects when a compatible Nikon filter is attached to the SB-700 flash head using the SZ-3 Color Filter Holder. The sensor reads the

encoded filter and sends the flash filter information to the camera so that the white balance can be automatically adjusted when the camera's white balance (**WB**) is set to Auto or Flash. This information is only used with cameras that are compatible with the filter detection system (D3s, D300s, D4, D700, D800, and D7000).

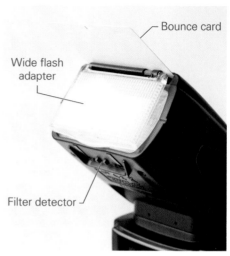

▶ **Flash head lock-release button.** Pressing this releases the flash head lock, allowing you to adjust the flash head angle vertically or horizontally for bounce flash.

1.4 The SB-700 with the built-in wide flash adapter, bounce card, and filter detector.

▶ **Wireless Remote ready light.** When you use the SB-700 as a Remote flash, this LED blinks to let you know that the flash is powered and ready to be fired.

▶ **Battery chamber.** Sliding the lid downward gives you access to the battery chamber so you can install four AA batteries to power the speedlight.

▶ **Mounting-foot locking lever.** This locks the speedlight into the hot shoe or the AS-22 speedlight stand.

▶ **Flash ready light/Test fire button.** When this is illuminated, the speedlight is ready to fire. After it fires, the light blinks until the speedlight is fully recycled. It also blinks when in TTL mode and fired at full power, which may indicate an underexposure. The ready light doubles as a test fire button and can also be set to fire a modeling flash. This causes the speedlight to fire repeatedly and very quickly at low power, giving you a preview of how the shadows from the lighting will appear on the subject. The test fire is also handy for firing your speedlight during long manual exposures.

▶ **LCD screen.** This is where all of the speedlight settings are displayed.

▶ **Flash head tilting-angle scale.** This scale allows you to see at which angle the flash head is tilted: 45, 60, 75, or 90 degrees.

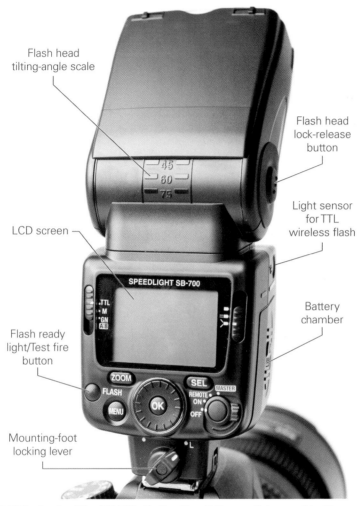

Flash head
tilting-angle scale

Flash head
lock-release
button

Light sensor
for TTL
wireless flash

LCD screen

SPEEDLIGHT SB-700

Battery
chamber

Flash ready
light/Test fire
button

Mounting-foot
locking lever

1.5 The back of the SB-700. Notice the sliding switches and buttons. These help you access key features more quickly than if the options were buried in the menu.

The control buttons, dials, and switches allow you to gain access to important functions on the SB-700 much more quickly than on previous flashes. In fact, in some cases, the SB-700 is faster to operate than its larger siblings, the SB-900 and SB-910.

The functions of the custom buttons are as follows:

▶ **Illuminator pattern selector switch.** With this conveniently located switch, you can quickly select from the following three illumination patterns:

- **Standard.** This setting is applicable to most photography situations.

- **Center-weighted.** Choose this setting for more light toward the center of the image and more light falloff toward the edges of the frame. This option is most suitable for portraits.

- **Even.** This selection provides little to no light falloff at the edges of your image. It is suitable for situations in which you need even illumination, such as a group portrait.

▶ **Sel (select) button.** Use this button to select the item that you would like to change. It is also a quick way to adjust the flash compensation.

▶ **On/Off/Wireless mode selector switch.** Rotating this switch one click turns the SB-700 on and readies it for operation. The other settings include Remote and Master. To switch to these settings, you must press the center button and rotate the switch at the same time. The lock button is used to prevent the speedlight from being accidentally switched to the Master or Remote setting. With a little practice, you can quickly switch from the On position to Remote or Master.

▶ **OK button.** Pressing this once confirms changes to the selected setting.

▶ **Selector dial.** This dial is used to quickly change the setting of the feature with which you are working. The selected setting is then highlighted on the LCD screen.

▶ **Zoom button.** Pressing this adjusts the zoom setting of the flash head to change coverage for different focal-length lenses. It allows coverage for lenses ranging from 14 to 120mm. The built-in wide-angle diffuser enables you to achieve 14mm coverage.

▶ **Mode selector switch.** You can select from the following modes:

- **TTL (iTTL flash).** The exposure is determined by the camera to sufficiently illuminate the subject on which it is focused.

- **M (Manual flash mode).** The photographer determines the flash output.

- **GN (Distance-based automatic mode).** The photographer enters the distance to the subject, and the speedlight determines the flash power.

- **Master.** When the SB-700 is set to function as a master flash, you can use the Sel (select) button to select the individual group and/or operating channel to which you want to change the flash mode. To change the operating mode, use the Mode selector switch.

• **Remote.** When the SB-700 is set to function as a wireless Remote, use the Sel button and Selector dial to set the speedlight to your desired group and channel.

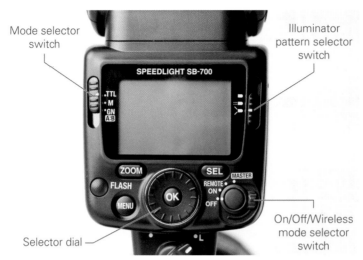

1.6 A closer view of the control panel on the SB-700.

 For more detailed information on flash modes and the Custom Settings menu, see Chapter 2.

SB-900

The SB-900, until recently, was the flagship speedlight from Nikon. It has many of the same functions as the SB-700 and the recently released SB-910, including an easy-to-use interface, as well as more automatic and custom settings. The SB-900, like the SB-700 and SB-910, has a Selector dial that allows users to quickly select custom functions and make desired changes. The features and functions of the SB-900 include:

▶ **Zooming/tilting flash head.** This is where the flashtube is located. Inside is a mechanism that moves the flashtube back and forth behind the speedlight lens, providing flash coverage for lenses of different focal lengths. The zooming/tilting flash head allows the speedlight to conserve energy by focusing the flash output on the appropriate area. You can tilt the flash head upward to 45, 60, 75, or 90 degrees, or downward to 7 degrees. You can also move it 180 degrees horizontally to the right or left.

▶ **AF-assist Illuminator.** This feature emits an LED array to provide additional contrast and help achieve focus in low-light situations.

▶ **Mounting foot.** This foot slides into the hot shoe on your camera body and locks down with a lever. The hot-shoe mounting foot has electronic contacts that enable the camera and speedlight to communicate flash output as well as white balance information.

▶ **Light sensor for automatic non-TTL flash.** This sensor reads the light reflected off of the subject. It tells the flash when to shut off when operating in AA, A, or non-TTL automatic mode.

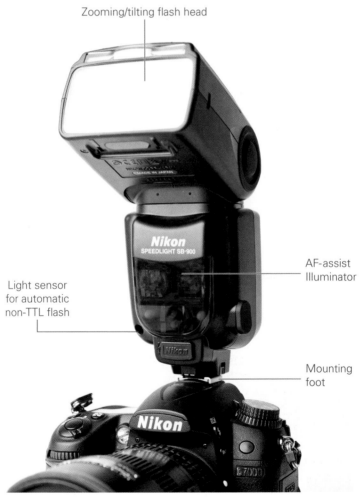

Zooming/tilting flash head

AF-assist Illuminator

Light sensor for automatic non-TTL flash

Mounting foot

1.7 The SB-900.

▶ **Bounce card.** When using the SB-900 for bounce flash, pulling out the bounce card redirects some of the light forward. This allows you to achieve a highlight in your subject's eyes, giving them a brighter, livelier appearance.

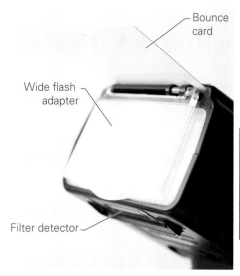

▶ **Filter detector.** The sensor detects when a compatible Nikon filter is attached to the SB-900 flash head using the SZ-2 Color Filter Holder. The sensor reads the encoded filter and sends the information to the camera. The white balance can then be adjusted automatically when the camera's white balance (**WB**) is set to Auto or Flash. This infor-

1.8 The SB-900 with wide flash adapter, bounce card, and filter detector.

mation is only used with cameras that are compatible with the filter detection system (D3s, D300s, D700, and D7000).

▶ **Wide flash adapter.** This built-in diffuser enables you to use the speedlight with a lens as wide as 11mm (DX) or 14mm (FX) without light falloff at the edges of the image. The diffuser spreads out the light for more even illumination with wide-angle lenses.

NOTE The SB-900 recognizes whether an FX or DX camera is attached to it, and adjusts the flash head for the appropriate format.

▶ **Wireless Remote ready lights.** When using the SB-900 as a Remote flash, these LEDs blink to let you know that the flash is powered and ready to be fired.

▶ **External power source terminal.** Nikon offers optional external power sources (including the SC-7 DC, the SD-8A high-performance battery pack, and the SK-6/SK-6A power bracket) that can be plugged in to this terminal.

▶ **Light sensor for TTL wireless flash.** This sensor reads signals from Commander units, enabling wireless flash.

▶ **External AF-assist contacts.** These electronic contacts are for use with the optional SC-29 TTL remote cord. This allows the SC-29 AF-assist beam to function when using the SB-900 off-camera with the TTL cord.

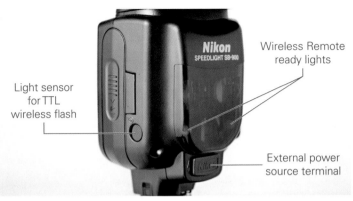

Wireless Remote
ready lights

Light sensor
for TTL
wireless flash

External power
source terminal

1.9 The SB-900 has the ability to receive an external power source. Here you can see the terminal with the cover on, the wireless Remote ready lights, and the light sensor for the TTL wireless flash window.

1.10 The power source terminal with the cover removed.

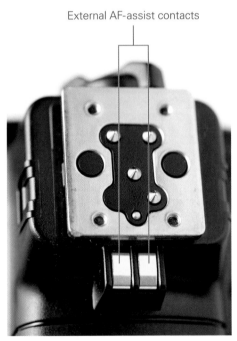

External AF-assist contacts

1.11 A close-up of the external AF-assist contacts on the SB-900.

▶ **PC sync terminal.** This terminal allows you to trigger the SB-800 using a PC sync cord. The sync cord allows you to connect your speedlight to the camera with a PC-to-PC connector. If the camera doesn't have a PC sync terminal, you can use a hot-shoe adapter, such as the Wein Safe Sync or the Nikon AS-15 PC sync terminal adapter. Both of these slide into the hot shoe of your camera.

1.12 The SB-900 and SB-910 are the only speedlights in the current Nikon lineup that include a PC sync terminal, as shown here.

The control buttons and Selector dial allow you to quickly change your settings. Because the SB-900 has additional features, there are more buttons and dials than there are on the speedlights covered previously. This gives the SB-900 a user interface that is a bit easier to navigate. These features include the following:

▶ **Flash head tilting-angle scale.** This scale allows you to see at which angle the flash head is tilted: 45, 60, 75, or 90 degrees.

▶ **Flash head lock-release button.** Pressing this releases the flash head lock, allowing you to adjust the flash head angle vertically or horizontally for bounce flash.

▶ **Battery chamber.** Sliding the lid downward allows access to the battery compartment so you can install four AA batteries.

▶ **LCD screen.** This is where all of the speedlight settings are displayed.

▶ **Flash ready light/Test fire button.** When this is on, the speedlight is ready to fire. After it fires, this light blinks until the speedlight is fully recycled. It also blinks when the speedlight is in TTL mode and fired at full power, which may indicate an underexposure. The ready light also doubles as a test fire button and can be set to fire a modeling flash. This causes the speedlight to fire repeatedly, very quickly, and at low power, allowing you to preview how the shadows from the lighting will appear on the subject.

▶ **On/Off/Wireless mode selector switch.** Rotating this switch one click turns the SB-900 on and readies it for operation. The other settings on the switch are Master and Remote. To switch to these settings, you must press the center button and rotate the switch at the same time. The lock button is used to prevent the speedlight from being accidentally switched to the Master or Remote setting.

▶ **Mounting foot.** This foot slides into the hot shoe on your camera and locks down with a lever. The hot-shoe mounting foot has electronic contacts that enable the camera and speedlight to communicate flash output, as well as white balance information.

▶ **Mounting-foot locking lever.** This lever locks the speedlight into the hot shoe or the AS-21 speedlight stand.

▶ **Selector dial.** Use this dial to quickly change the setting of the feature with which you are working. The selected setting is highlighted on the LCD screen.

▶ **OK button.** Press this once to confirm changes to the selected setting. Press and hold it for 1 second to display the Custom Settings Menu.

▶ **Zoom button.** Pressing this adjusts the zoom setting of the flash head, changing the coverage for different focal-length lenses. It allows coverage for lenses ranging from 17 to 200mm in FX mode, or 12 to 200mm in DX mode. The built-in, wide-angle diffuser (FX) or 10mm (DX) enables 14mm coverage.

▶ **Mode button.** Press this once to select the mode you want to change. You can then cycle through the flash modes by rotating the Selector dial. Press the button multiple times to cycle through the following seven flash modes:

- **TTL BL (iTTL).** Balanced fill flash. The exposure is determined by the camera and matched with the ambient light.

- **TTL (iTTL flash).** The exposure is determined by the camera to sufficiently illuminate the subject on which it is focused.

- **AA (Aperture-based automatic mode).** The photographer enters the aperture value, and the speedlight determines the flash power using data collected from the camera, such as aperture, ISO, distance, and exposure compensation.

- **A (Non-TTL Auto Flash).** This mode uses the SB-900 non-TTL sensor to determine the flash output by measuring the light reflected from the subject.

- **GN (Distance-based automatic mode).** The photographer enters the distance to the subject, and the speedlight determines the flash power.

- **RPT (Repeating flash mode).** This mode fires a series of flashes at a rate determined by the photographer.

- **M (Manual flash mode).** The photographer determines the flash output.

 For more detailed information on flash modes and the Custom Settings menu, see Chapter 2.

▶ **Function buttons.** These three buttons, located directly below the LCD screen, allow you to highlight different items to select them for change. The selected function differs, depending on the flash mode or wireless setting. Each function button's assignments are listed within each of the following SB-900 modes:

● **Manual.** In Manual mode, Function button 1 selects the flash output for adjustment. Function button 3 allows you to manually change the aperture setting on the flash (only when using a non-CPU lens or when non-CPU lens data is not entered into the camera). Function button 2 has no function in this mode.

● **TTL/TTL BL.** In Through-the-Lens (TTL) modes, Function button 1 selects the flash exposure compensation for adjustment. Function button 2 recalls the display of underexposure (if any). Function button 3 allows you to manually change the aperture setting on the flash (only when using a non-CPU lens or when non-CPU lens data is not entered into the camera).

● **AA.** In Auto Aperture mode, Function button 1 selects the flash exposure compensation for adjustment. Function button 3 allows you to manually change the aperture setting on the flash (only when using a non-CPU lens or when non-CPU lens data is not entered into the camera). Function button 2 has no function in this mode.

● **GN.** In Distance (GN) Priority mode, Function button 1 selects the flash exposure compensation for adjustment. Function button 2 selects the flash distance setting for change. Function button 3 allows you to manually change the aperture setting on the flash (only when using a non-CPU lens or when non-CPU lens data is not entered into the camera).

● **RPT.** In Repeating flash mode, pressing Function button 1 allows you to adjust the flash output. Function button 2 selects the number of times the flash should fire. Function button 3 allows you to change the frequency of the repeating flash.

 For more information on Repeating flash, see Chapter 3.

● **Master.** When the SB-900 is set to function as a Master flash, Function button 1 is used to select the group for which you wish to change the flash mode. Function button 2 is used to select the channel on which the SB-900 is communicating. Function button 3 does nothing in this mode.

- **Remote.** When you set the SB-900 to function as a wireless Remote, Function button 1 is used to assign a group to the speedlight. Function button 2 is used to assign the channel number. Function button 3 does nothing in this mode.

- **Function button 1 + Function button 2.** Pressing and holding these buttons simultaneously for 2 seconds locks the speedlight to prevent accidental changes to the settings.

▶ **Flash head rotating-angle scale.** This scale enables you to see at which degree the flash head is set when turned horizontally left or right. The scale markings include 30, 60, 90, 120, 150, and 180 degrees.

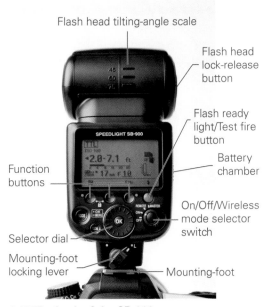

Flash head tilting-angle scale

Flash head lock-release button

Flash ready light/Test fire button

Battery chamber

On/Off/Wireless mode selector switch

Function buttons

Selector dial

Mounting-foot locking lever

Mounting-foot

1.13 The back of the SB-900.

1.14 The flash head rotating-angle scale on the SB-900.

SB-910

The SB-910 is the Nikon flagship speedlight. It is very similar to the SB-900, but Nikon has made some evolutionary changes. Updates on the SB-910 include the ability to use multi-point AF-assist, a dedicated Menu button, easier to understand LCD screen graphics, and a revamped Thermal cut-out feature that keeps your speedlight from shutting down completely by reducing the recycle time. The functions of the SB-910 include the following:

▶ **Zooming/tilting flash head.** This is where the flashtube is located. Inside is a mechanism that moves the flashtube back and forth behind the speedlight lens, providing flash coverage for lenses of different focal lengths. It allows the speed-light to conserve energy by focusing the flash output on the appropriate area. You can tilt the flash head upward to 45, 60, 75, or 90 degrees, or downward to 7 degrees. You can also move it 180 degrees horizontally to the right or left.

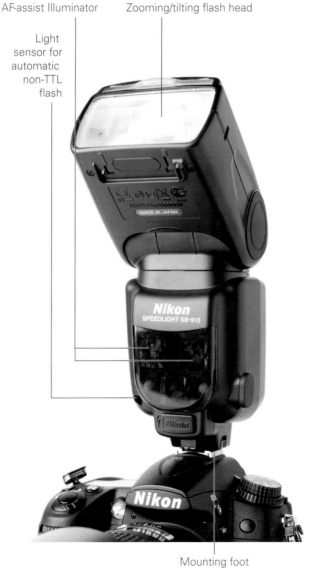

AF-assist Illuminator Zooming/tilting flash head

Light sensor for automatic non-TTL flash

Mounting foot

1.15 The SB-910.

▸ **Mounting foot.** This foot slides into the hot shoe on your camera and locks down with a lever. The hot-shoe mounting foot has electronic contacts that enable the camera and speedlight to communicate flash output, as well as white balance information.

▸ **Light sensor for automatic non-TTL flash.** This sensor reads the light reflected off of the subject. It tells the flash when to shut off when operating in AA, A, or non-TTL automatic mode.

▸ **AF-assist Illuminator.** This feature emits an LED array to provide additional contrast and help achieve focus in low-light situations.

▸ **Bounce card.** When using the SB-910 for bounce flash, pulling out the bounce card redirects some of the light forward. This creates a highlight in your subject's eyes, giving them a brighter, livelier appearance.

Bounce card

Wide flash adapter Filter detector

1.16 The SB-910 with wide flash adapter, bounce card, and filter detector.

▸ **Filter detector.** The sensor detects when a compatible Nikon filter is attached to the SB-910 flash head using the SZ-2 Color Filter Holder. The sensor reads the encoded filter and sends the flash filter information to the camera. The white balance can then be adjusted automatically when the camera's white balance (**WB**) is set to Auto or Flash. This information is only used with cameras that are compatible with the filter detection system (D3s, D300s, D700, and D7000).

▸ **Wide flash adapter.** This built-in diffuser enables you to use the speedlight with a lens as wide as 8mm (DX) or 12mm (FX) without light falloff at the edges of the image. The diffuser spreads out the light, giving you more even illumination with wide-angle lenses.

> The SB-910 recognizes whether an FX or DX camera is attached to it, and **NOTE** adjusts the flash head for the appropriate format.

▶ **Wireless Remote ready lights.** When you are using the SB-910 as a Remote flash, these LEDs blink to let you know that the flash is powered and ready to be fired.

▶ **External power source terminal.** Nikon offers optional external power sources (including the SD-8A or SD-9 high-performance battery packs, as well as the SK-6/SK-6A power bracket) that can be plugged in to this terminal.

▶ **Light sensor for TTL wireless flash.** This sensor reads signals from Commander units, enabling wireless flash.

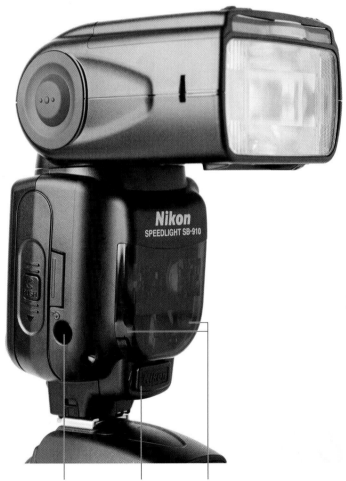

Light sensor for TTL External power Wireless Remote
wireless flash source terminal ready lights

**1.17 The SB-910 has the ability to receive an external power source.
Here you can see the terminal with the cover on, the Wireless
Remote ready lights, and the Light sensor for TTL wireless flash
window.**

▶ **External AF-assist contacts.**
These electronic contacts are for
use with the optional SC-29 TTL
remote cord. This allows the
SC-29 AF-assist beam to func-
tion when using your SB-910 off-
camera with the TTL cord.

▶ **PC sync terminal.** This terminal
allows you to trigger the SB-910
using a PC sync cord. The sync
cord allows you to connect your
speedlight to the camera with a

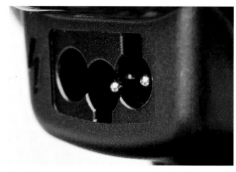

**1.18 The power source terminal with the
cover removed.**

PC-to-PC connector. If the camera doesn't have a PC sync terminal, you can use
a hot-shoe adapter, such as the Wein Safe Sync or the Nikon AS-15 PC sync
terminal adapter. All of these slide into the hot shoe of your camera.

External AF-assist contacts

**1.19 A close-up of the External AF-assist
contacts on the SB-910.**

**1.20 The SB-910 and SB-900 are the only
speedlights in the current Nikon lineup
that include a PC sync terminal, as shown
here.**

The control buttons and Selector dial allow you to quickly change your settings. This gives the SB-910 a user interface that is a bit easier to navigate. These buttons and functions include the following:

▶ **Flash head tilting-angle scale.** This scale allows you to see at which angle the flash head is tilted: 45, 60, 75, or 90 degrees.

▶ **Flash head lock-release button.** Pressing this releases the flash head lock, allowing you to adjust the flash head angle vertically or horizontally for bounce flash.

▶ **Battery chamber.** Sliding the lid downward allows access to the battery compartment so you can install four AA batteries.

▶ **LCD screen.** This is where all of the speedlight settings are displayed.

▶ **Flash ready light/Test fire button.** When this is on, the speedlight is ready to fire. After it fires, this light blinks until the speedlight is fully recycled. It also blinks when the speedlight is in TTL mode and fired at full power, which may indicate an underexposure. The Ready light also doubles as a test fire button and can be set to fire a modeling flash. This causes the speedlight to fire repeatedly, very quickly, and at low power, allowing you to preview how the shadows from the lighting will appear on the subject. When modeling is enabled and your SB-910 is set to Master, pressing this button directs all active speedlights to fire a modeling light.

▶ **On/Off/Wireless mode selector switch.** Rotating this switch one click turns the SB-910 on and readies it for operation. The other settings on the switch are Master and Remote. To switch to these settings, you must press the center button and rotate the switch at the same time. The lock button is used to prevent the speedlight from being accidentally switched to the Master or Remote setting.

▶ **Mounting-foot locking lever.** This lever locks the speedlight into the hot shoe or the AS-21 speedlight stand.

▶ **Selector dial.** Use this dial to quickly change the setting of the feature with which you are working. The selected setting is highlighted on the LCD screen.

▶ **OK button.** Press this once to confirm changes to the selected setting.

▶ **Menu button.** Press this once to bring up the SB-910 Custom Settings Menu.

▶ **Mode button.** Press this once to select the mode you want to change. You can then cycle through the flash modes by rotating the Selector dial. Press the button multiple times to cycle through the following six flash modes:

- **TTL BL (iTTL).** Balanced fill flash. The exposure is determined by the camera and matched with the ambient light.

- **TTL (iTTL flash).** The exposure is determined by the camera to sufficiently illuminate the subject on which it is focused.

- **AA (Aperture-based automatic mode).** The photographer enters the aperture value and the speedlight determines the flash power using data collected from the camera, such as aperture, ISO, distance, and exposure compensation.

- **GN (Distance-based automatic mode).** The photographer enters the distance to the subject and the speedlight determines the flash power.

- **RPT (Repeating flash mode).** This mode fires a series of flashes at a rate determined by the photographer.

- **M (Manual flash mode).** The photographer determines the flash output.

 For more detailed information on flash modes and the Custom Settings menu, see Chapter 2.

▶ **Function buttons.** These three buttons (located directly below the LCD screen) allow you to highlight different items to select them for change. The selected function differs, depending on the flash mode or wireless setting. Each function button's assignments are listed here, within each of the following SB-910 modes:

- **Manual.** In Manual mode, Function button 1 increases the zoom position of the flash head. Function button 2 both highlights and increases the power output of the speedlight. Function button 3 is only active when Function button 1 is highlighted; it allows you to change the illumination pattern of the flash head.

- **TTL/TTL BL.** In TTL modes, Function button 1 increases the zoom position of the flash head. Function button 2 both highlights and increases Flash Exposure Compensation. Function button 3, active only while Function button 1 is highlighted, allows you to change the illumination pattern of the flash head.

- **AA.** In Auto Aperture mode, Function button 1 increases the zoom position of the flash head. Function button 2 both highlights and increases Flash Exposure Compensation. Function button 3, active only while Function button 1 is highlighted, allows you to change the illumination pattern of the flash head.

- **GN.** In Distance (GN) Priority mode, Function button 1 highlights the zoom feature for adjustment. Function button 2 selects the Flash Exposure Compensation option. Function button 3 allows you to manually input your desired distance setting.

- **RPT.** In Repeating flash mode, pressing Function button 1 allows you to adjust the zoom position of the flash head. Function button 2 highlights and increases the power output of the speedlight (or you can use the Selector dial to increase/decrease power output). Function button 3 allows you to toggle between changing the number of flashes and changing the frequency of the repeating flash. While Function button 1 is highlighted, Function button 3 allows you to change the illumination pattern of the flash head.

For more information on Repeating flash, see Chapter 3.

- **Master.** When the SB-910 is set to function as a Master flash, Function button 1 is used to change the zoom position of the flash head. Function button 2 allows you to select the desired Remote group. Function button 3 highlights Flash Exposure Compensation when the Remote speedlight is in Through-the-Lens (TTL) or Auto Aperture mode. If the selected Remote speedlight is in Manual mode, Function button 3 allows you to change the output power of that particular speedlight.

- **Remote.** When you set the SB-910 to function as a wireless Remote, Function button 1 is used to change the zoom position of the flash head. Function button 2 is used to toggle between Group and Channel. Function button 3 enables/disables the Sound monitor. When enabled, the monitor beeps to indicate the status of the speedlight when used as a Remote. Please consult your speedlight manual for more information on the Sound monitor feature.

- **Function button 1 + Function button 2.** Pressing and holding these buttons simultaneously for 2 seconds locks the speedlight to prevent accidental changes to the settings.

The SB-910 Illumination Pattern

In most flash modes, you can adjust the illumination pattern in which the speed-light fires to better suit the type of situation and subject. This allows you to con-trol how much light falloff you have at the edges of the image frame. By pressing Function button 1, then Function button 2, you can cycle through the following illumination pattern options:

▶ **Standard.** This is the default setting for the SB-910 and is ideal for most sub-jects. The light falloff (or vignetting) at the edges of the frame is normally minimal, but it may be noticeable in some situations. If you forget about the ability to change the illumination pattern on your SB-910 and remain stuck on standard, you'll be fine.

▶ **Center-weighted.** This pattern causes the light from the speedlight to be more focused at the center of the frame, allowing the light to fall off at the edges of the frame, which draws attention to the subject. This is a good option for portraits or close-ups of a subject in the middle of the frame.

▶ **Even.** This pattern provides a more diffused light that covers more of the frame than the previous options. There is little falloff and the edges are suffi-ciently illuminated. It is best suited for subjects that fill the entire image, such as group portraits or still-life shots.

▶ **Flash head rotating-angle scale.** This scale enables you to see at which degree the flash head is set when turned horizontally left or right. The scale markings include 30, 60, 90, 120, 150, and 180 degrees.

1.21 The Flash head rotating-angle scale on the SB-910.

LCD screen Flash head tilting-angle scale

Function buttons

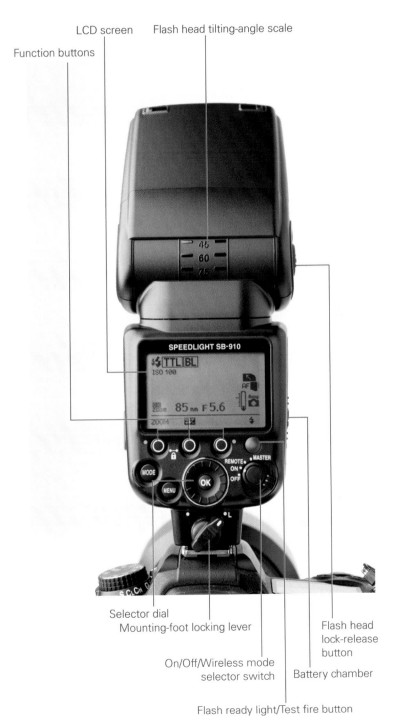

Selector dial
Mounting-foot locking lever

On/Off/Wireless mode
selector switch

Flash head
lock-release
button

Battery chamber

Flash ready light/Test fire button

1.22 The back of the SB-910.

Camera Compatibility

Some camera bodies only allow certain features to be used with CLS. Table 1.1 shows which functions are supported by each camera in the current Nikon lineup.

Table 1.1 The Nikon CLS Camera Compatibility

Camera Model/Series	CLS Feature	Available with:
D3000, D3100, D5000, D5100	iTTL flash	The built-in speedlight, SB-400, SB-700, SB-900, and SB-910.
	iTTL balanced fill flash	The built-in speedlight, SB-400, SB-700, SB-900, and SB-910.
	Auto aperture	The SB-700, SB-900, SB-910, and an autofocus lens.
	Non-TTL auto	The SB-700, SB-900, and SB-910.
	Distance priority manual	The SB-700, SB-900, and SB-910.
	Wide area AF-assist Illuminator	The SB-700, SB-900, SB-910, and SU-800.
D90	iTTL flash	The built-in speedlight, SB-400, SB-700, SB-900, and SB-910.
D300s, D700, D800	iTTL balanced fill flash	The built-in speedlight, SB-400, SB-700, SB-900, and SB910.
	Auto aperture	The SB-700, SB-900, SB-910, and an autofocus lens.
	Non-TTL auto	The SB-700, SB-900, and SB-910.
	Distance-priority manual	The SB-700, SB-900, and SB-910.
	Auto aperture	Available only with the SB-700, SB-900, SB-910, and a CPU lens.
	iTTL balanced fill flash	The SB-400, SB-700, SB-900, and SB-910.
D3s, D3x, D4, F6	Non-TTL auto	The SB-700, SB-900, and SB-910.
	Distance-priority manual	The SB-700, SB-900, and SB-910.
	Auto FP high-speed sync	The SB-700, SB-900, and SB-910.
	Wide area AF-assist Illuminator	The SB-700, SB-900, SB-910, and SU-800.

Although each camera doesn't offer the full functionality of all CLS features, there are some caveats, which I cover here.

D3000, D3100, D5000, D5100

Just because you can't use the built-in flash as a remote Commander with these cameras doesn't mean you can't use Advanced Wireless Lighting. The SB-700, SB-900, SB-910, and SU-800 can all be used as the Commander for wireless Remote speedlights.

D90, D300s, D700, D800

The built-in flash *can* be used as a wireless remote Commander with these cameras. You can use any number of speedlights in two groups on four channels. These cameras also include the option of turning the built-in flash off (or down) so as not to add to the exposure when they are acting as a Commander. To achieve the FV Lock feature, you must set the Function button in the camera's Custom Settings menu (✐).

This group of cameras offers the full range of CLS features when used with the SB-700, SB-900, or SB-910, and a CPU lens. They also have the added benefit of a built-in wireless Commander — something the D3s and D3x, which are much more expensive, do not provide.

D3s, D3x, D4, F6

The D3s, D3x, D4, and F6 cameras offer the full functionality of any of the speedlights. However, because cameras at this level do not feature a built-in flash, you also need an SB-700, SB-900, or SB-910 to take advantage of Advanced Wireless Lighting.

Included Accessories

Some speedlights come with more accessories than others, but they all have a few extras in the box. These range from small stands on which to place your speedlight off-camera, to soft cases for transporting your speedlight.

The SB-400 and SU-800 come with only a soft case. For that reason they aren't mentioned any further in this section.

SB-700

Nikon chose to add some helpful accessories to the SB-700 package that are well beyond the typical (but included) soft case.

▶ **SS-700 Soft Case**. While this padded case is an odd size (and probably some-thing you wouldn't wear on your belt), it fits the SB-700 and included accesso-ries perfectly. It allows you to transport your gear in style while keeping it safe.

▶ **AS-22 Speedlight Stand.** Similar to the AS-21 stand that comes with the SB-900 and SB-910, the AS-22 has three accessory shoe slots. You attach the speedlight to the stand and you can then place it on any flat surface. This stand also has a standard, 1/4-20 threaded socket (the same as the tripod socket on your camera body) for attaching to light stands or a tripod quick-release plate.

 The AS-22 stand is compatible only with the SB-700 speedlight. The SB-900 and SB-910 hot shoes are too large for the slots.

▶ **Color Correction Filters.** The SZ-3TN incandescent and SZ-3FL fluorescent fil-ters are included to help you balance the color temperature of your speedlight flash with that of the ambient color temperature. For instance, if you were pho-tographing a business meeting in an office primarily lit with fluorescent lighting, placing the SZ-3FL filter on your speedlight and adjusting your camera's white balance (**WB**) to fluorescent would produce a fairly accurate (and even) color temperature.

▶ **SW-14H Diffusion Dome.** This standard Diffusion Dome snaps over the top of the flash head. It diffuses the light from the speedlight, helping you avoid the harsh, direct light from the flash. It can also be placed over the top of the flash head while the color filters are in place.

SB-900

The SB-900 was the first Nikon speedlight to include a plethora of accessories. From a nice case to color filters, Nikon thought of just about everything. Here is a list of what was originally included with the SB-900:

▶ **SS-900 Soft Case.** This simple, padded nylon soft case provides a bit of protec-tion for your SB-900 when you're transporting it. It has a couple of small pouches as well — one to hold your filters and another for the stand. On the bottom of the case is a zippered compartment for the diffuser and filter holder. There is also a loop on the back for attaching the case to your belt or camera bag.

▶ **AS-21 Speedlight Stand.** This small, plastic stand has an accessory shoe slot. When you attach your speedlight to the stand, you can then place the speedlight on any flat surface. This stand also has a standard 1/4-20 threaded socket (the same as the tripod socket on your camera body) for attaching to light stands or even a tripod mount.

▶ **SJ-900 Color Filter Set.** These color filters balance the light from the flash with ambient light from incandescent or fluorescent light sources. The set includes four filters: the TN-1 and TN-2 for standard incandescent (tungsten) light bulbs, and the FL-1 and FL-2 for non-color-balanced fluorescent lamps. This set is not to be confused with the SJ-3 Color Filter Set (available separately), which includes filters for special effects.

▶ **SZ-2 Color Filter Holder.** This handy piece of clear plastic allows you to fit a filter from one of the previously mentioned filter kits into it. It then snaps over the top of the flash head. This allows the filter to avoid direct contact with the flash lens as the lens generates quite a bit of heat, and can melt or discolor the filter. This is a much-appreciated accessory that makes using filters with the SB-900 much easier.

 For more information on color filters, see Chapter 5.

▶ **SW-13H Diffusion Dome.** This accessory snaps over the top of the flash head and diffuses the light from the speedlight. This helps you avoid harsh, direct lighting from the flash. The diffusion dome also fits right over the top of the SZ-2 filter holder so that you can also use it when using color filters.

 For more information on using diffusers, see Chapter 3.

SB-910

The SB-910 is, as of this writing, the latest Nikon speedlight. Here is a list of included accessories that give you a great starting point for building your advanced speedlight kit:

▶ **SS-900 Soft Case.** This simple, padded nylon soft case provides a bit of protection for your SB-910 when you're transporting it. It has a couple of small pouches as well — one to hold your filters and another for the stand. On the bottom of the case is a zippered compartment for the diffuser and filter holder. There is also a loop on the back for attaching the case to your belt or camera bag.

▶ **AS-21 Speedlight Stand.** This small, plastic stand has an accessory shoe slot. When you attach your speedlight to the stand, you can then place the speedlight on any flat surface. This stand also has a standard 1/4-20 threaded socket (the same as the tripod socket on your camera body) for attaching to light stands or even a tripod mount.

▶ **SZ-2FL Fluorescent Color Filter.** This filter helps your speedlight better match the color temperature of fluorescent light sources which are commonly found in many office buildings.

▶ **SZ-2TN Incandescent Color Filter.** This filter helps your speedlight better match the color temperature of incandescent light sources, which are found indoors.

 For more information on color filters, see Chapter 5.

▶ **SW-13H Diffusion Dome.** This accessory snaps over the top of the flash head and diffuses the light from the speedlight. This helps you avoid harsh, direct lighting from the flash. The diffusion dome also fits right over the top of the SZ-2 filter holder so that you can also use it when using color filters.

Add-on Accessories

A few accessories are available separately. They can play an integral role in your CLS setup or you can use them as add-ons. You can use some of these accessories in conjunction with others, while some of them can be used to replace a function on another speedlight.

SU-800 Wireless Speedlight Commander

A Commander (also known as a Master) is what tells the Remote speedlights when to fire. It also reads the data provided by the Remote speedlights' pre-flashes, and relays that information to the camera body for use in setting the exposure levels.

The SU-800 is a wireless Commander for the Nikon Creative Lighting System. It functions in much the same way that the SB-700, SB-900, and SB-910 do in Master mode, except that it doesn't emit any visible light. Like the SB-700 and SB-900 series speedlights, the SU-800 Commander has four independent channels. This is helpful if you are working near other photographers because it prevents someone else's SU-800 Commander from setting off your flashes.

The SU-800 slides into the hot shoe of your camera like any other speedlight and is used to wirelessly control any number of SB-700, SB-900 series, or SB-R200 speedlights. With the SU-800, you can control up to three groups of flashes. You can also control the output of each group individually, which is a great timesaving feature. You

can set each group to TTL, A, or M in order to fine-tune the lighting to suit your needs. In addition, not all groups need to be set to the same metering mode. For example, you can set Groups A and C to TTL, Group B to M, or any combination that you choose.

You can also use the SU-800 solely as an AF-assist Illuminator by setting all groups to the "–" setting, which tells it not to fire Remote speedlights. This is beneficial in low-light situations when you're not using a speedlight and your camera doesn't have a built-in AF-assist Illuminator. It's also ideal if you'd rather have the less obtrusive red LED pattern of the SU-800 than the bright, white LED of the AF-assist on other Nikon cameras. Whether you're using the SU-800 for mastering Remote speedlights or for helping your D series camera autofocus, this is truly a handy addition to the CLS tool bag.

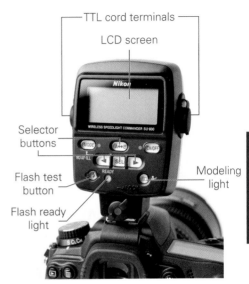

TTL cord terminals

LCD screen

Selector buttons

Flash test button

Flash ready light

Modeling light

1.23 The SU-800 Wireless Speedlight Commander.

 For information on setting up the SU-800, see Chapter 2.

R1/R1C1 and SB-R200 kits

The R1 and R1C1 kits are the Creative Lighting System answer for close-up and macro photography. For all intents and purposes, both of these kits are the same, with the exception that the R1 kit doesn't come with an SU-800 Commander (the R1C1 kit does). With the R1 kit, you need an SB-700, SB-900, SB-910, SU-800, or a camera with a built-in flash that you can use as a Commander, such as the D90, D300s, or D700.

These kits revolve around the SB-R200 speedlight. Each one comes with two SB-R200 speedlights and an SX-1 attachment ring that threads onto the front of the lens via adapter rings. The SB-R200 is then attached to the SX-1 and can be positioned in a number of ways so that you can shape the light on your subject. The SB-R200 speedlights also come with an AS-20 stand so you can use the flashes separately without mounting them to the SX-1 ring.

The SX-1 ring fits up to four SB-R200 speedlights when attached to the camera, or you can use it off-camera with a total of eight SB-R200s attached.

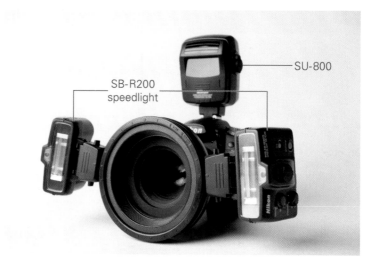

SU-800

SB-R200
speedlight

1.24 Looking like something Darth Vader may pilot in his next attack on the Rebellion, the R1C1 kit with the SU-800 fits nicely on the Nikon D7000.

SG-31R

The SG-31R is a simple and inexpensive little accessory, but it definitely comes in handy. It is a small, plastic device that fits into the camera's hot shoe and suspends an infrared filter that goes in front of the built-in flash. This blocks the output of the flash when used as a Commander for close-up photography with the R1 kit, or even when photographing objects up close with an SB-700 or SB-900 speedlight.

When you use the built-in flash as a Commander, the pre-flash (or, more accurately, the triggering flash) can sometimes add to the exposure. This is usually only noticeable when photo-graphing your subject up close.

1.25 The SG-31R atop the D7000.

Setting Up Your Nikon Speedlights

As you may have discovered, there are quite a few settings that you can change on your speedlight. Although you can just slide your speedlight into the hot shoe of your camera, use the automatic settings, and get acceptable shots, it's likely that you purchased this book because you want to take your lighting to the next level.

This chapter walks you through how to use the different flash modes on the SB-700, SB-900, and SB-910. I also cover how to adjust the custom settings for each speedlight so you can maximize its operation.

Power Requirements

The power requirements are the same for the SB-700, SB-900, and SB-910: four AA batteries. While the discontinued SB-800 had the ability to hold five AA batteries, Nikon increased the recycle time of the SB-700, SB-900, and SB-910 to the point that a fifth battery was no

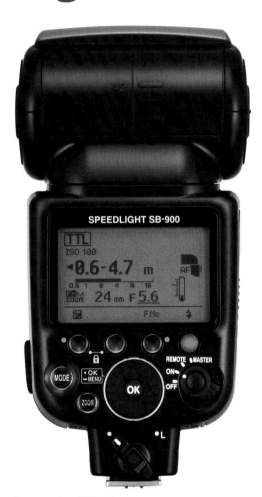

Image courtesy of Nikon, Inc.

The SB-900 control panel has been refined to make it much faster to operate.

longer needed. Having enough power for your speedlight is the key. Given the porta-bility of your speedlight, you wouldn't want to be stranded in the middle of nowhere with the perfect model and no power. I carry at least one additional set of batteries for each speedlight — sometimes more, depending on the type of shoot.

If you plan to use speedlights often when shooting, there's no better way to power them than with rechargeable batteries. It's true, the initial out-of-pocket expense is greater than if you were buying standard batteries, but spread that cost out over time and you'll see the benefit. It's also a good idea to take care of Mother Earth; the fewer batteries that end up in our landfills, the better.

Three different types of rechargeable and nonrechargeable AA batteries are available for use in Nikon speedlights.

Nonrechargeable batteries

These batteries drain your pocket as well as their toxic insides into our drinking water. If you use these with a speedlight (or three), you'll be amazed at how quickly the bat-teries are consumed. Listed below are the two types of nonrechargeable batteries for use in your speedlight:

- ▶ **Alkaline-manganese.** These are the everyday, standard type of battery. Alkalines are available nearly everywhere, from your local gas station to high-end camera shops. They can differ greatly in price and quality.

- ▶ **Lithium.** These batteries cost a little more than the standard alkalines, but they last a lot longer and actually weigh half as much as alkalines. You can find them at most electronics stores, specialty battery shops, and most camera stores.

Rechargeable batteries

As mentioned previously, rechargeable batteries require more of an initial investment, but you get your money back in what you save by not having to continually buy dispos-able batteries. I recommend buying a few sets of rechargeables. There used to be different types of rechargeable batteries, but the only type that is generally available now is the nickel-metal hydride (NiMH).

NiMHs are the most expensive type of battery, but as the saying goes, you get what you pay for. They have a good charge life and can usually be used for a few years before you have to replace them. It's not a bad idea to label your rechargeable batter-ies with a purchase date so you know approximately when to invest in some new ones. NiMH batteries come in different power ratings that are expressed in

milliampere hours (mAh). They range from about 1400mAh up to 3000mAh; the higher the mAh rating, the longer the battery holds its charge. I recommend using a battery with an mAh of 2500 or better.

 Most NiMH batteries must be fully charged before you use them in your speedlight. If one of the batteries in the set becomes discharged before the others, the discharged battery goes into polarity reversal. This means the positive and negative poles become reversed and cause permanent damage to the cells, rendering the battery useless and possibly damaging the speedlight. As a result, some manufacturers sell pre-charged, rechargeable batteries.

Not long ago, nickel-zinc (NiZn) batteries made a splash in the market claiming to be the end-all for rechargeable battery needs. While initial reports seemed positive for photographers, over time it appears the love affair has worn off. NiZn batteries are like short-distance sprinters and, as such, start to lose power not too far out of the gate. Those initial high-power bursts can also lead to the SB-900 series employing its Thermal cut-out feature, which can either shut down your flash or drastically reduce recycle time. Also keep in mind that using a 1.6-volt cell in your 1.5-volt recommended speedlight could void your warranty. That's a big price to pay for a few high-speed recycles.

Navigating the Speedlight Settings and Menus

Now that you know how to power your speedlight, I'll cover all of the available settings. Most speedlights offer a lot of functions, features, and custom settings. They all offer enough customization to give you a great deal of flexibility. In the following sections, I cover every flash mode and custom setting available on the SB-900, SB-910, and SB-700.

Flash modes

Your speedlight has different modes of operation. These modes control how the camera determines the amount of light the speedlight needs to emit in order to achieve a proper exposure for the scene. These flash modes are not to be confused with *flash sync modes*, which control how the flash interacts with different exposure and camera settings. The available flash modes differ for each speedlight model.

 For more information on flash sync modes, see Chapter 3.

i-TTL and i-TTL BL

TTL stands for *Through-the-Lens*. This means that the flash exposure is metered directly by the camera by reading the amount of light that is entering the lens of the camera. Nikon has used Through-the-Lens flash metering for quite a few years and has redesigned and adapted the system for the changing technology that is prevalent with today's dSLRs.

The most current Nikon Through-the-Lens system is referred to as i-TTL. The i-TTL system is the most innovative flash mode developed by Nikon. The camera gets most of the metering information from monitor pre-flashes emitted from the speedlight. These pre-flashes are emitted almost simultaneously with the main flash, so it looks as if the flash fires once. The pre-flashes are fired and reflect off of the subject. The light then travels down the lens and is evaluated by the camera's metering sensor.

 i-TTL BL is only available when the camera's exposure metering system is set to Matrix (▦) or Center-weighted (▣).

The camera interprets the data from the sensor and tells the speedlight at what power to fire. The camera also uses data from the lens, such as distance information and f-stop values, to help get an accurate exposure. i-TTL metering is used on all CLS-compatible cameras with all current speedlights. The i-TTL metering system can also be employed when using speedlights off-camera as a remote, with any of the built-in speedlights, or when using the SB-700, SB-900, SB-910, or SU-800 as a Commander.

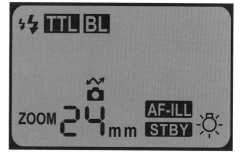

2.1 Although the LCD screen shows Through-the-Lens (TTL), the speedlight is using i-TTL. Just think of the *i* as silent.

 Because the SB-400 is the simplest Nikon speedlight, it functions only with i-TTL — no other flash modes are available.

Going hand-in-hand with i-TTL is TTL BL. TTL BL uses the Nikon i-TTL system in the same way, but it also takes into account the metering information from the camera regarding the *ambient light.* Ambient light is simply the available or existing light in the scene, such as sunlight, moonlight, or car headlights. The camera then adjusts the flash output to better match the ambient lighting of the scene to give the image a more natural look, rather than making it appear that a flash has been used.

This flash metering system is known as *Automatic Balanced Fill Flash* in Nikon terminology (this is where the *BL* comes from in TTL BL). *Fill flash* is a flash technique that employs the flash to fill in shadows on a subject when photographing outdoors in natural light.

 For more information on fill flash, see Chapter 3.

Auto Aperture and non-TTL Auto Flash

When using non-TTL Auto Flash, the camera does not use TTL metering to determine the flash output. There are a few variations of this flash mode. You can set them in the Custom Functions menu of the SB-900 and SB-910 (the SB-700 does not support non-TTL Auto Flash modes). The speedlight Custom Functions menu is covered later in this chapter.

The SB-900 and SB-910 have four, non-TTL Auto Flash settings:

▶ **Auto Aperture with pre-flashes.** When using this mode, the camera automatically transmits aperture and ISO information to the speedlight, which fires a series of pre-flashes immediately preceding the main flash. When the flash is fired, the speedlight reads the reflected light from the sub-

2.2 Auto Aperture with pre-flashes option located in the Custom Functions menu of your speedlight.

ject using the non-TTL Auto Flash sensor, located on the front. When the flash detects enough light to make a proper exposure for the aperture and ISO setting, the flash is stopped. The information provided by the pre-flash helps with getting a more accurate flash exposure.

▶ **Auto Aperture.** When using AA or Auto Aperture Flash, the flash output is determined by the aperture and ISO settings of the camera, which are automatically transmitted from the camera to the speedlight. The flash is fired and the speedlight reads the reflected light from the sub-

2.3 Auto Aperture.

ject using the non-TTL Auto Flash sensor, located on the front of the speedlight.

▶ **Non-TTL Auto Flash with pre-flashes.** In this mode, pre-flashes are fired to obtain subject information to aid in the exposure; however, no aperture information is

communicated between the camera and the speedlight. In order to achieve a proper exposure in this mode, you must enter the aperture setting directly into the speedlight. You can do this by pressing Function button 3 repeatedly until the proper aperture setting appears, or you can press the button once, and then rotate the Selector dial until the desired aperture setting is displayed. When using this mode, you can adjust the exposure by adjusting the aperture (⊛) setting on the camera without adjusting the setting on the speedlight.

2.4 Non-TTL Auto Flash with pre-flashes is located in the Custom Settings Menu.

▶ **Non-TTL Auto Flash.** This mode is the same as the previous one, but without the pre-flashes. The aperture setting is also adjusted in the same way.

Some people prefer the non-TTL Auto modes without the pre-flash for children and pet photography because the pre-flashes (both i-TTL and non-TTL Auto) can cause your subject to blink, resulting in portraits with closed eyes.

2.5 Non-TTL Auto Flash located in the Custom Settings Menu.

Guide Number (GN) Distance Priority

Guide Number (GN) Distance Priority is a semiautomatic mode in which you set the flash-to-subject distance on the SB-700, SB-900, and SB-910. When the aperture (⊛) is adjusted, the speedlight automatically adjusts the flash output to ensure consistent exposures, even while shooting at different apertures.

This mode should only be used when the camera, speedlight, and subject are in a set position and the distance isn't going to change. If the distance does change, the exposure will not be accurate. The preferred exposure modes are Manual (**M**) or Aperture Priority (**A**). This allows you to control the flash exposure by adjusting the aperture (⊛) setting on the camera. To adjust your ambient exposure in this mode, simply change your shutter speed or ISO setting.

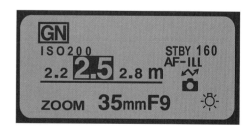

2.6 The SB-900 Guide Number Distance Priority setting. The highlighted number is the distance the subject needs to be from the speedlight.

 Guide Number (GN) Distance Priority mode is only available when the speed-light is on the camera or connected with a TTL cord. The flash head must also be pointed at the default, straight-ahead position or at the –7-degree position.

To set GN Distance Priority mode with the SB-700, follow these steps:

1. **Slide the Mode selector switch to the GN position.**

2. **Press Sel. This highlights the distance setting.**

3. **Rotate the Selector dial to adjust the distance setting.** Press Sel to set the distance. This highlights the exposure compensation setting for change.

To set GN Distance Priority mode with the SB-900, follow these steps:

1. **Press Mode (or press Mode and rotate the Selector dial) until GN appears on the LCD screen in the upper-left corner.** Press OK to set the mode.

2. **Press Function button 2 and rotate the Selector dial until the preferred distance appears on the LCD.** Press OK to set the distance.

3. **Set your camera to Aperture Priority (A) or Manual (M) mode.** Shoot as usual.

To set GN Distance Priority mode with the SB-910, follow these steps:

1. **Press Mode (or press Mode and rotate the Selector dial) until GN appears on the LCD screen in the upper-left corner.** Press OK to set the mode.

2. **Press Function button 3 and rotate the Selector dial until the preferred distance appears on the LCD.** Press OK to set.

3. **Set your camera to Aperture Priority (A) or Manual (M) mode.** Shoot as usual.

 If you are using a non-CPU lens with a camera that does not support non-CPU lens data, you can manually set the aperture on the flash by pressing Function button 3 and rotating the Selector dial. You can adjust FEC by pressing Function button 1 and rotating the Selector dial.

Manual

Setting your speedlight to Manual mode requires that you also manually adjust the flash output settings. One of the best ways to figure this out is by using a *guide number*

formula. The guide number (GN) is a measure of the flash output. The higher the guide number, the more output and range the flash has. You need to know the GN of your speedlight in order to figure out which aperture to use to get the correct flash exposure for the distance to your subject.

The formula to get the correct aperture is GN/Distance = Aperture (or GN/D = A). Of course, you can also use a flash meter to determine the proper settings. Although not as technically precise as using a GN formula or flash meter, you can also view the LCD screen on your camera to check out the results and fine-tune accordingly.

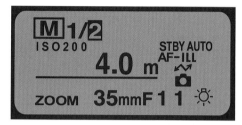

2.7 The Manual flash setting display on the SB-700, SB-900, and SB-910 all look very similar.

For more information on how to use the GN/D = A equation to determine proper exposure settings, see Chapter 3.

Manual exposure is my mode of choice for most speedlight applications. Why, you might wonder, would I want to use Manual mode and not take advantage of the Nikon i-TTL technology? While i-TTL and similar modes are good, they aren't foolproof. I prefer to know what my results are going to be with each frame or image, and with Manual exposure, I know that my frames (for the most part) will be consistent. A common situation in which i-TTL might fail you would be when shooting a snow-covered field with a cloudy sky. The camera's meter sees a large portion of bright tones and, therefore, believes the scene is very bright. To compensate, the camera often underexposes the image. Shooting in Manual lets me push my whites to the brink of overexposure, if needed, to ensure proper exposure of the subject.

Repeating flash

In this mode (abbreviated as RPT), the flash fires repeatedly like a strobe light during a single exposure. You must manually determine the proper flash output using the formula (GN/D = A) to get the correct aperture, and then decide the frequency and the number of times you want the flash to fire. The slower the shutter speed, the more flashes you are able to capture. For this reason, I recommend only using this mode in low-light situations; otherwise, the ambient light may overexpose the image. This mode is useful for creating a multiple-exposure-type image.

 For more detailed information on using the Repeating (RPT) flash mode, see Chapter 3.

SU-4

The name for this mode (also referred to as a slave mode) comes from a Nikon accessory that was used to achieve wireless TTL prior to the CLS. The SU-4 is a small, hot-shoe optical trigger that is attached to a speedlight and allows the Remote flash to oper-ate in conjunction with the Master flash. When the Master flash fires, the Remote flash does also. When the Master flash stops firing, the Remote flash stops. This type of operation is very useful when shooting sports or action. Because the CLS pre-flashes create a bit of a shutter lag, this can cause you to miss the peak of the action while the camera does the CLS operation. Since the SU-4 mode doesn't use CLS pre-flashes, the flashes fire instantaneously, allowing you to capture the shot at the precise moment you press the Shutter Release button.

Flash output level

Number of flash firings | Frequency of flash firings

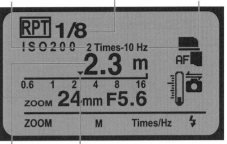

Effective flash output distance

Effective flash output distance (numeric indicator)

2.8 An example of the Repeating (RPT) flash mode screen on the SB-910.

Setting the SB-700, SB-900, and SB-910 to SU-4 mode disables their CLS functions. They act as a single group of optical Remote flashes, and exposure compensation must be physically adjusted on each one separately. It's generally a good idea to make sure the speedlight set to SU-4 mode has its light sensor window facing the Master (or main) light source.

Setting the SB-700, SB-900, or SB-910 as a Master flash while it's also set to SU-4 mode automatically disables the pre-flashes. The only flash modes that operate with the SB-900 or SB-910 set as a Master in SU-4 mode are Manual, non-TTL Auto, and GN Distance Priority. While set to SU-4, the SB-700 offers non-TTL Auto, Manual, and the Quick Wireless Control modes.

The SB-700 also allows you to control two groups (A and B) with ratios in Quick Wireless Control mode. To access this mode, follow these steps:

1. **Turn the On/Off/Wireless switch to the Master setting.**

2. **Slide the Mode selector switch to the G/N A:B setting.**

3. Press Select to highlight A:B. Notice that you cannot change any Master settings. That's because the Master flash does not contribute to the exposure.

4. Rotate the Selector dial to set the desired ratio of groups A and B.

When you set your SB-700, SB-900, or SB-910 Speedlight to SU-4 mode and set it as a Remote, you have two modes from which to choose: Manual or Auto. On the SB-700, slide the Mode selector switch to make mode changes. On the SB-900 and SB-910, press the Mode button to toggle between the two modes. The differences between the two options are as follows:

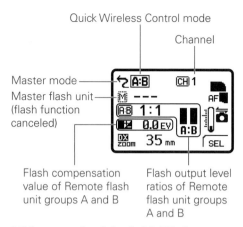

Quick Wireless Control mode

Channel

Master mode

Master flash unit (flash function canceled)

Flash compensation value of Remote flash unit groups A and B

Flash output level ratios of Remote flash unit groups A and B

2.9 An example of the Quick Wireless Control mode screen on the SB-700.

▶ **Manual.** In this mode, you set the Remote speedlight output on the flash the same way you would when using the speedlight in Manual mode when it's not set to SU-4. Of course, you should use a flash meter or the GN/D = A equation to determine the proper settings. If your flash meter isn't handy and you're not in a mathematical mood, you can always look at the camera's LCD screen, view the results of the histogram, and make any necessary changes. In this mode, the Remote flash is triggered by the Master flash and starts firing when the Master flash fires.

2.10 The Manual mode icon.

▶ **Auto.** This mode is best suited for using the Master flash in non-TTL Auto mode. The Remote flash starts and stops in sync with the Master flash. This results in all of the SU-4 Remotes firing at the same output as the Master flash. You want to be sure that your Remote flashes are the same distance from the subject as the Master flash, or adjust the FEC on the Remote to reflect the differences and ensure proper exposures.

2.11 The Auto mode icon.

The SB-900 Custom Functions menu and settings

The Custom Functions menu on the SB-900 allows you to change the settings on your flash and control how it functions in different modes. This menu also allows you to customize other aspects of the speedlight's output, enabling you to use it for a wide array of flash applications.

To enter the SB-900 Custom Functions menu, simply press and hold the OK button for approximately 1 second. From here, use the Selector dial to scroll through the different options until the one that you want to adjust is highlighted on the LCD screen. Next, press OK to enable the function to be changed. Use the Selector dial to scroll between the choices. When the selected setting is changed, press OK to return to the Custom Functions menu. When you're finished making adjustments in the Custom Functions menu, press Function button 1 to return to normal operation.

Non-TTL Auto Flash mode

This is where you set the non-TTL Auto Flash mode. The different options are discussed in detail earlier in this chapter. You can only select one mode at a time. The options are as follows:

2.12 Auto Aperture with pre-flash. This is the default setting.

2.13 Auto Aperture without pre-flash.

2.14 Non-TTL Auto with pre-flash.

2.15 Non-TTL Auto without pre-flash.

Master Repeating (RPT) flash

Setting this custom function to On allows the SB-900 to control the Remote speedlights using the Repeating flash function.

 For more information on using the Repeating (RPT) flash mode, see Chapter 3.

Manual mode output

Setting this custom function option to On allows you the choice of adjusting the output level from 1/3 or 1 EV, between 1/1 and 1/2 power. Flash output settings from 1/2 down to 1/128 are still adjusted in 1/3 EV steps. This is a great feature, as you will often require a setting between 1/2 and full power (1/1).

SU-4

Turning on this custom function enables the flash to work in SU-4 mode in both Master and Remote settings. Turning on this option disables CLS and pre-flashes, causing it to function as a simple optical Remote (slave).

Illumination pattern

You can adjust the illumination pattern to better suit the type of shooting situation and subject. This allows you to control how much light falloff you have at the edges of the image frame. The options are as follows:

▶ **Standard.** This is the default setting for the SB-900 and is ideal for most subjects. The light falloff, or *vignetting*, at the edges of the frame is minimal, but it may be noticeable in some situations. If you forget about the ability to change your illumination pattern on the SB-900 and remain stuck on Standard, you'll be fine.

2.16 The Standard illumination pattern icon.

▶ **Center-weighted.** This pattern causes the light from the speedlight to be more focused at the center of the frame, allowing the light to fall off at the edges of the frame, which draws attention to the subject. This is a good option for single portraits or close-ups of a subject in the middle of the frame.

2.17 The Center-weighted illumination pattern icon.

▶ **Even.** This pattern provides a more diffused light that covers more of the frame than the previous options. There is little falloff and the edges are sufficiently illuminated. It is best suited to subjects that fill the entire image, such as group portraits or still-life shots.

2.18 The Even illumination pattern icon.

The test fire button

This custom function allows you to use the test fire button on the SB-900. You have two choices:

▶ **Flash.** This is the default setting. When set to this option, pressing the test fire button fires a single flash pop.

▶ **Modeling.** Selecting this option causes the flash to fire a continuous series of low-power flashes for about 1.5 seconds. This allows you to see what effect the speedlight's output will have on your subject. This is mostly useful for checking the shadow placement on your subject. Depending on your location and ambient lighting, this can also be useful for assisting the camera to obtain accurate focus.

2.19 The Flash icon indicates that the SB-900 is ready to fire.

2.20 The Modeling Flash icon indicates that the SB-900 is ready to fire.

The i-TTL test fire flash output level

This custom function option determines the output level of the speedlight test fire when you set the SB-900 to i-TTL. You can choose from three power levels: 1/128 (default), 1/32, or 1/1 (full power).

Pressing the test fire button when in non-TTL Auto or AA mode causes the speedlight to flash at the output specified by the settings. When in Manual modes (M, GN, and RPT), the flash test fires at the selected setting.

DX or FX format selection

The SB-900 can automatically detect whether the camera to which it is attached is a DX or an FX (or an FX camera set to DX mode). This allows the speedlight to adjust the light distribution so that it is used more efficiently, thereby saving power. You can use this setting to disable the automatic setting, or to manually set the SB-900 to FX or DX. Below are the options for manually setting your format selection:

▶ **FX <-> DX.** This is the default setting. The SB-900 automatically adjusts the light distribution depending on the camera image area.

▶ **FX.** This option sets the light distribution to be optimized for cameras using the full-frame (FX) Nikon sensor. If the speedlight is attached to a DX camera, the SB-900 does not automatically switch to DX.

▶ **DX.** This option sets the light distribution to be optimized for cameras using the smaller APS-C-sized (DX) Nikon sensor. If the speedlight is attached to an FX camera, the SB-900 does not automatically switch to FX.

 NOTE When the wide-angle flash panel is down or the SW-13H diffuser is attached, the power zoom function is disabled and the zoom head is set to 11mm (DX) or 17mm (FX).

Power zoom

The SB-900 has an automatic zooming flash head, which allows it to adjust the light distribution based on the focal length of the lens in use.

 NOTE When a non-CPU lens is attached, you must manually adjust the speedlight zoom setting. With cameras that support non-CPU lens data, the speedlight zoom head adjusts automatically to the specified setting.

Notice that this custom function is a little counterintuitive. You can choose from the following two options for this setting:

▶ **On.** This turns the power zoom off. This means you must adjust the zoom setting manually by pressing the Zoom button on the back of the SB-900.

▶ **Off.** This turns the power zoom on. The speedlight automatically detects the focal length of the lens and adjusts the zoom head position.

AF-assist Illuminator

This custom function setting is used to control whether the AF-assist feature is on or off. The AF-assist projects an array pattern using LEDs. This gives the scene some elements of contrast so that the AF can lock on to the subject when the ambient light is dim. There are three options for this setting:

2.21 This icon indicates that the AF-assist Illumin- ator light is on.

▶ **On.** This allows the AF-assist Illuminator light to come on when photographing with the SB-900 in low-light situations.

▶ **Off.** This disables the AF-assist feature. You can use this setting when you don't want the AF-assist LED array to distract your subject prior to snapping the shot.

2.22 This icon indicates that the AF-assist feature is disabled.

▶ **AF Only.** This option allows the AF-assist to function, but disables the flash altogether. This comes in handy if you are in a situation with low ambient light but don't want to use a flash, such as at weddings, concerts, or museums where flash photography isn't permitted. The AF-assist array helps the AF to lock focus.

2.23 This icon indicates that the AF-assist is on, but no flash will fire.

Standby mode

This custom function option allows you to set the amount of time that the SB-900 stands idle before it goes into Standby mode (sleep). You may choose from the following six options:

▶ **Auto.** This setting syncs the SB-900 with the camera's exposure meter. When the camera goes to sleep or is turned off, the speedlight goes into Standby mode.

▶ **40.** This activates Standby mode after the SB-900 is idle for 40 seconds.

▶ **80.** Select this option to activate Standby mode after the SB-900 is idle for 80 seconds.

▶ **160.** This activates Standby mode after the SB-900 is idle for 160 seconds.

▶ **300.** Choose this option to activate Standby mode after the SB-900 is idle for 300 seconds.

▶ **– –.** This disables the Standby function altogether.

You can awaken the flash by lightly tapping the Shutter Release button or pressing the test fire button. I prefer to disable this feature. While it may save battery life, it is frustrating to have the perfect moment in front of you only to waste it waking up your speedlight.

ISO

This custom function option allows you to manually adjust the ISO setting of the speedlight. This affects the GN of the flash. The ISO can be adjusted from ISO 3 all the way up to ISO 8000 in 1/3-stop increments. Use this function when you connect your speedlight to an older Nikon film camera. For all Nikon cameras from the N8008 and up, the ISO information is communicated to the SB-900 and set automatically.

Remote ready light

When the SB-900 is set to function as a remote, there are two LEDs up front, and the test fire button on the rear, that illuminate to indicate that the speedlight is ready to fire, depending on which option you choose from the following:

▶ **Rear, Front.** In the default setting, the rear ready light is illuminated and the front LEDs blink to indicate that the speedlight is ready to fire. I've found this to be the best option for most shooting situations.

READY

2.24 The Remote ready light icon.

▶ **Rear.** When you select this option, only the rear ready light is illuminated.

▶ **Front.** This option allows only the front LEDs to blink to indicate that the SB-900 is ready to fire.

LCD screen illuminator

The SB-900 LCD screen is illuminated by a bright-blue light for easy reading in low-light situations. There is a custom function that allows you to turn off the LCD illuminator when you're shooting in daylight to conserve energy.

2.25 The LCD screen illuminator On icon.

 NOTE When the speedlight is in the Custom Functions menu, or the camera's LCD control screen illuminator is activated, the SB-900 LCD screen illuminator is automatically activated.

Thermal cut-out

The SB-900 includes a Thermal cut-out feature that shuts down the speedlight if it overheats from firing multiple times in succession. You can deactivate this feature by setting the custom function to Off.

I'm thankful that this feature can be turned off. I appreciate why Nikon added it, but I've found the Thermal cut-out to be much too sensitive — sometimes it cuts the flash after just a few full-power flashes. I recommend that you test this feature on your SB-900 and see what you think.

2.26 The Thermal cut-out On icon.

 CAUTION Turning off the Thermal cut-out feature can result in damage to your SB-900 if overheating occurs. Do this at your own risk.

Sound monitor

The SB-900 has a sound monitor that beeps to indicate the status of the speedlight when it's used as a Remote. Using this custom function option, you can deactivate the sound monitor for silent operation.

While memorizing and listening for the audible beeps can be helpful in knowing the status of your speedlight, I have this feature turned off. I haven't tested my hypothesis, but I'm going to assume that most brides wouldn't appreciate a bunch of beeps going off during the wedding ceremony. Also, if the bride happened to be a Nikon user and kept hearing eight short beeps, she may be concerned that I don't know what I'm doing. If you decide to turn on this feature, the beeps indicate the following:

▶ **One beep.** The SB-900 is charged and ready to fire at full power.

▶ **Two quick beeps.** This is a warning that the speedlight is overheating. You should let it cool down before continuing to use it.

▶ **Two short beeps.** After the SB-900 fires, this indicates that the subject received proper flash exposure.

▶ **Eight short beeps.** When this occurs after firing, either the flash fired at full power and the image may be under-exposed, or the remote sensor didn't correctly detect the pre-flashes or non-TTL Auto Flash. You should review your images to ensure that they're properly exposed.

2.27 The sound monitor On icon.

LCD screen contrast

This custom function allows you to control the contrast of the LCD screen. Making the contrast higher enables you to view the LCD better when in bright light.

LCD

2.28 The LCD screen contrast adjustment icon.

Distance unit

This option allows you to choose whether the distance settings on the SB-900 appear in feet or meters.

Wide-angle flash panel zoom position

If the wide-angle flash panel is accidentally broken off, the automatic power zoom function of the SB-900 may

m/ ft

2.29 The distance setting icon.

become disabled and stay at the widest setting (11mm for DX, 17mm for FX). If this situation arises, you can set this option to On to allow the camera to automatically detect the focal length.

2.30 The zoom position for the wide-angle flash On icon.

 If this setting is turned on when the flash panel is not broken, the zoom head automatically adjusts when the flash panel is down.

My Menu settings

To enable you to quickly surf through all of the custom functions, the SB-900 allows you to customize the Custom Functions menu to include only the settings that you change the most. There are three options in this menu:

▶ **Full.** This is the default. It shows all of the available Custom Functions menu settings.

▶ **My Menu.** This option displays only the Custom Functions menu settings that you select.

2.31 The full Custom Functions menu icon.

▶ **Setup.** Use this option to select and set which Custom Functions menu options appear in My Menu. To select the options to display in My Menu, follow these steps:

1. **Select Setup from the My Menu option in the Custom Functions menu.** Press OK to view the available custom function settings.

2.32 The My Menu icon in the Custom Functions menu.

2. **Use the Selector dial to scroll through the settings.** A check box appears next to each available Custom Function setting that can be set to My Menu (if the option cannot be set, no box is shown). Press OK to select or deselect the option. When a check mark appears in the box, the option is set to My Menu.

2.33 When a custom setting is turned on, a check mark is shown.

3. **When you finish selecting the options, press Function button 1 to return to the Custom Functions menu.** Press Function button 1 again to exit the Custom Functions menu.

Firmware

This option displays the current version of the *firmware* that is installed on the SB-900. Firmware is a fixed version of software that the user cannot access. Firmware controls

the functions of the SB-900 and can be updated to fix problems or provide added functionality if needed. To update the firmware, you must use a D700 or D3 series camera body. If your camera body doesn't support firmware updates, you must take your speedlight to an authorized repair center.

Reset custom functions

This option resets all of the custom function settings back to the factory defaults.

 The Distance unit setting and My Menu are not affected when the custom function settings are reset to their factory defaults.

The SB-910 Custom Functions menu and settings

The Custom Functions menu on the SB-910 allows you to change the settings on your flash and control how it functions in different modes. It also allows you to customize other aspects of the speedlight's output, enabling you to use it for a wide array of flash applications.

To enter the SB-910 Custom Functions menu, simply press the Menu button. From here, use the Selector dial to scroll through the different options (you may also use Function buttons 1 and 2 to scroll) until the one that you want to adjust is highlighted on the LCD screen. Next, press OK to enable the function to be changed. Use the Selector dial to scroll between the choices. When the selected setting is changed, press OK to return to the Custom Functions menu. When you have finished making adjustments to the settings, press Menu to return to normal operation.

 Pressing Function button 3 while in the Custom Functions menu allows you to toggle between the full Custom Functions menu and My Menu.

Non-TTL Auto Flash mode

This is where you set the non-TTL Auto Flash mode. The different options are discussed in detail earlier in this chapter. You can only select one mode at a time. The options are as follows:

2.34 Auto Aperture with pre-flash. This is the default mode.

2.35 Auto Aperture without pre-flash.

2.36 Non-TTL Auto with pre-flash.

2.37 Non-TTL Auto without pre-flash.

Master Repeating (RPT) flash

Setting this custom function to On allows the SB-910 to control the Remote speed-lights using the Repeating flash function.

 For more information on using the Repeating (RPT) flash mode, see Chapter 3.

Manual mode output

Setting this custom function option to On allows you the choice of adjusting the output level from 1/3 or 1 EV between 1/1 and 1/2 power. Flash output settings from 1/2 down to 1/128 are still adjusted in 1/3 EV steps. This is a great feature, as you will often require a setting between 1/2 and full power (1/1).

Wireless

This custom function enables you to distinguish which type of wireless lighting you'll be performing. Select Advanced for controlling multiple groups of Remote speed-lights, or select SU-4 for wireless slave, multiple flash photography.

The test fire button

This custom function option allows you to use the test fire button on the SB-910. You have two choices:

2.38 The Test Flash icon indicates that the SB-910 is ready to fire.

▶ **Flash.** This is the default setting. When set to this option, pressing the test fire button fires a single flash pop.

▶ **Modeling.** Selecting this option causes the flash to fire a continuous series of low-power flashes for about 1.5 seconds. This allows you to see what effect the speed-light's output will have on your subject. This is most useful for checking the shadow placement on your subject. Depending on your location and the ambient lighting, this can also be useful for assisting the camera to obtain accurate focus.

2.39 The Modeling Flash icon indicates that the SB-910 is ready to fire.

The i-TTL test fire flash output level

This custom function option determines the output level of the speedlight test fire when you set the SB-910 to i-TTL. You can choose from three power levels: 1/128 (default), 1/32, or 1/1 (full power).

 Pressing the test fire button when in non-TTL Auto or AA mode causes the speedlight to flash at the output specified by the settings. When in Manual modes (M, GN, and RPT), the flash test fires at the selected setting.

DX or FX format selection

The SB-910 can automatically detect whether the camera to which it is attached is DX or FX (or an FX camera set to DX mode). This allows the speedlight to adjust the light distribution so that it is used more efficiently, thereby saving power. You can use this setting to disable the automatic setting, or to manually set the SB-910 to FX or DX. Below are the options for manually setting your format selection:

▶ **FX <-> DX.** This is the default setting. The SB-910 automatically adjusts the light distribution depending on the camera image area.

▶ **FX.** This option sets the light distribution to be optimized for cameras using the full-frame (FX) Nikon sensor. If the speedlight is attached to a DX camera, the SB-910 does not automatically switch to DX.

▶ **DX.** This option sets the light distribution to be optimized for cameras using the smaller APS-C-sized (DX) Nikon sensor. If the speedlight is attached to an FX camera, the SB-910 does not automatically switch to FX.

 When the wide-angle flash panel is down or the SW-13H diffuser is attached, the power zoom function is disabled and the zoom head is set to 8mm (DX) or 12mm (FX).

Power zoom

The SB-910 has an automatic zooming flash head, which allows it to adjust the light distribution based on the focal length of the lens in use.

 When a non-CPU lens is attached, you must manually adjust the speedlight zoom setting. With cameras that support non-CPU lens data, the speedlight zoom head adjusts automatically to the specified setting.

Notice that this custom function is a little counterintuitive. You can choose from the following two options for this setting:

▶ **On.** This turns the power zoom off. This means you must manually adjust the zoom setting by pressing the Zoom button on the back of the SB-910.

▶ **Off.** This turns the power zoom on. The speedlight automatically detects the focal length of the lens and adjusts the zoom head position.

AF-assist Illuminator

This custom function setting is used to control whether the AF-assist feature is on or off. The AF-assist projects an array pattern using LEDs. This gives the scene some elements of contrast so that the AF can lock on to the subject when the ambient light is dim. There are three options for this setting:

2.40 This icon indicates that the AF-assist Illuminator is on.

▶ **On.** This allows the AF-assist Illuminator light to come on when photographing with the SB-910 in low-light situations.

▶ **Off.** This disables the AF-assist feature. You can use this setting when you don't want the AF-assist LED array to distract your subject prior to snapping the shot.

2.41 This icon indicates that the AF-assist feature is disabled.

▶ **AF Only.** This option allows the AF-assist to function, but disables the flash altogether. This comes in handy if you don't want (or aren't permitted) to use a flash in a location with low ambient light, such as at a wedding, concert, or museum. The AF-assist array also helps the AF to acquire focus.

2.42 This icon indicates that the AF-assist is on, but no flash will fire.

Standby mode

This custom function option allows you to set the amount of time that the SB-910 stands idle before it goes into Standby mode (sleep). You may choose from the following six options:

▶ **Auto.** This setting syncs the SB-910 with the camera's exposure meter. When the camera goes to sleep or is turned off, the speedlight goes into Standby mode.

▶ **40.** This activates Standby mode after the SB-910 is idle for 40 seconds.

- ▶ **80.** Select this option to activate Standby mode after the SB-910 is idle for 80 seconds.

- ▶ **160.** This activates Standby mode after the SB-910 is idle for 160 seconds.

- ▶ **300.** Choose this option to activate Standby mode after the SB-910 is idle for 300 seconds.

- ▶ **– –.** This disables the Standby function altogether.

You can awaken the flash by lightly tapping the Shutter Release button or by pressing the test fire button. I prefer to disable this feature. While it may save battery life, it is frustrating to have the perfect moment in front of you, only to waste it waking up your speedlight.

ISO

This Custom Functions menu option allows you to manually adjust the ISO setting of the speedlight. This affects the GN of the flash. The ISO can be adjusted from ISO 3 all the way up to ISO 8000 in 1/3-stop increments. Use this function when you connect your speedlight to an older Nikon film camera. For all Nikon cameras from the N8008 and up, the ISO information is automatically communicated to the SB-910 and set.

Remote ready light

When the SB-910 is set to function as a Remote, the two LEDs on the front and the test fire button on the rear illuminate to indicate that the speedlight is ready to fire, depending on which option you choose from the following:

- ▶ **Rear, Front.** At the default setting, the rear ready light illuminates and the front LEDs blink to indicate that the speedlight is ready to fire. I've found this to be the best option for most shooting situations.

2.43 The Remote ready light icon.

- ▶ **Rear.** When you select this option, only the rear ready light illuminates.

- ▶ **Front.** This option allows only the front LEDs to blink to indicate that the SB-910 is ready to fire.

LCD screen illuminator

The SB-910 LCD screen is illuminated by a bright-blue light for easy reading in low-light situations. There is a custom function that allows you to turn off the LCD screen illuminator when you're shooting in daylight to conserve energy.

2.44 The LCD screen illuminator On icon.

 When the speedlight is in the Custom Functions menu or the camera's LCD screen control panel illuminator is activated, the SB-910 LCD screen illuminator is automatically activated.

LCD screen contrast

This custom function allows you to control the contrast of the LCD screen. Making the contrast higher enables you to view the screen better when in bright light.

2.45 The LCD screen contrast adjustment icon.

Distance unit

This option allows you to choose whether the distance settings on the SB-910 appear in feet or meters.

2.46 The distance unit setting icon.

Wide-angle flash panel zoom position

If the wide-angle flash panel is accidentally broken off, the automatic power zoom function of the SB-910 may become disabled and stay at the widest setting (8mm for DX, 12mm for FX). If this situation arises, you can set this option to On to allow the camera to automatically detect the focal length.

2.47 The zoom position for the wide-angle flash On icon.

 If this setting is turned on when the flash panel is not broken, the zoom head automatically adjusts when the flash panel is down.

My Menu settings

To enable you to quickly surf through all of the custom functions, the SB-910 allows you to customize the Custom Functions menu to include only the settings that you change the most. There are three options in this menu:

▶ **Full.** This is the default. It shows all of the available Custom Functions menu settings.

2.48 The full Custom Functions menu icon.

▶ **My Menu.** This option displays only the Custom Functions menu settings that you select.

▶ **Setup.** Use this option to select and set which Custom Functions menu options appear in My Menu. To select the options you want displayed, follow these steps:

2.49 The My Menu icon in the Custom Functions menu.

1. **Select Setup from the My Menu option in the Custom Functions menu.** Press the OK button to view the available custom function settings.

2. **Use the Selector dial to scroll through the settings.** A check box appears next to each available custom function setting that can be set to My Menu (if the option cannot be set, no box is shown). Press OK to select or deselect the option. When a check mark appears in the box, the option is set to My Menu.

2.50 When a Custom Functions menu setting is turned on, a check mark is shown.

2

3. **When you finish selecting the options, press Function button 1 to return to the Custom Functions menu.** Press Function button 1 again to exit the Custom Functions menu.

Firmware

This option displays the current version of the *firmware* installed on the SB-910. Firmware is a fixed version of software that the user cannot access. It controls the functions of the SB-910 and can be updated to fix problems or provide added functionality if needed. To update the firmware, you must use a D700 or D3 series camera body. If your camera body doesn't support firmware updates, you must take your speedlight to an authorized repair center.

Reset custom functions

This option resets all of the custom function settings back to the factory defaults.

The Distance unit setting and My Menu are not affected when the custom function settings are reset to their factory defaults.

The SB-700 Custom Functions menu and settings

To enter the SB-700 Custom Functions menu, simply turn on the speedlight and press the Menu button. To navigate through the menu options, use the Selector dial. To highlight an item, press the OK button located in the center of the Selector dial. You may then use the Selector dial to scroll through any options contained within that custom setting. To exit the Custom Functions menu, simply press the Menu button again. I cover all of the SB-700 custom functions and settings below.

Color filters

The SB-700 comes with a handy set of snap-on color filters that allow you to color balance your speedlight with ambient fluorescent or incandescent (tungsten) light. The speedlight also has the ability to determine which supplied filter is attached. By using the optional SZ-3 Color Filter Holder and the SJ-4 Color Filter Set, you can also use different color filters or gels. There are five options for this setting:

 FILTER

2.51 The SB-700 color filter icon.

 ▶ **Red.** Use this option when attaching a red filter to the optional SZ-3 Color Filter Holder.

 ▶ **Blue.** Choose this setting when attaching a blue filter to the optional SZ-3 Color Filter Holder.

 ▶ **Yellow.** Use this option when attaching a yellow filter to the optional SZ-3 Color Filter Holder.

 ▶ **Amber.** Choose this option when attaching an amber filter to the optional SZ-3 Color Filter Holder.

 ▶ **Other.** This option should be used when attaching any color filter other than those listed above to the optional SZ-3 Color Filter Holder.

Remote flash unit setting

This function determines whether the SB-700 will be used as a Remote in an Advanced Wireless Lighting setup or as an SU-4 (slave) setup. There are only two options in this custom setting:

⤿ REMOTE

2.52 The Remote icon on the SB-700.

 ▶ **Advanced.** Use this option for Advanced Wireless Lighting.

 ▶ **SU-4.** Use this one for SU-4-type wireless, multiple flash-unit photography.

Sound monitor

When you are using the SB-700 as a Remote, this option allows you to check the sta-
tus of your speedlight using a series of beeps. The icon is the same as the sound
monitor icon on the SB-900 (see Figure 2.27). When this feature is turned on, the
beeps indicate the following:

▶ **One beep.** The SB-700 is ready to fire.

▶ **Two short beeps.** The speedlight fired properly.

▶ **Three long beeps for three seconds.** Insufficient flash output for correct
exposure.

▶ **High- and low-tone beeps alternate for six seconds.** This is due to either Auto
Aperture Flash or non-TTL Auto Flash mode being selected, or the remote light
sensor not receiving (or seeing) the command light from the Master speedlight.

LCD screen contrast

This custom function allows you to control the contrast of the LCD screen. Making the
contrast higher enables you to view the screen better when in bright light. The icon for
this setting is the same as that on the SB-900 and SB-910 (see Figure 2.45).

Standby mode

This custom function option allows you to set the amount of time that the SB-700
stands idle before it goes into Standby mode (sleep). There are three options for this
setting:

▶ **Auto.** This option syncs the SB-700 with the camera's exposure meter. When
the camera goes to sleep or is turned off, the speedlight goes into Standby
mode.

▶ **40.** This activates Standby mode after the SB-700 is idle for 40 seconds.

▶ **– –.** Choose this option to disable the Standby function altogether.

DX or FX format selection

Just like the SB-900 and SB-910, the SB-700 can automatically detect whether the
camera to which it is attached is DX or FX (or an FX camera set to DX mode). This
allows the speedlight to adjust the light distribution so that it is used in a more effi-
cient manner, thereby saving power. You can use this custom function setting to

disable the automatic setting, and manually set the SB-700 to FX or DX using one of the following options:

▶ **FX <-> DX.** This is the default setting. The SB-700 automatically adjusts the light distribution depending on the camera image area.

▶ **FX.** This sets the light distribution to be optimized for cameras using the full-frame (FX) Nikon sensor. If the speedlight is attached to a DX camera, the SB-700 does not automatically switch to DX.

▶ **DX.** Choose this to set the light distribution to be optimized for cameras using the smaller APS-C-sized (DX) Nikon sensor. If the speedlight is attached to an FX camera, the SB-700 does not automatically switch to FX.

Flash compensation step in Manual flash mode

Setting this custom function option to On allows you the option of adjusting the output level from 1/3 or 1 EV between 1/1 and 1/2 power. Flash output settings from 1/2 down to 1/128 are still adjusted in 1/3 EV steps. This is a great feature, as you will often need a setting between 1/2 and full power (1/1).

Distance unit

This option allows you to choose whether the distance settings on the SB-700 appear in feet or meters. The icon is the same as that on the SB-900 and SB-910 (see Figure 2.46).

AF-assist Illuminator

This custom function setting is used to control whether the AF-assist feature is on or off. The AF-assist projects an array pattern using LEDs. This helps give the scene some elements of contrast so that the AF can lock on to the subject when the ambient light is dim. The following two options are available for this setting:

▶ **On.** This option allows the AF-assist Illuminator light to come on when photographing with the SB-700 in low-light situations.

▶ **Off.** This disables the AF-assist feature. You may want to use this setting when you don't want the AF-assist LED array to distract your subject.

2.53 This icon indicates that the AF-assist Illuminator is on.

Firmware

This option displays the current version of the firmware that is installed on the SB-700. Firmware is a fixed version of software, which the user cannot access. It controls the

functions of the SB-700 and can be updated to fix problems or provide added function-ality if needed. To update the firmware, you must use a D300, D300s, D700, or D3 series camera body. If your camera body doesn't support firmware updates, you must take your speedlight to an authorized repair center.

Reset custom functions

This option resets all of the Custom Functions menu settings back to the factory defaults.

 The Distance unit setting and My Menu are not affected when the custom function settings are reset to their factory defaults.

2

Flash Photography Fundamentals

In this chapter, I cover the basic properties of flash photography. Most of these aren't specific to any one Nikon speedlight but, rather, can be applied to almost all flash photography, whether you're using the CLS or a studio strobe.

While using a speedlight in Manual mode may seem daunting at first, once you understand how it works, you will see that the speedlight is one of the best tools available for aiding in the creation of many different kinds of images. What would your next shoot look like if you could use techniques like Repeating flash or Rear-curtain sync?

As with any subject contained in these pages, it may take awhile for a particular technique to sink in. Don't be afraid to revisit these subjects. After all, this is a Field Guide — you *can* take it with you.

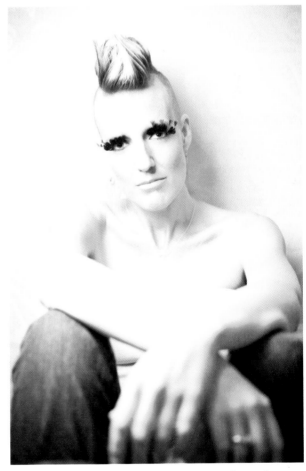

With only one speedlight, you can create dramatic images like this high-key portrait.

Understanding Flash Exposure

In the past, flash photography was often only used by professionals. There were no Through-the-Lens meters to control the flash output for you, and determining the proper settings required using difficult mathematical equations and expensive flash meters. You also had to get the film processed before you could see if your calculations were correct. This was a major deterrent to most amateur photographers who thought flash photography was too expensive and difficult to master.

Previously, even professional photographers steered clear of learning flash photography because of the general belief that it's still very complex. Instead, the professional settled for available light, missing out on a whole new world of image creation. Today, however, more and more professional and amateur photographers alike are embracing flash photography, thanks (in part) to camera manufacturers using technology like that found in the Nikon CLS.

While allowing your camera and flash to control all of the settings for you can produce usable images, it's a good idea to understand how and why it works as it does. Making this effort will help you create better images in the long run. Trust me — understanding all of the functions your speedlight can perform is not useless information.

Key Terms

As with any subject, it's a good idea to have a handle on the terms and definitions that surround it. Learning these will help you take part in any discussions you may encounter about flash photography. It will also help you better understand any tutorials on the subject, as well as this book. Some useful terms you should know include the following:

▶ **Key light.** Also known as the main light, this provides most of the illumination for your subject. Placement of the key light determines the lighting pattern for the subject.

▶ **Fill light.** This is the secondary light that *fills in* the shadows. Fill light is not to be confused with fill flash, although the same principles are at work.

▶ **Accent lights.** These aren't necessary for the basic exposure, but they can add depth and separate the subject from the background. Some common accent lights include the following:

 • **Background light.** This light is aimed directly at the background. It is used to provide separation, and it can also be used with color filters to add a splash of color.

- **Rim light.** This light is angled so that it lights only the extreme edge of the subject. This provides a bright highlight only on the edge, which can add drama and definition to the image. The rim light is usually 1 to 2 stops brighter in exposure than the key light.

- **Hair light.** Yes, this lights your subject's hair. (See! You're getting it!) There are two ways in which this type of light can be used. The first is to place it behind the subject to give the hair a glowing backlight. This provides separation from the background, especially if it's low-key. The second way is to use a boom stand to aim the light down on top of the head. This provides some illumination without drawing any unnecessary attention to the hair. It's a great way to separate your subject from the background, and it's equally good for finding any out-of-place hairs.

▶ **Angle of light.** This is the angle at which a light source is placed in relation to the subject. The angle number is based on the camera position, which is always considered the 0 degree mark (see Figure 3.1). The angle of light also has an impact on your basic portrait lighting patterns. The most typical angles include (but are not limited to):

 - **10 degrees.** At this position, the light is placed just off to the side of the camera. This is where the light is positioned for the *butterfly portrait lighting* pattern.

 - **45 degrees.** This is the most common angle of light. The *loop* or *Paramount lighting* pattern is based on this angle.

 - **60 degrees.** This isn't a very common angle to use, but it does come in handy from time to time. The *Rembrandt lighting* pattern is achieved by placing the light at this angle and from a higher position to mimic Rembrandt's own painting studio.

 - **90 degrees.** At this angle, the light is placed directly to the side of the subject. This is how you achieve the *split lighting* (also referred to as *side lighting*) pattern. You may also choose to place your rim lights at this position.

 - **180 degrees.** At this angle, the light is placed directly behind the subject, a technique known as *backlighting*. This is reserved almost exclusively for accent lighting.

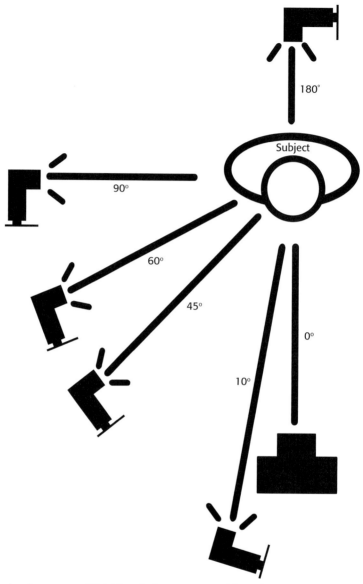

3.1 The angle of your speedlight in relation to your subject determines the lighting pattern.

▶ **Lighting ratio.** The difference in light output between the key light and fill light. Keep in mind that the fill light could simply be light from the key light bounced off of a reflector onto the subject. The difference in the number of stops between the key and fill lights determines the ratio number.

Some popular lighting ratios include the following:

- **1:1 ratio.** This means that the key and fill lights are both emitting the same amount of light. This provides a flat light that is almost shadow-free.

- **2:1 ratio.** This means that the key light is producing twice as much light (a 1-stop difference) as the fill light. This is a useful, general lighting ratio that gives enough shadow to create depth, but not enough to be overly dramatic.

- **4:1 ratio.** This provides a 2-stop difference — just enough for dramatic shadows without losing too much detail in those shadowed areas.

▶ **Broad lighting.** Not meant to be a derogatory remark, this refers to how the key light illuminates your subject. This term is often used in conjunction with portrait photography. With broad lighting, the key light is placed so that it lights the side of the face that is nearest to the camera. This type of lighting is good for people with narrow faces and angular features.

▶ **Short lighting.** This is the opposite of broad lighting. In this scenario, the key light is used to illuminate the side of the face that is facing away from the camera. This is good to use with a person who has a broad face and features.

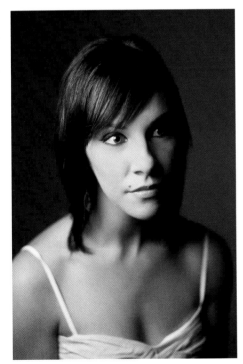

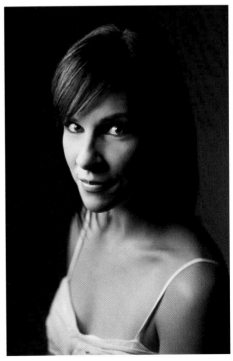

3.2 An example of broad lighting.

3.3 An example of short lighting.

▶ **High key.** This describes the tone of the image. High-key images are very bright and usually have white or light-colored backgrounds. They are often used in fashion photography.

▶ **Low key.** This is when the tone of the image is darker. Low-key images often use high contrast and convey a serious, more somber mood. Using low-key lighting can add depth and drama to an image.

3.4 An example of high-key lighting. Two speedlights were used: One in a softbox on the subject and one bouncing into an umbrella to light the background.

3.5 An example of low-key lighting, taken with one speedlight and a softbox.

▶ **Hard lighting.** This type of lighting comes from a small point source in relation to the subject. It is characterized by high contrast and hard shadows. Hard lighting can be used to bring out texture or accentuate features. Diffusion (such as that from a softbox or scrim) is generally not used with hard lighting.

▶ **Diffused lighting.** This is the opposite of hard lighting and, therefore, is often referred to as soft light. A softbox, umbrella, or bounce flash is used to diffuse the light. It is often used in glamour photography.

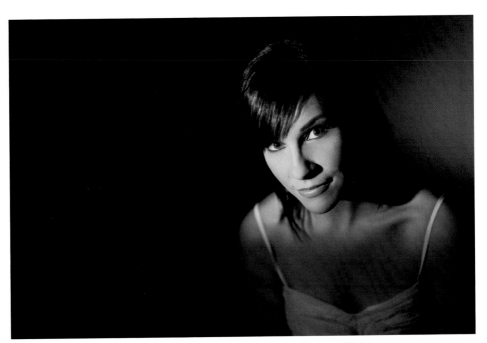

3.6 An example of hard lighting, taken with one bare-bulb speedlight.

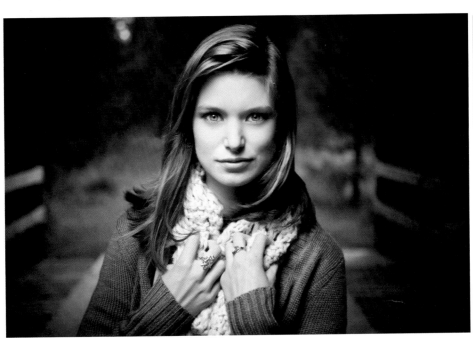

3.7 An example of diffused lighting, taken outdoors with a single speedlight and softbox.

Flash Basics

Have you ever captured an amazing image and found that, no matter what you did, you just couldn't repeat it? Perhaps certain conditions, such as the sun shifting or a cloud passing, change the shooting environment. There's nothing wrong with going *auto everything* to capture everyday images. However, if you want any kind of consistency in your photography, as well as the confidence to walk into any scenario and know how to set up your speedlight, you have to understand the principles at work. So, grab some caffeine and read on to discover what these principles are.

Achieving proper exposures

To determine the proper settings for your camera and flash to achieve a good exposure, you might want to remember this simple equation: GN/D = A. This equation contains the three most important parts of flash exposure: Guide Number (GN), Distance (D), and Aperture (A). You may, at this point, be wondering about shutter speed. Actually, shutter speed doesn't play a role in the flash exposure — it's a bit like Robin is to Batman — but it does come into play. I explain its role later in this chapter.

The guide number

The guide number (GN) is a numeric value that represents the amount of light that your speedlight emits at a specific setting. The GN of the speedlight isn't a fixed number — it changes with the ISO setting and the zoom head position. Furthermore, each model of speedlight has a different GN.

The following tables provide the guide number for each speedlight model at ISO 100. The BA column is the GN with the Nikon Diffusion Dome attached, the WP column is the GN with the built-in wide panel in place, and the WP+BA column is the guide number with both attached. Each table contains the following information:

▶ **Table 3.1 provides the GN for the SB-700 in the DX format.**

▶ **Table 3.2 provides the GN for the SB-700 in the FX format.**

▶ **Table 3.3 provides the GN for the SB-900 in the DX format.**

▶ **Table 3.4 provides the GN for the SB-900 in the FX format.**

▶ **Table 3.5 provides the GN for the SB-910 in the DX format.**

▶ **Table 3.6 provides the GN for the SB-910 in the FX format.**

Table 3.1 SB-700 DX Guide Numbers

Flash Output Level	Zoom Head Position (mm):												
	10			16	17	18	20	24	28	35	50	70	85
	WP+BA	BA	WP										
1/1	10m / 32.8 ft.	14m / 45.9 ft.	14m / 45.9 ft.	23m / 75.5 ft.	23.5m / 77.1 ft.	24.5m / 80.4 ft.	26m / 85.3 ft.	28m / 91.9 ft.	29m / 95.1 ft.	31.5m / 103.3 ft.	34.5m / 113.2 ft.	37m / 121.4 ft.	38m / 124.7 ft.
1/2	7.1 m / 23.3 ft.	9.9 m / 32.5 ft.	9.9 m / 32.5 ft.	16.3m / 53.5 ft.	17m / 55.8 ft.	17.7m / 58.1 ft.	18.7m / 61.4 ft.	19.8m / 65 ft.	20.5m / 67.3 ft.	21.9m / 71.8 ft.	24m / 78.7 ft.	26.2m / 86 ft.	26.9m / 88.3 ft.
1/4	5m / 16.4 ft.	7m / 23 ft.	7m / 23 ft.	11.5m / 37.7 ft.	12m / 39.4 ft.	12.5m / 41 ft.	13.3m / 33.6 ft.	14m / 45.9 ft.	14.5m / 47.7 ft.	15.5m / 50.9 ft.	17m / 55.8 ft.	18.5m / 60.7 ft.	19m / 62.3 ft.
1/8	3.5m / 11.5 ft.	4.9m / 16.1 ft.	4.9m / 16.1 ft.	8.1m / 26.6 ft.	8.5m / 27.9 ft.	8.8m / 28.9 ft.	9.4m / 30.8 ft.	9.9m / 32.5 ft.	10.3m / 33.8 ft.	11m / 36.1 ft.	12m / 39.4 ft.	13.1m / 43 ft.	13.4m / 44 ft.
1/16	2.5m / 8.2 ft.	3.5m / 11.5 ft.	3.5m / 11.5 ft.	5.8m / 19 ft.	6m / 19.7 ft.	6.3m / 20.7 ft.	6.6m / 21.7 ft.	7m / 23 ft.	7.3m / 23.9 ft.	7.8m / 25.6 ft.	8.5m / 27.9 ft.	9.3m / 30.5 ft.	9.5m / 31.2 ft.
1/32	1.8m / 5.9 ft.	2.5m / 8.2 ft.	2.5m / 8.2 ft.	4.1m / 13.5 ft.	4.2m / 13.8 ft.	4.4m / 14.4 ft.	4.7m / 15.4 ft.	4.9m / 16.1 ft.	5.1m / 16.7 ft.	5.5m / 18 ft.	6m / 19.7 ft.	6.5m / 21.3 ft.	6.7m / 22 ft.
1/64	1.3m / 4.3 ft.	1.8m / 5.9 ft.	1.8m / 5.9 ft.	2.9m / 9.5 ft.	3m / 9.8 ft.	3.1m / 10.2 ft.	3.3m / 10.8 ft.	3.5m / 11.5 ft.	3.6m / 11.8 ft.	3.9m / 12.8 ft.	4.3m / 14.1 ft.	4.6m / 15.1 ft.	4.8m / 15.7 ft.
1/128	0.9m / 3 ft.	1.2m / 3.9 ft.	1.2m / 3.9 ft.	2m / 6.6 ft.	2.1m / 6.9 ft.	2.2m / 7.2 ft.	2.3m / 7.5 ft.	2.5m / 8.2 ft.	2.6m / 8.5 ft.	2.7m / 8.9 ft.	3m / 9.8 ft.	3.3m / 10.8 ft.	3.4m / 11.2 ft.

3

Table 3.2 SB-700 FX Guide Numbers

Flash Output Level	Zoom Head Position (mm):										
	14			24	28	35	50	70	85	105	120
	WP+BA	BA	WP								
1/1	10m 32.8 ft.	14m 45.9 ft.	14m 45.9 ft.	23m 75.5 ft.	25m 82 ft.	28m 91.9 ft.	31m 101.7 ft.	34m 111.5 ft.	35.5m 116.5 ft.	37m 121.4 ft.	38m 124.7 ft.
1/2	7.1m 23.3 ft.	9.9m 32.5 ft.	9.9m 32.51 ft.	16.3m 53.5 ft.	17.7m 58.1 ft.	19.8m 65 ft.	21.9m 71.8 ft.	24m 78.7 ft.	25.1m 82.3 ft.	26.2m 86 ft.	26.9m 88.3 ft.
1/4	5m 16.4 ft.	7m 23 ft.	7m 23 ft.	11.5m 37.7 ft.	12.5m 41 ft.	14m 45.9 ft.	15.5m 50.9 ft.	17m 55.8 ft.	17.8m 58.4 ft.	18.5m 60.7 ft.	19m 62.3 ft.
1/8	3.5m 11.5 ft.	4.9m 16.1 ft.	4.9m 16.1 ft.	8.1m 26.6 ft.	8.8m 28.9 ft.	9.9m 32.5 ft.	11m 36.1 ft.	12m 39.4 ft.	12.6m 41.3 ft.	13.1m 43 ft.	13.4m 44 ft.
1/16	2.5m 8.2 ft.	3.5m 11.5 ft.	3.5m 11.5 ft.	5.8m 19 ft.	6.3m 20.7 ft.	7m 23 ft.	7.8m 25.6 ft.	8.5m 27.9 ft.	8.9m 29.2 ft.	9.3m 30.5 ft.	9.5m 31.2 ft.
1/32	1.8m 5.9 ft.	2.5m 8.2 ft.	2.5m 8.2 ft.	4.1m 13.5 ft.	4.4m 14.4 ft.	4.9m 16.1 ft.	5.5m 18 ft.	6m 19.7 ft.	6.3m 20.7 ft.	6.5m 21.3 ft.	6.7m 22 ft.
1/64	1.3m 4.3 ft.	1.8m 5.9 ft.	1.8m 5.9 ft.	2.9m 9.5 ft.	3.1m 10.2 ft.	3.5m 11.5 ft.	3.9m 12.8 ft.	4.3m 14.1 ft.	4.4m 14.4 ft.	4.6m 15.1 ft.	4.8m 15.7 ft.
1/128	0.9m 3 ft.	1.2m 3.9 ft.	1.3m 3.9 ft.	2m 6.6 ft.	2.2m 7.2 ft.	2.5m 8.2 ft.	2.7m 8.9 ft.	3m 9.8 ft.	3.1m 10.2 ft.	3.3m 10.8 ft.	3.4m 11.2 ft.

Table 3.3 SB-900 DX Guide Numbers

Flash Output Level	Zoom Head Position (mm):																				
	10 WP+BA	BA	WP	12	14	16	17	18	20	24	28	35	50	70	85	105	120	135	180	200	
1/1	13m 42.7 ft.	16m 52.5 ft.	17m 55.8 ft.	23m 75.5 ft.	25m 82.0 ft.	27m 88.6 ft.	29m 95.1 ft.	30m 98.4 ft.	31m 101.7 ft.	34m 111.5 ft.	36m 18.1 ft.	40m 131.2 ft.	46m 150.9 ft.	49.5m 162.4 ft.	51m 167.3 ft.	52.5m 172.2 ft.	54m 177.2 ft.	56m 183.7 ft.	56.5m 185.4 ft.	57m 187 ft.	
1/2	9.1m 29.9 ft.	11.3m 37 ft.	12m 39.3 ft.	16.2m 53.1 ft.	17.6m 57.7 ft.	19m 62.3 ft.	20.5m 67.3 ft.	21.2m 69.6 ft.	21.9m 71.9 ft.	24m 78.7 ft.	25.4m 83.3 ft.	28.2m 92.5 ft.	32.5m 106.6 ft.	35m 114.8 ft.	36m 118.1 ft.	37.1m 121.7 ft.	38.1m 125 ft.	39.5m 129.6 ft.	39.9m 130.9 ft.	40.3m 132.2 ft.	
1/4	6.5m 21.3 ft.	8m 26.2 ft.	8.5m 27.9 ft.	11.5m 37.7 ft.	12.5m 41.0 ft.	13.5m 44.3 ft.	14.5m 47.6 ft.	15m 49.2 ft.	15.5m 50.9 ft.	17m 55.8 ft.	18m 59.0 ft.	20m 65.6 ft.	23m 75.5 ft.	24.7m 81.0 ft.	25.5m 83.7 ft.	26.2m 86.0 ft.	27m 88.6 ft.	28m 91.9 ft.	28.2m 92.5 ft.	28.5m 93.5 ft.	
1/8	4.5m 14.8 ft.	5.6m 18.8 ft.	6m 19.7 ft.	8.1m 26.6 ft.	8.8m 28.9 ft.	9.5m 31.2 ft.	10.2m 33.5 ft.	10.6m 34.8 ft.	10.9m 35.8 ft.	12m 39.3 ft.	12.7m 41.7 ft.	14.1m 46.3 ft.	16.2m 53.1 ft.	17.5m 57.4 ft.	18m 59.0 ft.	18.5m 60.7 ft.	19m 62.3 ft.	19.7m 64.6 ft.	19.9m 65.3 ft.	20.1m 65.9 ft.	
1/16	3.2m 10.5 ft.	4m 13.1 ft.	4.2m 13.8 ft.	5.7m 18.7 ft.	6.2m 20.3 ft.	6.7m 21.9 ft.	7.2m 23.6 ft.	7.5m 24.6 ft.	7.7m 25.3 ft.	8.5m 27.9 ft.	9m 29.5 ft.	10m 32.8 ft.	11.5m 37.7 ft.	12.3m 40.4 ft.	12.7m 41.7 ft.	13.1m 43.0 ft.	13.5m 44.3 ft.	14m 45.9 ft.	14.1m 46.3 ft.	14.2m 46.6 ft.	
1/32	2.2m 7.2 ft.	2.8m 9.2 ft.	3m 9.8 ft.	4m 13.1 ft.	4.4m 14.4 ft.	4.7m 15.4 ft.	5.1m 16.7 ft.	5.3m 17.4 ft.	5.4m 17.7 ft.	6m 19.7 ft.	6.3m 20.7 ft.	7m 23.0 ft.	8.1m 26.6 ft.	8.7m 28.5 ft.	9m 29.5 ft.	9.2m 30.2 ft.	9.5m 31.2 ft.	9.8m 32.2 ft.	9.9m 32.5 ft.	10m 32.8 ft.	
1/64	1.6m 5.2 ft.	2m 6.6 ft.	2.1m 6.9 ft.	2.8m 9.2 ft.	3.1m 10.2 ft.	3.3m 10.8 ft.	3.6m 11.8 ft.	3.7m 12.1 ft.	3.8m 12.5 ft.	4.2m 13.8 ft.	4.5m 14.8 ft.	5m 16.4 ft.	5.7m 18.7 ft.	6.1m 20.0 ft.	6.3m 20.7 ft.	6.5m 21.3 ft.	6.7m 21.9 ft.	7m 23 ft.	7m 23.0 ft.	7.1m 23.3 ft.	
1/128	1.1m 3.6 ft.	1.4m 4.6 ft.	1.5m 4.9 ft.	2m 6.6 ft.	2.2m 7.2 ft.	2.3m 7.5 ft.	2.5m 8.2 ft.	2.6m 8.5 ft.	2.7m 8.9 ft.	3m 9.8 ft.	3.1m 10.2 ft.	3.5m 11.5 ft.	4m 13.1 ft.	4.3m 14.1 ft.	4.5m 14.8 ft.	4.6m 15.1 ft.	4.7m 15.4 ft.	4.9m 16.1 ft.	4.9m 16.1 ft.	5m 16.4 ft.	

Table 3.4 SB-900 FX Guide Numbers

Flash Output Level	Zoom Head Position (mm):																	
	14			17	18	20	24	28	35	50	70	85	105	120	135	180	200	
	WP+BA	BA	WP															
1/1	13m 42.7 ft.	16m 52.5 ft.	17m 55.8 ft.	22m 72.2 ft.	23m 75.5 ft.	24m 78.7 ft.	27m 88.6 ft.	30m 98.4 ft.	34m 111.5 ft.	40m 131.2 ft.	44m 144.1 ft.	47m 154.2 ft.	49.5m 162.4 ft.	51m 167.3 ft.	51.5m 169.0 ft.	54m 117.2 ft.	56m 183.7 ft.	
1/2	9.1m 29.9 ft.	11.3m 37 ft.	12m 39.3 ft.	15.5m 50.9 ft.	16.2m 53.1 ft.	16.9m 55.4 ft.	19m 62.3 ft.	21.2m 69.6 ft.	24m 78.7 ft.	28.2m 92.5 ft.	31.1m 102.0 ft.	33.2m 108.9 ft.	35m 114.8 ft.	36m 118.1 ft.	36.4m 119.4 ft.	38.1m 125.0 ft.	39.5m 129.6 ft.	
1/4	6.5m 21.3 ft.	8m 26.2 ft.	8.5m 27.9 ft.	11m 36.1 ft.	11.5m 37.7 ft.	12m 39.3 ft.	13.5m 44.3 ft.	15m 49.2 ft.	17m 55.8 ft.	20m 65.6 ft.	22m 72.2 ft.	23.5m 77.1 ft.	24.7m 81.0 ft.	25.5m 83.7 ft.	25.7m 84.3 ft.	27m 88.6 ft.	28m 91.9 ft.	
1/8	4.5m 14.8 ft.	5.6m 18.8 ft.	6m 19.7 ft.	7.7m 25.3 ft.	8.1m 26.6 ft.	8.4m 27.6 ft.	9.5m 31.2 ft.	10.6m 34.8 ft.	12m 39.3 ft.	14.1m 46.3 ft.	15.5m 50.9 ft.	16.6m 54.5 ft.	17.5m 57.4 ft.	18m 59.0 ft.	18.2m 59.7 ft.	19m 62.3 ft.	19.7m 64.6 ft.	
1/16	3.2m 10.5 ft.	4m 13.1 ft.	4.2m 13.8 ft.	5.5m 18.0 ft.	5.7m 18.7 ft.	6m 19.7 ft.	6.7m 21.9 ft.	7.5m 24.6 ft.	8.5m 27.9 ft.	10m 32.8 ft.	11m 36.1 ft.	11.7m 38.4 ft.	12.6m 40.4 ft.	12.7m 41.7 ft.	12.8m 42.0 ft.	13.5m 44.3 ft.	14m 45.9 ft.	
1/32	2.2m 7.2 ft.	2.8m 9.2 ft.	3m 9.8 ft.	3.8m 12.5 ft.	4m 13.1 ft.	4.2m 13.8 ft.	4.7m 15.4 ft.	5.3m 17.4 ft.	6m 19.7 ft.	7m 23.0 ft.	7.7m 25.3 ft.	8.3m 27.2 ft.	8.7m 28.5 ft.	9m 29.5 ft.	9.1m 29.9 ft.	9.5m 31.2 ft.	9.8m 32.1 ft.	
1/64	1.6m 5.2 ft.	2m 6.6 ft.	2.1m 6.9 ft.	2.7m 8.9 ft.	2.8m 9.2 ft.	3m 9.8 ft.	3.3m 10.8 ft.	3.7m 12.1 ft.	4.2m 13.8 ft.	5m 16.4 ft.	5.5m 18.0 ft.	5.8m 19.0 ft.	6.1m 20.0 ft.	6.3m 20.7 ft.	6.4m 21.0 ft.	6.7m 21.9 ft.	7m 23.0 ft.	
1/128	1.1m 3.6 ft.	1.4m 4.6 ft.	1.5m 4.9 ft.	1.9m 6.2 ft.	2m 6.6 ft.	2.1m 6.9 ft.	2.3m 7.5 ft.	2.6m 8.5 ft.	3m 9.8 ft.	3.5m 11.5 ft.	3.8m 12.5 ft.	4.1m 13.5 ft.	4.3m 14.1 ft.	4.5m 14.8 ft.	4.5m 14.8 ft.	4.7m 15.4 ft.	4.9m 16.1 ft.	

Table 3.5 SB-910 DX Guide Numbers

Flash Output Level	Zoom Head Position (mm):																			
	10 WP+BA	10 BA	10 WP	12	14	16	17	18	20	24	28	35	50	70	85	105	120	135	180	200
1/1	13m 42.7 ft.	16m 52.5 ft.	17m 55.8 ft.	23m 75.5 ft.	25m 82 ft.	27m 88.6 ft.	29m 95.1 ft.	30m 98.4 ft.	31m 101.7 ft.	34m 111.5 ft.	36m 118.1 ft.	40m 131.2 ft.	46m 147.6 ft.	49m 160.8 ft.	50.5m 165.7 ft.	51.5m 169 ft.	52m 170.6 ft.	53m 173.9 ft.	53.5m 175.5 ft.	54m 177.2 ft.
1/2	9.1m 29.9 ft.	11.3m 37.1 ft.	12m 39.4 ft.	16.2m 53.1 ft.	17.6m 57.7 ft.	19m 62.3 ft.	20.5m 67.3 ft.	21.2m 69.6 ft.	21.9m 71.8 ft.	24m 78.7 ft.	25.4m 83.3 ft.	28.2m 92.5 ft.	31.8m 104.3 ft.	34.6m 113.5 ft.	35.7m 117.1 ft.	36.4m 119.4 ft.	36.7m 120.4 ft.	37.4m 122.7 ft.	37.8m 124 ft.	38.1m 125 ft.
1/4	6.5m 21.3 ft.	8m 26.2 ft.	8.5m 27.9 ft.	11.5m 37.7 ft.	12.5m 41 ft.	13.5m 44.3 ft.	14.5m 47.6 ft.	15m 49.2 ft.	15.5m 50.9 ft.	17m 55.8 ft.	18m 59 ft.	20m 65.6 ft.	22.5m 73.8 ft.	24.5m 80.4 ft.	25.2m 82.7 ft.	25.7m 84.3 ft.	26m 85.3 ft.	26.5m 86.9 ft.	26.7m 87.6 ft.	27m 88.6 ft.
1/8	4.5m 14.8 ft.	5.6m 18.4 ft.	6m 19.7 ft.	8.1m 26.6 ft.	8.8m 28.9 ft.	9.5m 31.2 ft.	10.2m 33.5 ft.	10.6m 34.8 ft.	10.9m 35.8 ft.	12m 39.4 ft.	12.7m 41.7 ft.	14.1m 46.3 ft.	15.9m 52.2 ft.	17.3m 56.8 ft.	17.8m 58.4 ft.	18.2m 59.7 ft.	18.3m 60 ft.	18.7m 61.4 ft.	18.9m 62 ft.	19m 62.3 ft.
1/16	3.2m 10.5 ft.	4m 13.1 ft.	4.2m 13.8 ft.	5.7m 18.7 ft.	6.2m 20.3 ft.	6.7m 22 ft.	7.2m 23.6 ft.	7.5m 24.6 ft.	7.7m 25.3 ft.	8.5m 27.9 ft.	9m 29.5 ft.	10m 32.8 ft.	11.2m 36.7 ft.	12.2m 40 ft.	12.6m 41.3 ft.	12.8m 42 ft.	13m 42.7 ft.	13.2m 43.3 ft.	13.3m 43.6 ft.	13.5m 44.3 ft.
1/32	2.2m 7.2 ft.	2.8m 9.2 ft.	3m 9.8 ft.	4m 13.1 ft.	4.4m 14.4 ft.	4.7m 15.4 ft.	5.1m 16.7 ft.	5.3m 17.4 ft.	5.4m 17.7 ft.	6m 19.7 ft.	6.3m 20.7 ft.	7m 23 ft.	7.9m 25.9 ft.	8.6m 28.2 ft.	8.99m 29.2 ft.	9.1m 29.9 ft.	9.1m 29.9 ft.	9.3m 30.5 ft.	9.4m 30.8 ft.	9.5m 31.2 ft.
1/64	1.6m 5.2 ft.	2m 6.6 ft.	2.1m 6.9 ft.	2.8m 9.2 ft.	3.1m 10.2 ft.	3.3m 10.8 ft.	3.6m 11.8 ft.	3.7m 12.1 ft.	3.8m 12.5 ft.	4.2m 13.8 ft.	4.5m 14.8 ft.	5m 16.4 ft.	5.6m 18.4 ft.	6.1m 20 ft.	6.3m 20.7 ft.	6.4m 21 ft.	6.5m 21.3 ft.	6.6m 21.7 ft.	6.6m 21.7 ft.	6.7m 22 ft.
1/128	1.1m 3.6 ft.	1.4m 4.6 ft.	1.5m 4.9 ft.	2m 6.6 ft.	2.2m 7.2 ft.	2.3m 7.5 ft.	2.5m 8.2 ft.	2.6m 8.5 ft.	2.7m 8.9 ft.	3m 9.8 ft.	3.1m 10.2 ft.	3.5m 11.5 ft.	3.9m 12.8 ft.	4.3m 14.1 ft.	4.4m 14.4 ft.	4.5m 14.8 ft.	4.5m 14.8 ft.	4.6m 15.1 ft.	4.7m 15.4 ft.	4.7m 15.4 ft.

3

Table 3.6 SB-910 FX Guide Numbers

Flash Output Level	Zoom Head Position (mm):																
	14			17	18	20	24	28	35	50	70	85	105	120	135	180	200
	WP+BA	BA	WP														
1/1	13m 42.7 ft.	16m 52.5 ft.	17m 55.8 ft.	22m 72.2 ft.	23m 75.5 ft.	24m 78.7 ft.	27m 88.6 ft.	30m 98.4 ft.	34m 111.5 ft.	40m 131.2 ft.	44m 144.4 ft.	46m 150.9 ft.	49m 160.8 ft.	50.5m 165.7 ft.	51m 167.3 ft.	52m 170.6 ft.	53m 173.9 ft.
1/2	9.1m 29.9 ft.	11.3m 37 ft.	12m 39.4 ft.	15.5m 50.9 ft.	16.2m 53.1 ft.	16.9m 55.4 ft.	19m 62.3 ft.	21.2m 69.6 ft.	24m 78.7 ft.	28.2m 92.5 ft.	31.1m 102 ft.	33.5m 106.6 ft.	34.6m 113.5 ft.	35.7m 117.1 ft.	36m 118.1 ft.	36.7m 120.5 ft.	37.4m 122.7 ft.
1/4	6.5m 21.3 ft.	8m 26.2 ft.	8.5m 27.9 ft.	11m 36.1 ft.	11.5m 37.7 ft.	12m 39.4 ft.	13.5m 44.3 ft.	15m 49.2 ft.	17m 55.8 ft.	20m 65.6 ft.	22m 72.2 ft.	23m 77.5 ft.	24.5m 80.4 ft.	25.2m 82.7 ft.	25.5m 83.7 ft.	26m 85.3 ft.	26.5m 86.9 ft.
1/8	4.5m 14.8 ft.	5.6m 18.4 ft.	6m 19.7 ft.	7.7m 25.3 ft.	8.1m 26.6 ft.	8.4m 27.6 ft.	9.5m 31.2 ft.	10.6m 34.8 ft.	12m 39.4 ft.	14.1m 46.3 ft.	15.5m 50.9 ft.	16.2m 53.1 ft.	17.3m 56.8 ft.	17.8m 58.4 ft.	18m 59.1 ft.	18.3m 60 ft.	18.7m 61.4 ft.
1/16	3.2m 10.5 ft.	4m 13.1 ft.	4.2m 13.8 ft.	5.5m 18 ft.	5.7m 18.7 ft.	6m 19.7 ft.	6.7m 22 ft.	7.5m 24.6 ft.	8.5m 27.9 ft.	10m 32.8 ft.	11m 36.1 ft.	11.7m 37.7 ft.	12.2m 40 ft.	12.6m 41.3 ft.	12.7m 41.7 ft.	13m 42.7 ft.	13.2m 43.3 ft.
1/32	2.2m 7.2 ft.	2.8m 9.2 ft.	3m 9.8 ft.	3.8m 12.5 ft.	4m 13.1 ft.	4.2m 13.8 ft.	4.7m 15.4 ft.	5.3m 17.4 ft.	6m 19.7 ft.	7m 23 ft.	7.7m 25.3 ft.	8.1m 26.6 ft.	8.6m 28.2 ft.	8.9m 29.2 ft.	9m 29.5 ft.	9.1m 290.9 ft.	9.3m 30.5 ft.
1/64	1.6m 5.2 ft.	2m 6.6 ft.	2.1m 6.9 ft.	2.7m 8.9 ft.	2.8m 9.2 ft.	3m 9.8 ft.	3.3m 10.8 ft.	3.7m 12.1 ft.	4.2m 13.8 ft.	5m 16.4 ft.	5.5m 18 ft.	5.7m 18.7 ft.	6.1m 20 ft.	6.3m 20.7 ft.	6.4m 21 ft.	6.5m 21.3 ft.	6.6m 21.7 ft.
1/128	1.1m 3.6 ft.	1.4m 4.6 ft.	1.5m 4.9 ft.	1.9m 6.2 ft.	2m 6.6 ft.	2.1m 6.9 ft.	2.3m 7.5 ft.	2.6m 8.5 ft.	3m 9.8 ft.	3.5m 11.5 ft.	3.8m 12.5 ft.	4.1m 13.1 ft.	4.3m 14.1 ft.	4.4m 14.1 ft.	4.5m 14.8 ft.	4.5m 14.8 ft.	4.9m 15.1 ft.

 If you plan to do a lot of manual flash exposures, I suggest making copies of the guide number tables and keeping them in your camera bag with your flash.

To figure out the GN at ISO settings other than ISO 100, multiply the GN by an ISO sensitivity factor.

To figure out the adjusted guide number, multiply the GN at ISO 100 by:

▶ **1.4 for ISO 200**

▶ **2 for ISO 400**

▶ **2.8 for ISO 800**

▶ **4 for ISO 1600**

▶ **5.6 for ISO 3200**

▶ **8 for ISO 6400**

Why do these numbers look so familiar? They are the same as the 1-stop intervals for aperture settings.

 If you have access to a flash meter, you can determine the actual guide number of your speedlight at any setting by placing the meter 10 feet away and firing the flash. Next, take the aperture reading from the flash meter and multiply by ten.

Distance

The second component in the flash exposure equation is the distance from the light source to the subject. The closer the light is to your subject, the more light falls on it. Conversely, the farther away the light source, the less illumination your subject receives, and the more power the light source needs to make the correct exposure. This is important because if you set your speedlight to a certain output, you can still achieve a proper exposure by moving it closer or further away as needed.

One thing to consider when taking distance into account is the *inverse square law.* This law of physics states that for a point source of light (in this case a speedlight), the intensity of the light is inversely proportional to the square of the distance between the subject and the light source. Feel free to read that several times. While the inverse square law may sound a bit confusing on the first read (or the second, for that matter), it simply means that doubling the distance between the subject and the light source results in one-quarter the amount of illumination.

What does this mean for you? If your speedlight is set up 4 feet from your subject and you move it so that it's 8 feet away, you need 4 times the amount of light to get the same exposure. Quadrupling the light is most easily accomplished by opening the aperture 2 stops or by increasing the flash illumination manually.

Aperture

The third component in the flash exposure equation is the aperture (⊛) setting. As you already know, the larger the aperture, the more light that falls on the sensor. Using a larger aperture allows you to use a lower power setting (such as 1/4 when in Manual mode) on your flash or, if you're using the automatic i-TTL mode, the camera fires the flash using less power. Using a wider aperture can also help you conserve battery power because the flash fires at a reduced level.

GN/D = A

Here's where the GN, distance, and aperture all come together. The basic formula allows you to take the GN and divide it by the distance to determine the aperture at which you need to shoot. However, you can also change this equation in the following ways to discover other information:

▶ **GN/D = A.** If you know the GN of the flash and the distance of the flash from the subject, you can determine the aperture (⊛) to use to achieve the proper exposure.

▶ **GN/A = D.** If you know the aperture (⊛) you want to use and the GN of the flash, you can determine the distance to place your flash from the subject.

▶ **A × D = GN.** If you already have the right exposure, you can take your aperture (⊛) setting and multiply it by the distance of the flash from the subject to determine the approximate GN of the flash.

For example, say that you're photographing a portrait in your home studio. You want to use a wide aperture of f/2.8 to soften the background. To determine what the GN of the speedlight is at the settings you are using (zoom setting, output level, and ISO), refer to Tables 3.1 through 3.6 or the GN chart in the manual. Suppose that you want to use a 50mm zoom setting (for your 50mm lens) and that you want the flash to fire at 1/32 power. When you check the chart, you get a GN of about 36. To determine how far you need to place your subject from the speedlight, simply plug the numbers into the equation like so: GN (36)/A (2.8) = D (12.8 ft.). So, you need to place the speedlight about 13 feet from your model.

Although there is some math and physics involved here, it's quite simple after you learn how to use the necessary equations, and it's a very practical skill to have. In the

future, you may step up to studio lighting, and these same equations will apply. They are also helpful when setting up a speedlight to use with the Repeating flash mode, which is covered later in this chapter.

If all of these equations overwhelm you, give them some time to sink in and come back to them later. If you decide that they are too much to handle, this won't keep you from making great images.

Flash sync modes

Flash sync modes control how the flash operates in conjunction with your camera. These modes work with both the built-in speedlight and accessory speedlights, such as the SB-700, SB-900, SB-910, and so on. These modes allow you to choose when the flash fires — at the beginning or the end of the exposure — and they also allow you to keep the shutter open for longer periods. This enables you to capture more ambient light in low-light situations.

Sync speed

Before getting into the different sync modes, it's important to understand *sync speed*. The sync speed is the fastest shutter speed that can be used while achieving a full flash exposure. This means that if you set your shutter speed faster than the rated sync speed of the camera, you don't get a full exposure and end up with a partially underexposed image.

Limited sync speeds exist because of the way shutters work in modern cameras. The shutter controls the amount of time the light is allowed to reach the imaging sensor. All dSLR cameras have what is called a *focal plane shutter,* which is (you guessed it) the shutter located directly in front of the focal plane. It is, essentially, on the sensor. The focal plane shutter has two shutter curtains that travel vertically in front of the sensor. These control the time during which the light can enter through the lens. At slower shutter speeds, the front curtain covering the sensor moves away, exposing the sensor to light for a set amount of time. When the exposure has been made, the second curtain then moves in to block the light, thus ending the exposure.

To achieve a faster shutter speed, the second curtain of the shutter starts closing before the first curtain has exposed the sensor completely. This means the sensor is actually exposed by a slit that travels the length of the sensor. This allows your camera to have extremely fast shutter speeds, but limits the flash sync speed because the entire sensor must be exposed to the flash at once to achieve a full exposure.

The sync speed for most recent Nikon cameras is usually 1/200 or 1/250 second. Some Nikon dSLRs, such as the discontinued D70/D70s, D50, and D40, have a faster

sync speed of 1/500 second. This is because these cameras use a combination electronic/mechanical shutter (also known as a *hybrid shutter*) as opposed to the strictly mechanical shutters used in the other models.

When using a combination shutter at speeds above 1/200 second, the camera controls the shutter speed electronically by *gating* the signal at the sensor instead of using the shutter curtain to block the light. Gating the signal is essentially turning on the sensor for a specified amount of time. Basically, it works like this:

1. **The mechanical shutter opens.** The mechanical shutter is limited to about 1/200 second. This allows the whole sensor to be exposed for a period of time.

2. **The electronic gate is opened.** Once the shutter is fully opened, the camera activates the sensor so that it is light sensitive.

3. **The electronic gate is closed.** Once the sensor has been activated for the predetermined amount of time (typically 1/200 to 1/4000 second), the sensor is deactivated.

4. **The mechanical shutter closes.**

These combination, or hybrid, shutters reduce the wear and tear that faster shutter speeds can have on the shutter mechanism, thereby giving it a longer working life. So which kind of shutter is better? The short answer is that electronic shutters have inherent problems that make them less desirable than mechanical shutters. In fact, when Nikon first started making dSLR cameras, the combination electronic/mechanical shutters were initially used. The top-of-the-line D1, D1X, and D1H cameras all use these types of shutters.

Some of the problems that occur with electronic shutters include the following:

▶ **Blooming.** This occurs when photographing an extremely bright point of light, such as a sunset. The pixels around the bright spot are contaminated by extraneous light, causing a halo or streaking effect around the bright areas in the image.

▶ **Image quality and resolution.** The electronics that are used to control the sensor must be built on to the chip. This leaves less room for pixels and circuitry for noise reduction and higher sensitivity.

▶ **Exposure inconsistency.** The circuitry on the sensors is temperature and humidity sensitive. Sometimes this can affect the sensor control, causing exposures to fluctuate.

Auto FP High-speed Sync

Most dSLR cameras use a focal plane shutter. The physical limitations of the shutter mechanism only allow the user a maximum shutter speed of about 1/250 second.

However, there may be times when you require a faster shutter speed. An example would be when shooting a portrait outdoors at noon. The ambient light, of course, would be very contrasting. A large aperture to blur out the background and draw attention to the subject would be ideal. At a sync speed of 1/250 second and ISO 200, the aperture would need to be f/16. If you opened the aperture (☉) to f/4, you would then need a shutter speed of 1/4000 second. This shutter speed and aperture combination is possible using Auto FP.

How does this feature work? Instead of firing a single pop, the flash fires multiple times at a lower intensity as the shutter curtain travels across the focal plane of the sensor.

This comes at a price, however. The flash power is diminished so the working distance of the flash is greatly reduced. For example, when shooting in bright sunlight, the flash will probably only work up to about 12 feet away when using a shutter speed of 1/8000 second at ISO 200 and f/1.4. Other issues include battery consumption and overheating the speedlight.

A workaround for maintaining a large aperture in bright ambient light is to use a variable neutral-density filter. These filters screw on to the front of the lens and allow you to easily adjust how many stops of ambient light you'd like to take away. I learned this technique from my friend Kevin Kubota, and I use it nearly every day.

3

Hybrid shutters aren't commonly used in newer cameras because the cost outweighs the benefit of having a moderately faster sync speed. That being said, most current Nikon camera bodies do offer a feature that allows you to sync up to the top shutter speed of your camera. This is called Auto FP High-speed Sync. See the sidebar in this chapter for more information.

All Nikon CLS-compatible cameras offer Auto FP High-speed Sync.

Front-curtain sync

Front-curtain sync is the default sync mode for your camera, whether you are using the built-in flash or speedlights. With Front-curtain sync, the flash is fired as soon as the shutter's front curtain fully opens. This mode works well with most general flash applications.

Front-curtain sync works well at faster shutter speeds (1/60 second and faster); however, when the shutter is slowed down (also known as *dragging the shutter* when doing flash photography), your images may have an unnatural-looking blur in front of them. This blur is created by the ambient light recording the moving subject.

While you photograph with the flash at slow speeds, your camera is actually recording two exposures: the flash exposure and the ambient light. When you use a fast shutter speed, the ambient light usually isn't bright enough to have an effect on the image. When you slow down the shutter speed, it allows the ambient light to be recorded to the sensor, causing what is known as *ghosting*. Ghosting is a partial exposure that usually appears somewhat transparent in the image.

Ghosting also causes a trail to appear in front of the subject because the flash freezes the initial movement of the subject. Because the subject is still moving, the ambient light records it as a blur that appears in front of the subject, creating the illusion that it's moving backward. To counteract this problem, you can use the Rear-curtain sync setting, which I explain later in this chapter.

Red-Eye Reduction

This is a common problem that most of us have encountered in a picture at one time or another — that unholy red glare emanating from the subject's eyes. It's caused by light reflecting off the retina (this also happens with animals and can appear in varying colors, including red, green, blue, or even yellow). Fortunately, all Nikon dSLRs offer a Red-Eye Reduction flash mode. When this mode is activated, the camera fires some pre-flashes (when using an accessory speedlight) or turns on the AF-assist Illuminator (when using the built-in flash), which causes the pupils of the subject's eyes to contract. This stops the light from the flash from reflecting off of the retina, and thereby reduces or eliminates the red-eye effect. This mode is useful when taking portraits or snapshots of people or pets when there is little ambient light available.

3.8 An example of Front-curtain sync at a shutter speed of 1 second. Notice that the flash freezes the subject during the beginning of the exposure. The trail caused by the ambient exposure appears in the front, causing the subject to look a bit ghostly and appear to be traveling backward.

Slow Sync

Slow Sync essentially tells your camera to drag the shutter, and it is only available in the Programmed Auto (**P**) and Aperture Priority (**A**) modes. When set to default, the camera sets the shutter speed to the default sync speed.

 When the camera is set to Shutter Priority (**S**) or Manual Exposure (**M**) mode, you can do a shutter drag without setting the flash mode to Slow Sync simply by selecting a slow shutter speed.

When using a flash at a sync speed with a background that is very dark, the subject may appear properly exposed but also as if it's hiding in a cave. Slow Sync mode helps take care of this problem (assuming your subject really isn't in a cave).

 When using Slow Sync mode, be sure the subject remains still for the whole exposure to avoid ghosting. Of course, you can also use ghosting creatively.

In Slow Sync mode, the camera allows you to set a longer shutter speed (up to 30 seconds) to capture the ambient light of the background. Your subject and the background are lit, so you can achieve a more natural-looking photograph.

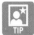 Use Slow Sync in conjunction with Red-Eye Reduction for night portraits.

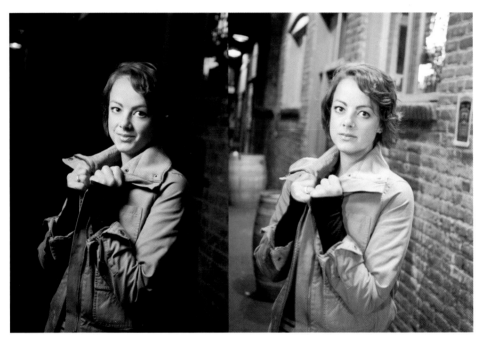

3.9 The image on the left was shot with standard flash at night. The image on the right was shot with Slow Sync. Notice that the background and the subject are more evenly exposed when using Slow Sync. This can also introduce colorcasts in your image, so you may want to use color filters to balance the color temperature.

Rear-curtain sync

As discussed earlier, by default, the flash fires as soon as the front shutter curtain opens. When using Rear-curtain sync, the camera fires the flash just before the *rear* curtain of the shutter starts moving. This mode is useful when taking flash photographs of moving subjects. Rear-curtain sync allows you to more accurately portray the motion of the subject by creating a motion blur trail behind the subject rather than in front of it, as is the case with Front-curtain sync. Rear-curtain sync is most often used in conjunction with Slow Sync.

 When you select Rear-curtain sync while using Aperture Priority (**A**) or Programmed Auto (**P**) mode, Slow Sync mode is automatically activated.

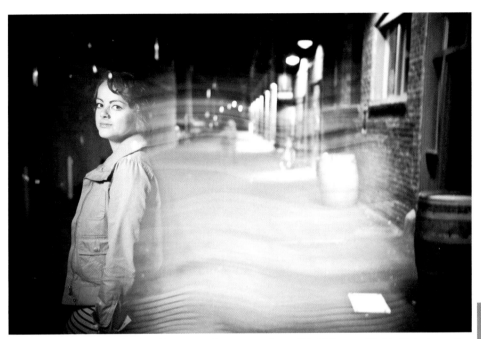

3.10 An image created using Rear-curtain sync and one SB-900 speedlight. Note how the subject looks like she's traveling at a great speed; this is due to the speedlight firing just before the rear curtain starts to travel.

Flash Exposure Compensation

Whether you use an external speedlight or your camera's built-in flash, there may be times when the flash causes your principal subject to appear too light or too dark. Nothing in an automatic world is foolproof, and, as such, it's inevitable that your camera meter will occasionally misread the light in a scene. A camera meter is usually fooled by difficult lighting situations that may include extreme backlighting from the sun, snow-covered fields, or small beams or points of ambient light on the subject.

Flash Exposure Compensation (FEC) (⚡️☑️) allows you to manually adjust the flash output while still retaining Through-the-Lens (TTL) readings. This provides you with more flexibility and control in the output of your flash and how it contributes to the overall

exposure of the image. With most cameras, you can vary the output of an attached speedlight or the built-in flash's Through-the-Lens (TTL) setting from –3 to +1 EV. This means that if your flash exposure is too bright, you can adjust it down 3 full stops under the original setting. If the image seems underexposed or too dark, you can adjust it to be brighter by 1 full stop. This can be adjusted on most cameras by pressing the Flash Mode button and rotating the Subcommand dial. Keep in mind that not all cameras operate this way. Check your owner's manual for instructions regarding how to adjust the FEC.

Additionally, you can apply FEC directly via the speedlight itself. The SB-700 requires you to press the Sel (Select) button, and then rotate the Selector dial right to increase the output or left to decrease it. On the SB-900 and SB-910, you apply FEC by pressing Function button 1 and rotating the Selector dial.

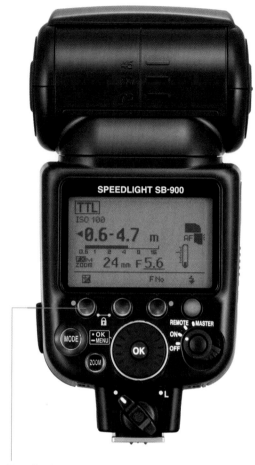

Function button 1

3.11 Function button 1 on the SB-900.

 NOTE You can only apply Flash Exposure Compensation (FEC) when the flash is set to i-TTL, i-TTL BL, Auto Aperture, or non-TTL Auto Flash. When you set the flash to Manual, Distance (GN) Priority, or Repeating flash, FEC is not applied; rather, you are setting the flash output manually.

Understanding Color Temperature

Any type of light, whether it is sunlight, tungsten light from a bulb, or light from a flash, has its own specific color. This color is measured using the Kelvin scale. This measurement is also known as *color temperature*. The *white balance* (**WB**) setting on

your camera allows you to adjust the color temperature so that your images look natural, regardless of the light source. Because white is the color that is most dramatically affected by the color temperature of the light source, this is what you base your settings on, hence the term white balance. You can change the white balance (**WB**) in the camera's Shooting menu or by pressing the WB button on the camera and rotating one of the Selector dials. See your owner's manual for more information if you're not sure how to change your camera's white balance setting.

The term color temperature may sound strange to you. How can a color have a temperature? Once you know more about the Kelvin scale, things will make more sense.

The Kelvin scale

William Thomson, 1st Baron Kelvin (Lord Kelvin), was a British physicist who introduced the idea of absolute zero and conducted experiments in thermodynamics. His research ultimately led to the introduction of the Kelvin temperature scale. It is normally used in physics and astronomy, where absolute zero (0°K) denotes the absence of all heat energy.

The concept is based on a theoretical object called a *black body radiator*. In theory, as this black body radiator is heated, it starts to glow. When it is heated to a certain temperature, it glows a specific color. This is akin to heating a bar of iron with a torch. As the iron gets hotter, it turns red, then yellow, and then eventually white before it reaches its melting point (although the theoretical black body does not have a melting point).

3

The concept of Kelvin and color temperature is tricky because it's the opposite of what you likely think of as warm and cool colors. On the Kelvin scale, red is the lowest temperature, increasing through orange, yellow, white, and to shades of blue, which represent the highest temperatures. Humans tend to perceive reds, oranges, and yellows as warm, and white and blue as cold. However, physically speaking, the opposite is true as defined by the Kelvin scale.

White balance settings

Now that you know a little about the Kelvin scale, you can begin to explore the white balance (**WB**) settings on your camera. The reason that white balance is so important is to ensure that your images have a natural look. When dealing with different lighting sources, the color temperature of the source can have a drastic effect on the coloring of the subject. For example, a standard light bulb casts a very yellow light; if you don't compensate the color temperature of the light bulb by introducing a bluish cast, the subject can look overly yellow.

In order to adjust for the *colorcast* (the casting of color on a subject) of the light source, the camera introduces a color of the complete opposite color temperature. For example, to combat the green color of a fluorescent lamp, the camera introduces a slight magenta cast to neutralize the green.

By keeping your white balance (**WB**) setting at Automatic when using your speedlight, you can reduce the number of images taken with incorrect color temperatures. Although the flash white balance (**WB**) setting is 5500K, the actual color temperature of the light emitted from the flash varies with the flash duration. The flash communicates this information to the camera, allowing it to automatically adjust the color temperature setting for a more accurate white balance.

Mixed lighting

When using a speedlight, you often introduce a second light source into the scene (unless you're using the speedlight as your only light source). The first light source is ambient light, which can be almost any type of light. As you now know, all light sources have different color temperatures. After introducing a second light source, such as a speedlight, into the mix, you now have two lights, most likely with different color temperatures. This can cause different white balances in the same image and is known as *mixed lighting*.

When using TTL-BL, the effects of mixed lighting are usually more pronounced because the camera is attempting to balance light from the speedlight with the ambient light. When shooting in mixed lighting, one option is to shoot with a custom white balance (**WB**) setting that is approximately between the color temperature settings of the two light sources.

The best and easiest way to deal with mixed lighting (other than turning everything you shoot into black-and-white artwork) is to place a filter over the flash head. This changes the color temperature of the flash to match the ambient light. The SB-700, SB-900, and SB-910 Speedlights come with color-balancing filters that allow you to compensate for both tungsten and fluorescent lighting (the two most common light sources).

The SB-900 Speedlight works with the SJ-3 Filter Set. The SB-R200 Speedlight requires the SJ-2 Filter Set.

One of my favorite ways to combat mixed lighting is to use a product called Sticky Filters. These filters are self-adhesive flash gels that stick to the head of the speedlight.

They are fairly inexpensive, easy to use, and help a great deal in creative lighting or balancing unwanted colorcasts. The only drawback to Sticky Filters is, well, they're sticky. Over time and with repeated exposure to heat (from the flash head), they may leave residue on the speedlight flash head.

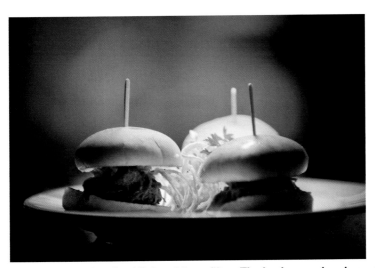

3.12 This image was shot in mixed light with no filter. The background and some of the plate have a blue tone from the sunlight that was creeping through the windows. The warm light on the food was created by the existing incandescent flood lights keeping the food warm.

 For more information on using color filters, see Chapter 5.

Using Repeating Flash

Repeating flash (RPT) is an interesting option that allows you to use stroboscopic flashes from your speedlight to record multiple images during a single exposure. This is an easy way to record a sequence shot in one frame, or to be the life of the party as you introduce your handheld strobe light.

 The SB-900 and SB-910 are the only speedlights that offer the Repeating flash option. It is available with the built-in flash on certain camera models, such as the D300s, D700, and D90. See the manual for your specific camera model for more details.

To use this feature effectively, a number of calculations and some planning are required. Remember the GN/D = A equation? You're going to need it to use the Repeating flash feature properly.

 The SB-910 can be used as a Master in Repeating flash (RPT) mode, allowing the SB-700 to perform repeating flashes.

First, review the following terms related to Repeating flash (RPT) mode:

▶ **Times.** This is the number of times you want the speedlight to flash during a single exposure.

▶ **Frequency.** This is how many times the speedlight flashes per second. It is represented in hertz (Hz); for example, 10 Hz is 10 times per second.

▶ **Flash output level.** This is the same as setting your flash output when using the speedlight in Manual mode.

To avoid frustration and concern that your speedlight isn't functioning correctly, remember that all speedlights max out at 1/8 power when using Repeating flash. You need to understand these terms to determine the proper shutter speed and aperture to use.

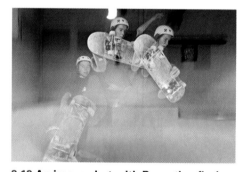

First, you need to determine what flash output level you want to use. This is where the GN/D = A equation

3.13 An image shot with Repeating flash.

comes into play. As discussed in the beginning of this chapter, the flash output level is the determining factor in how far the subject should be from the speedlight. If you prefer, you can determine the output level based on the subject's distance.

 The flash output level is also a factor in determining the maximum number of repeating flashes per frame. The speedlight does not allow you to enter a number higher than the maximum amount.

I find that the easiest way to start is to decide what aperture you want to use and how far you want the subject to be from the speedlight. From there, determine the GN (A × D = GN). Next, refer to the tables earlier in this chapter for your respective speedlight to determine the proper output level from the GN.

The next step is setting the number of flashes. This is based on personal preference and what you are trying to do. Keep in mind that the maximum number of flashes per frame is dependent on the flash output level and the frequency (Hz) setting. Table 3.7 shows the maximum number of flashes allowed per setting.

After deciding the number of times you want the flash to fire, you need to set the frequency of flashes. The frequency determines the rate or speed at which the flashes are fired. A higher frequency causes the speedlight to fire the flashes at faster intervals; conversely, a lower frequency fires the flashes at slower intervals. For shorter shutter speeds, a higher frequency is usually recommended.

The last step in the process is determining the correct shutter speed to use for the number and frequency you have set. This requires another equation: shutter speed = number of flashes/frequency (Hz). For example, for 16 flashes at a rate of 30 Hz, your shutter speed needs to be at least 1/2 second (16/30 = 0.533). For 20 flashes at 5 Hz, your shutter speed needs to be at least 4 seconds (20/5 = 4).

You can always use the Bulb setting on your camera and close the shutter when the flash is done firing.

If the shutter speed is set too fast for the Repeating flash settings, the speedlight will only fire while the shutter is open. This means that if the required shutter speed is 4 seconds and the shutter speed is set for 2 seconds, the speedlight will stop firing after 2 seconds regardless of whether it has fired the specified number of flashes.

To set the Repeating flash on the SB-900, follow these steps:

1. **Press Mode until RPT appears in the top-left corner of the LCD screen.**

2. **Press Function button 1 to select the flash output level.** Rotate the Selector dial to change the output level. The SB-900 allows you to adjust the output in 1/3-EV steps, such as: 1/32, 1/32 + 0.3 EV, 1/32 + 0.7 EV, and so on.

3. **Press Function button 2 to select the number of flashes.** Use the Selector dial to change the settings.

4. **Press Function button 3 to select the frequency.** Repeatedly press Function button 3 or use the Selector dial to change the settings.

5. **Press OK to save the settings.**

Table 3.7 Maximum Number of Flashes

Frequency (Hz)	Flash Output Level:												
	M1/8	M1/8-1/3 EV	M1/8-2/3 EV	M1/16	M1/16-1/3 EV	M1/16-2/3 EV	M1/32	M1/32-1/3 EV	M1/32-2/3 EV	M1/64	M1/64-1/3 EV	M1/64-2/3 EV	M1/128
1	14	16	22	30	36	46	60	68	78	90	90	90	90
2	12	14	18	30	36	46	60	68	78	90	90	90	90
3	10	12	14	20	24	30	50	56	64	80	80	80	80
4	8	10	12	20	24	30	40	44	52	70	70	70	70
5	6	7	10	20	24	30	32	36	40	56	56	56	56
6	6	7	10	20	24	26	28	32	36	44	44	44	44
7	5	6	8	10	12	14	24	26	30	36	36	36	36
8	5	6	8	10	12	14	22	24	28	32	32	32	32
9	4	5	6	8	9	10	20	22	26	28	28	28	28
10	4	5	6	8	9	10	12	14	18	24	24	24	24

 Repeating flash is also available with the built-in flash on certain cameras. You can usually find it in the camera's Custom Functions menu (✐). If you're unsure whether your camera offers this feature, check the manual.

Using Bounce Flash

Bounce flash is a simple technique that photographers use to improve the lighting on their subject. This is not to be confused with bouncing your SB-900 off the concrete, which I've done on more than one occasion. This invaluable technique requires no accessories or adapters. All you need is a speedlight with a tilting flash head, which is standard on all current models, with the exception of the SB-R200.

Bounce flash is exactly what it sounds like: the light from your speedlight is bounced onto a surface, which then falls onto the subject. Most of the time, bounce flash is used when there's a low, white ceiling you can use; however, other surfaces work just as well. This technique improves your flash photos 100 percent. On-camera flash gives a harsh, flat light reminiscent of old Polaroids, where every subject seemed to have demonic red eye.

The full-frontal lighting from an on-camera flash can look very unnatural because we are used to light that comes from above or at an angle (like the sun). Another downside to using an on-camera speedlight straight on is the harsh shadows that appear behind your subject when it is near a wall.

Bouncing the flash redirects the light, making it look much more natural. It also diffuses the light, providing softer light and shadows with less contrast. The larger the light source, the softer the light, remember? By bouncing the speedlight flash onto the ceiling or wall, you turn a small light source (the speedlight) into a large light source (the ceiling or wall). Another benefit of bounce flash is that it prevents red-eye without the need to use the Red-Eye Reduction feature.

More often than not, bounce flash is achieved with the speedlight mounted on-camera. The flash head is tilted up and the flash is bounced from the ceiling onto the subject. Another effective bouncing technique is to position your subject near a wall. By rotating the flash head to the side, the flash can be bounced off of the wall with a very pleasing effect similar to side light with an off-camera flash. You can use this technique if the ceiling is too high to effectively bounce the flash.

 The SB-400 flash head only tilts upward for ceiling bounce flash. To bounce the flash off of a wall, you need to hold the camera in the portrait orientation.

Bounce flash is not limited to on-camera flash applications, either. You can use the Advanced Wireless Lighting features of the CLS and still use the bounce flash technique with excellent results. Most often this would be applied in a studio-type setting or when lighting a large hall for a ceremony or reception. For studio applications, you can place the speedlight on a stand facing away from the subject and fire it at a reflector that bounces the light back onto the subject. This scatters the light in the same way that bouncing from a ceiling or wall does, making it much more diffused. Using a reflector to bounce the light is also much more efficient than bouncing it from the ceiling or a wall because less light is lost due to reflectance. Also, repositioning a reflector is much easier (and less expensive) than repositioning a wall.

Although bounce flash is a simple and straightforward technique, there are a few things of which you should be aware, as well as some pitfalls to avoid. These include the following:

▶ **Loss of light.** When bouncing flash you typically lose 2 to 3 stops of light, depending on the subject and bounce distance, as well as the color and reflectivity of the surface from which the flash is being bounced. Using i-TTL metering compensates for this loss, but when using the flash manually you will want to keep this in mind and increase the output as needed, or shoot with a wider aperture (⊛).

When calculating the flash-to-subject distance for manual bounce flash exposures using the GN/D = A equation, estimate the distances from the speedlight to the surface from which you are bouncing and from the surface to the subject.

▶ **Angle of incidence.** One of the most basic laws of physics is that the angle of incidence is equal to the angle of reflection. Take a look at your subject, as well as the distance between you, the subject, and the ceiling, before shooting. Adjust the flash head angle so that the light is bounced onto the subject — not behind or in front of it. This is a pretty easy concept to visualize — just think of the game Pong.

▶ **Colored surfaces.** Light bounced from colored surfaces transmits the color to the subject. Stick with bouncing from neutral surfaces for the best results, or adjust your white balance (**WB**) accordingly.

▶ **Ceiling height.** Bounce flash is best when used with a ceiling height of 8 to 10 feet. The higher the ceiling, the less effective the flash is. Ceilings that are higher than 12 feet may not bounce enough light back onto your subject to illuminate it properly.

 Keep in mind that you're asking your speedlight to work harder by bouncing light off of a ceiling rather than directly onto the subject. This can increase the drain on your batteries.

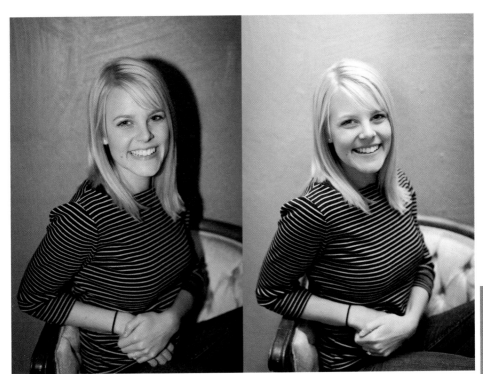

3.14 The picture on the left was shot with straight flash. The picture on the right was shot using flash bounced from the ceiling. Which do you find more flattering?

Using Fill Flash

Fill flash is a handy technique that allows you to use your speedlight as a secondary light source to *fill in* the shadows, rather than as the main light source. Fill flash can be used outdoors to fill in harsh and contrasting light from the sun, or it can be used inside to fill in shadows cast by the key light. In short, using fill flash allows you to reduce the contrast of the image by filling in the dark shadows, thus allowing you to see more detail in the image.

You may also want to use fill flash when your subject is *backlit* (lit from behind). When the subject is backlit, the camera meter reads the bright part of the image, which is

behind your subject, and tries to keep the bright areas from being overexposed. This results in a properly exposed background while your subject is underexposed and dark. On the other hand, using the Center Weighted metering mode (⊙) to obtain the proper exposure on your subject overexposes and blows out the background. The ideal solution is to use fill flash to provide an amount of light on your subject that is equal to the ambient light of the background. This brings sufficient detail to both the subject and the background, resulting in a properly and evenly exposed image.

All Nikon dSLR cameras offer i-TTL BL (Nikon calls this Balanced Fill Flash or, in layman's terms, automatic fill flash) with both the built-in flash and all CLS-compatible speed-lights. When using a speedlight, the camera automatically sets the flash to provide fill flash, as long as the camera is not in Spot metering mode (⊡). This is a very handy feature because it allows you to concentrate on composition and not have to worry about the flash settings. If you decide that you don't want to use the i-TTL BL option, you can set the camera to Spot metering mode (⊡). If you're using an SB-700 or SB-900, simply press the speedlight's Mode button to set it to Through-the-Lens (TTL).

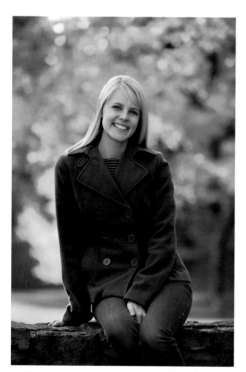

3.15 A picture taken without fill flash.

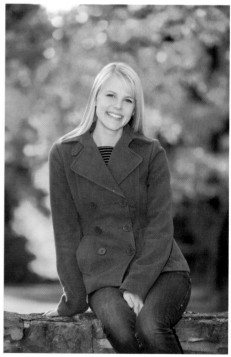

3.16 The same image with fill flash from an SB-900 on the hot shoe. The fill flash was needed to keep the overall exposure at a point where the nice autumn colors in the background didn't overexpose. A reflector in this case wouldn't have been powerful enough.

Of course, if you'd rather control the flash manually, you can still use fill flash. It's actually a simple process that can vastly improve your images when used in the right situations. To execute a manual fill flash, follow these steps:

1. **Use the camera light meter to determine the proper exposure for the background or ambient light.** A typical exposure for a sunny day is 1/250 second at f/16 at ISO 200. Be sure not to set the shutter speed higher than the rated sync speed of your camera.

2. **Determine the flash exposure.** Use the GN/D = A formula to find the flash output-level setting that you need to properly expose the subject with the flash.

3. **Reduce the flash output.** Setting the flash output level down 1/3 to 2/3 stop allows the flash exposure to be less noticeable while filling in the shadows or lighting a backlit subject. This makes your images look more natural, as if a flash didn't light them, which is often the goal when attempting fill flash.

Use the LCD screen to preview the image and adjust the flash output level as needed.

Simple Light Modifiers

One of the easiest and most economical ways to get better lighting from an on-camera speedlight is to use a diffuser or a bounce device. These are simple modifiers that diffuse the light coming from the speedlight. Every photographer who uses a speedlight should carry one of these devices in their bag. While your speedlight may have come with one, there are a few aftermarket modifiers that achieve better results and are a bit more versatile.

Diffusion domes

The SB-700, SB-900, and SB-910 all come with simple diffusion domes that slide right over the top of the flash head. These are best used in conjunction with bounce flash. Another option when using the diffusion dome is to simply tilt the flash head to the 60-degree setting and shoot without worrying about adjusting the bounce angle. This is because the diffusion dome spreads the light in a wider pattern, allowing more light to be projected forward even though the flash head is tilted upward.

With the SW-14H Diffusion Dome in place, the SB-700 flash zoom head is automatically set to 14mm. With the SW-13H Diffusion Dome in place, the SB-900 and SB-910 zoom heads are automatically set to 10mm DX or 14mm FX.

You can purchase a diffusion dome as well. The Sto-Fen Omni-Bounce is similar to the diffusion domes provided by Nikon for the SB-700 and SB-900. They cost less than $20 and are worth every penny. Sto-Fen also offers the Omni-Bounce in colors for shooting in mixed lighting, as well as an Omni-Bounce for the SB-400 that is designed to work with the tilting functions for that particular speedlight.

My favorite diffusion device is the FlashBender by Rogue. It comes in various sizes and is also available in a kit. You can shape the FlashBender to suit your needs. You can cast the light from your speedlight up, back at your subject, or both. FlashBenders also give you the ability to *snoot* your speedlight. A snoot simply directs and condenses the beam of light that comes from your light source, enabling you to create a very narrow beam.

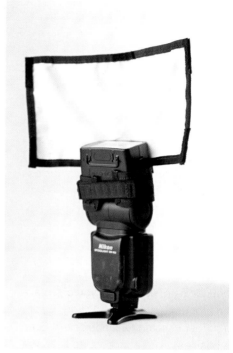

3.17 An SB-900 with a FlashBender attached.

Bounce cards

A bounce card is a simple device that redirects some of the light from the flash forward when the flash head is tilted upward. A bounce card is used to provide a little fill to the subject when using bounce flash. Although bounce flash is much better than direct flash, it can sometimes leave the subject's eyes in shadow (due to the shadow cast by the brow ridge). It also often causes the subject's eyes to lack a

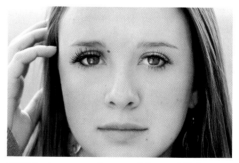

3.18 A close-up of eyes with catchlights.

catchlight, which is a highlight that appears in the eye. Catchlights are very important in portraiture as they can make your subject appear more vibrant and alive. Nobody wants to be known as the photographer whose clients look lifeless, right?

 You can also use a bounce card outdoors to add a catchlight without adding fill flash by pointing the flash head straight upward.

The SB-700, SB-900, and SB-910 all have a bounce card built into the flash head. To access the bounce card, pull out the wide-angle diffusion panel on the flash head. The bounce card should slide right out with it. Next, carefully slide the diffusion panel back in (unless you want to use it). You may need to hold on to the bounce card slightly so that it doesn't slide back in with the diffusion panel.

If your flash isn't equipped with a bounce card, never fear; you can make one for next to nothing. All you need is a rubber band and an index card. Even a business card with a white back will work.

Speedlights versus Studio Strobes

If you bought this book, you more than likely have at least one speedlight. However, studio strobes are another option available to photographers. There are two kinds of studio strobes: the power-pack type and monolights. Pack and head strobes have a central power pack that draws power from an AC plug. The heads are attached to it separately via cables. Monolights are very similar but have the power pack built right into the heads.

3.19 A homemade bounce card attached to a speedlight.

For all practical purposes these two types are the same, and I refer to them through-out the rest of the book simply as studio strobes.

Speedlights and studio strobes each have strengths and weaknesses. However, both can be used effectively with most subjects, and most professional photographers own both speedlights and studio strobes.

Some of the strengths that speedlights have over studio strobes include the following:

▶ **Portability.** Speedlights are relatively small (I can fit three or four in my camera bag). Studio strobes are much larger and usually need their own large carrying case to protect them from damage while being transported. I do a lot of interna-tional travel and would have a hard time bringing my studio strobes along.

▶ **Power.** Speedlights run on AA batteries. You don't have to rely on a household current and long extension cords to power them. You can power studio strobes with accessory batteries, but they sometimes weigh more than the strobes themselves. That's one more piece of equipment per strobe to transport.

▶ **Ease of use.** After you set up your speedlights, you can control the output of each flash centrally from the Commander unit on your camera, whether it's the built-in flash or an SB-700, SB-900, SB-910, or SU-800. With studio strobes, you must make adjustments on the power pack or the strobe heads individually.

Of course, in some situations, studio strobes have a few advantages over speedlights, such as the following:

▶ **Power.** Studio strobes usually offer the photographer more flash power and more light with which to work. In other words, you can illuminate the subject from a greater range (speedlights are limited to less than 100 feet). Many studio strobe models easily provide more light output. This is an advantage if your stu-dio work consists of illuminating large objects (such as automobiles) or groups, or if it requires you to overpower the sun. Additionally, you won't have to change batteries every 150 flashes as you do when using a speedlight.

▶ **Recycle time.** This is the amount of time it takes the flash to be ready for another photo. Speedlights typically take from 0.1 to 6 seconds between shots (depending on the output and battery charge), whereas studio strobes can fire multiple bursts in that same time frame.

▶ **Accessories.** Studio strobes offer a much wider range of light-modifying acces-sories. Barn doors, snoots, softboxes, umbrellas, gels, and diffusers are standard studio strobe accessories. These accessories are now available for speedlights as well, but they are often not as widely available as those for studio strobes — you

may have to special order them. Photographers often rely on mixing and matching these accessories to gain more lighting effects for their work.

► **Modeling light.** Studio strobes have the ability to illuminate the subject using a modeling light before the flash is fired. A *modeling light* is a second light element in the strobe head that, when turned on, simulates the light output of the flash, allowing the photographer to preview the lighting effect and adjust it as needed. Although some speedlights and cameras offer a modeling light feature, it isn't continuous. This means that you can't always preview the effect.

 The modeling light from a speedlight fires a quick, 2.5-second series of flashes. It shows you a quick preview of the lighting, but it doesn't provide constant lighting so that you can see what you are doing.

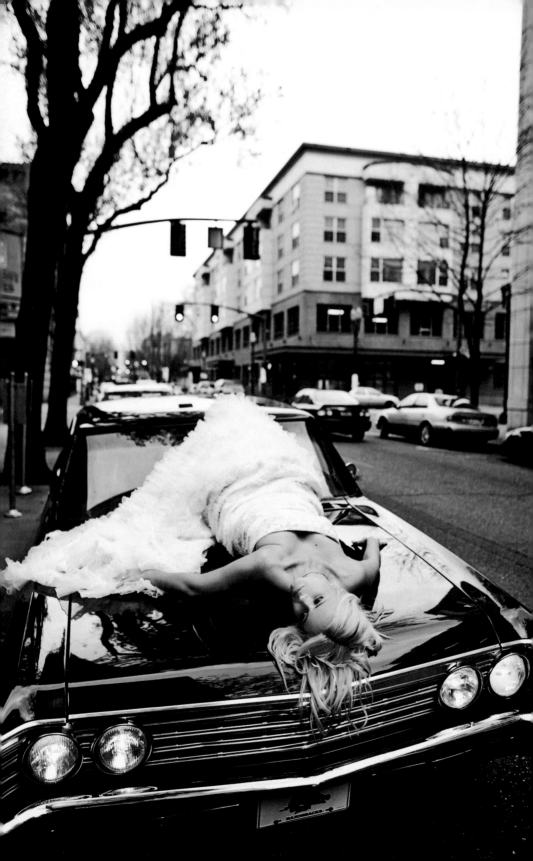

Advanced Wireless Lighting

One of the most amazing attributes of the Nikon Creative Lighting System is the Advanced Wireless Lighting (AWL) feature. As you probably already know, this feature allows you to use any number of speedlights off-camera to create a limitless range of lighting possibilities. The AWL feature can be infinitely tweaked. You can add as little or as much light as you desire. You can control all of this from one speedlight or an SU-800 on the camera's hot shoe.

This is the most important feature of the Creative Lighting System because it enables you to progress from using the out-of-the-box camera flash to creating professional-looking images that are full of depth. Because you can automatically control the speedlight output, you can experiment with moving lights to create different effects, without worrying about changing the settings of your speedlights each time.

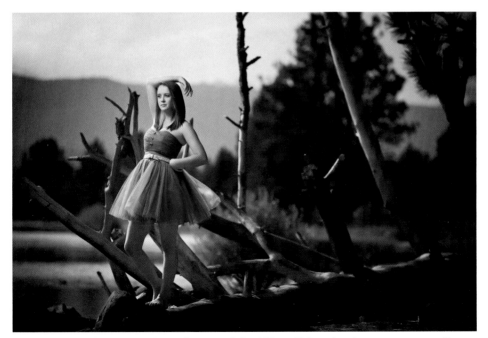

The Advanced Wireless Lighting feature of the Nikon CLS makes it easy to get studio-type lighting, even outdoors.

Flash Setup for Advanced Wireless Lighting

It's always a good idea to have a plan going into a shoot. Knowing the components of the CLS system and how they function will help you choose the right piece of equipment for the job. The CLS is flexible enough to allow you to photograph the following situations:

► **Portraits.** When shooting portraits, you can set up the speedlights to achieve particular lighting patterns. Move them closer for a softer light source or farther away for harder light.

► **Action.** When shooting action photography, you can set up your speedlights at the location where you know the action will be occurring. This leaves you free to move around, capturing different angles without changing the direction or output of your light.

► **Architecture.** Placing speedlights in darkened corners or areas can help you to get a more evenly illuminated scene.

► **Macro.** Using the Nikon R1C1 setup, including the SU-800, allows you to freely move around, or with, your subjects as they crawl through the scene.

► **Products.** AWL allows you to move your speedlights around to get the most pleasing light on the subject. You can use the speedlights to bring out the texture of an object or to fill in dark shadows.

The first thing you need to do is to determine how many lights you need to light your shot the way you want it. At the very least, you need two speedlights, one to use as a Remote and one to use as a Master. The Master (or Commander) can be a built-in flash (however, some cameras do not allow this function), or it can be an SB-700, SB-900, SB-910, or SU-800. For a Remote you need at least one SB-700, SB-900, SB-910, or SB-R200. Now, as the saying goes, more is better, right? Not always. I recommend starting out simple and practicing with the bare minimum. From there, as your budget allows, you can start adding more speedlights.

Generally, most photographers use a two-light setup: One as the main (or key) light and the other as the fill light, which is used to fill in the shadows or light the background. For larger subjects, though, you may need more lights. Any number of speedlights can be grouped together for use as a main light, as well as the fill light.

Even for a simple subject, such as a portrait, you can easily use four speedlights: One main light, one fill light, one background light, and one hair (or accent) light. If you include one speedlight as a Commander, that could mean five speedlights for a single portrait. Of course, you can also get amazing results using a built-in flash as a Master and one speedlight with reflectors. How many speedlights you need depends on your requirements and your budget.

How AWL Works — in a Nutshell

To use the Advanced Wireless Lighting feature, you need a CLS-compatible camera and at least one SB-R200, SB-700, SB-900, or SB-910. Although most Nikon dSLR cameras are compatible with CLS, not all of them share the same functions.

Basically, the Nikon CLS is a communicative system. When set to i-TTL, the camera body relays information to the Commander unit. The Commander then tells the Remotes what to do. The shutter opens and the Commander triggers the Remotes to fire. Sounds fairly simple, doesn't it? It is for you, but it's definitely a great feat of electronic engineering.

Broken down into more detail, the whole system is based on *pulse modulation*. This is the technical term for the process of the speedlight firing rapid bursts of light in a specific order. Using these pulses, the Commander unit — whether it is an SB-700, SB-900, SB-910, SU-800, or a built-in speedlight — conveys instructions to the Remote units. These pulses are imperceptible to the human eye.

The first instruction the Commander sends out to the Remotes is to fire a series of monitor pre-flashes to determine the exposure level. These pre-flashes are read by the camera's i-TTL metering sensors, which combine readings from all of the separate groups of speedlights along with a reading of the ambient light.

The camera then tells the Commander what the proper exposure needs to be. The Commander relays specific information, via pulse modulation, to each group about how much exposure they need to give to the subject. The camera then tells the Commander when the shutter is opened, and the Commander instructs the Remote flashes to fire at the specified output.

All of this is done in a split second. Of course, when you press the Shutter Release button, it looks like the flashes fire instantaneously. There's no waiting for the shutter to fire while the speedlights do their calculations.

4

When you're ready to use your speedlights wirelessly, there are some decisions to be made. Start out by following the sample workflow below and adapting it to your working style:

1. **Choose a Master flash.** The first thing to decide is how to control your Remote speedlights. Generally, an SU-800 is ideal because it's the easiest Commander to set up. It also frees the speedlights to do what they do best — fire flashes. If you want a fill light from the front, use an SB-700 or SB-900. If you want to travel lightly, you can usually rely on the built-in flash (depending on the camera body). Another consideration is how many groups of flashes you need.

2. **Select a channel.** The CLS has four communication channels (1–4). They allow more than one photographer in the same vicinity to use his speedlights wirelessly, without worrying that they will be triggered by another photographer's Master. If you are working near another photographer using Nikon CLS, just ask which channel she is using and use a different one. Keep in mind that if any of your speedlights are in SU-4 mode, they may fire when they see a flash from another speedlight in the area.

 Make sure that the Master and all Remote speedlights are set to the same channel.

3. **Set up groups.** Generally, you want to set your main lights to one group, the fill lights to one group, and any peripheral lights (such as hair and background lights) to another. This allows you to adjust the output of the specific lights based on their functions without affecting the other two exposures. A good rule of thumb is to work front to back with the main light on group A, the fill light on group B, and the hair or backlight on group C. The main light is the brightest and is probably pretty close to the Through-the-Lens (TTL) reading from your camera. The fill lights need to be a little under what the Through-the-Lens reading is, so by setting them to a separate group, you can adjust them without altering the exposure of your main lights. The background lights may or may not need to be adjusted, depending on the darkness of the background, whether you're shooting high or low key, and so on.

4. **Choose flash modes.** The last thing to do when setting up is to decide which flash mode(s) you want to use. You can set a different mode for each group if you like. For example, you can have group A set to Auto Aperture, group B set to TTL, and group C set to Manual. Manual mode is usually best because it provides consistency from shot to shot.

Setting Up a Master or Commander Flash

The *Master* or *Commander* flash is the brain of the AWL feature. This is where you control the settings and flash modes for the output of each group of Remote speed-lights, and set the channels on which the speedlights are to communicate. Although a Master and Commander essentially do the same job, there is one big difference: When used as a Master, the flash is actually fired during the exposure, whereas, when used as a Commander, the speedlight controls the Remotes by firing a pre-flash, but without firing a flash during the actual exposure. The following speedlights are capable of performing as a Master and/or Commander:

▶ **SB-700.** Can be used as a Master or Commander.

▶ **SB-900.** Can be used as a Master or Commander.

▶ **SB-910.** Can be used as a Master or Commander.

▶ **SU-800.** Can be used only as a Commander.

▶ **Built-in flash.** Depending on the camera, the built-in flash might be able to oper-ate as a Master or Commander. Check the owner's manual for specifics.

SB-700, SB-900, and SB-910

Each speedlight is set to Master mode differently. The SB-700, SB-900, and SB-910 are by far the easiest. Simply turn the power switch On, press the Lock Release button in the center of the switch, and continue to rotate the switch until it is in Master mode.

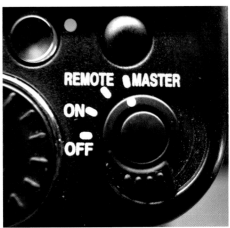

Built-in flash

Because quite a few Nikon dSLRs allow you to use the built-in flash as a Master, I won't go into the specifics for each camera. The process is quite similar for all of them, so here is a brief overview. If you get stuck, check the owner's manual for the specific settings on your camera.

4.1 The SB-700, SB-900, and SB-910 are easily set to the Master mode position.

4

In general, you follow these steps:

1. **Enter the Custom Settings menu () on your camera by pressing the Menu button (MENU).** Menu button placement varies depending on your particular Nikon dSLR. If you are unable to locate the Menu button, please refer to your owner's manual.

2. **Use the multi-selector to scroll to the specific menu setting.** On higher-end models, this option is usually found in the Custom Settings () Bracketing/Flash submenu.

3. **Select Commander mode from the menu options.** Pressing OK or tapping the multi-selector to the right takes you to the Commander setting submenu. This is where you set the modes, groups, and so on.

You can turn down the built-in flash so that, when it fires, it doesn't contribute to the exposure of the scene but still controls the Remote flashes.

Setting the Flash Mode

After your flash is set to Master, you need to decide which flash mode you want to use for each individual group as well as the Master flash. If you skipped Chapter 2 and are unsure of the different flash modes for your specific speedlight, it's time to rewind and review.

Using AWL, you can choose from the following flash modes:

▶ **TTL (Through-the-Lens).** This is the full i-TTL mode. The camera and speedlights determine the output settings for each group.

▶ **AA/A (Auto Aperture or non-TTL Auto Flash).** If you are using a non-CPU lens without entering non-CPU lens data in your camera, or if your camera doesn't support non-CPU lens data, this mode is automatically set.

▶ **M (Manual).** You determine the output settings.

▶ **RPT (Repeating flash).** This allows the Remote speedlight to fire repeating flashes. The RPT mode is set in the Custom Settings Menu.

▶ **– –.** When this setting is selected, the flash is cancelled for that group, and the speedlight will not fire.

To save time, when assigning the groups a flash mode you should also set the channel that the Master will use to communicate with the Remote speedlights.

SB-910

To assign the flash modes to each group on the SB-910, first be sure that it is set as the Master. Next, follow these steps:

1. **Press Function button 1 to access the groups and ready them for change.** When a group is ready to be set, its icon is highlighted. To scroll through the groups, press Function button 2 repeatedly or use the Selector dial. The options include M (Master), A, B, and C.

2. **When the desired group setting is highlighted, press Mode to cycle through the different flash modes.** When the desired flash mode is displayed, press Function button 2 to continue to the next group, or press OK to set.

3. **Repeat Step 2 until all of the groups and Master are set to the desired flash mode.**

If any of the channels have been set to Manual, you also need to set the output level. You can do this by pressing Function button 3 when the group is highlighted. You can continuously press Function button 3 to scroll through the settings, or you can use the Selector dial to do it more quickly. When in TTL or A mode, pressing Function button 3 allows you to adjust the Flash Exposure Compensation (FEC).

To set the channel, be sure that you have exited the group flash mode settings and press Function button 3. This highlights the channel numbers in the upper-right corner of the LCD screen. You can press Function button 3 repeatedly to cycle through the channels (1–4), or you can use the Selector dial. Once the channel is set to the correct number, press OK to set it.

SB-900

To assign the flash modes to each group on the SB-900, first be sure that it is set as the Master. Next, follow these steps:

1. **Press Function button 1 to access the groups to ready them for change.** When the group is ready to be set, its icon is highlighted. To scroll through the groups, press Function button 1 repeatedly or use the Selector dial. The options include M (Master), A, B, and C.

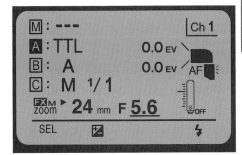

4.2 Press Function button 1 to change the group flash modes.

2. **When the desired group setting is highlighted, press Mode to cycle through the different flash modes.** When the desired flash mode is displayed, press Function button 1 to continue to the next group, or press OK to set.

3. **Repeat Step 2 until all of the groups and the Master are set to the desired flash mode.**

If any of the channels have been set to Manual, you also need to set the output level. You can do this by pressing Function button 2 when the group is highlighted. You can continuously press Function button 2 to scroll through the settings, or you can use the Selector dial to do it more quickly. When in TTL or A mode, pressing Function button 2 allows you to adjust the Flash Exposure Compensation (FEC).

To set the channel, be sure that you have exited the group flash mode settings and press Function button 2. This highlights the channel numbers in the upper-right corner of the LCD screen. You can press Function button 2 repeatedly to cycle through the channels (1–4), or you can use the Selector dial. Once the channel is set to the correct number, press OK to set it.

SB-700

While the SB-700 can function well as a Master or Commander, it has fewer features than the SB-900 and SB-910. For example, the SB-700 does not give you the option to choose different flash modes for your separate groups. Available flash mode options for your Remote groups are TTL, Manual, and GN. To change the output levels of your Remote speedlight, follow these steps:

1. **Press Sel (Select) to cycle through the options.** When the desired group is highlighted, it's ready to be changed.

2. **Rotate the Selector dial to cycle through the flash output levels.**

3. **Press OK to apply the changes.**

SU-800

To set the flash modes on the SU-800, follow these steps:

1. **Press Sel (Select).** When the group flash mode is flashing, it's ready to be changed.

4.3 Press Sel (Select) to change the group flash modes on the SU-800.

2. **Press Mode to cycle through the flash modes.** Use the arrow buttons to set the flash output or adjust the Flash Exposure Compensation (FEC). When finished, press Sel again to adjust the next group.

3. **Repeat Step 2 until all of the groups are set.**

4. **When finished, press Sel repeatedly until none of the groups is flashing.**

To set the channel on the SU-800, press Sel until the channel number is flashing. Press the arrow buttons to cycle through the channel numbers (1–4).

Setting Up Remotes and Remote Groups

A Remote flash (also referred to as a slave) is a speedlight used off-camera. In order to be fired wirelessly, each speedlight must be set to Remote mode. This is something that might be overlooked at 2 a.m., when you're half asleep and still on assignment.

Setting the SB-700, SB-900, or SB-910 to function as a Remote is as simple as flipping the On/Off/Wireless mode switch to Remote. Be sure to press the Lock Release button in the center of the switch to enable it to be set.

To properly function as Remotes, your speedlights must be set to a group. Depending on your Master, you can control up to three separate groups of speedlights. Any number of speedlights can be assigned to each group, but you really only need one (or a few). The group settings are A, B, and C. To control all three flash groups, you must use an SB-700, SB-900, SB-910, or SU-800 as a Master. When using a camera that allows the built-in flash to act as a Master, you are limited to controlling only Groups A and B. The exception to this is the D70/D70s, which only allows you to control Group B on channel 3.

SB-910

To assign an SB-910 to a group, you must first make sure it's set to Remote mode, as described earlier in this chapter. Press Function button 2 to cycle through the groups. You can also press Function button 2 and use the Selector dial to cycle through the group settings. When the desired setting is selected, press OK to set it. While in Remote mode, you can enable/disable the Sound monitor by pressing Function button 3.

4

SB-900

To assign an SB-900 to a group, you must first make sure it's set to Remote mode, as described earlier in this chapter. Press Function button 1 to cycle through the groups. You can also press Function button 1 and use the Selector dial to cycle through the group settings. When the desired setting is selected, press OK to set it.

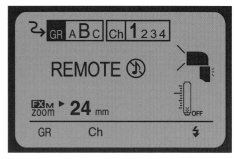

4.4 Setting Remote groups on the SB-900.

SB-700

To assign the SB-700 to a group, first set it to Remote mode. This is the same procedure as that previously described for the SB-900 and SB-910. Press Sel (Select) until Group is highlighted. Then, use the Selector dial to cycle through the groups. When the desired group is selected, press OK until no settings are highlighted on the LCD screen.

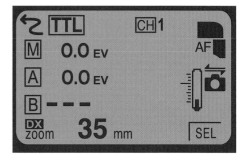

4.5 Setting Remote groups on the SB-700.

Making Adjustments on the Fly

Once you have the Master and Remote flashes set up within the proper groups, channels, and flash modes, you're ready to shoot. More often than not, you're not going to get exactly what you want. Even when taking advantage of Through-the-Lens metering, you'll encounter instances where the camera gets fooled and you have to make changes. This is where the CLS really excels.

The ability to make changes on the fly saves a lot of time running back and forth between speedlights so you can stay where you should be — behind (or near) the camera. My speedlight has been suspended from some crazy places, and the ability to control its output from the camera, without having to run up and down a ladder, has been invaluable. The rest of this chapter covers some ways to tweak your settings.

SB-910

To adjust the output of the Remote groups when using the SB-910 as a Master flash, do the following:

1. **Press Function button 2.** This highlights the group to be changed. Press it repeatedly until the specific group is highlighted. You can choose the Master (M), or groups A, B, or C.

2. **Once the desired group is highlighted, press Function button 3 to adjust the output.** When the Flash mode is set to Through-the-Lens (TTL) or Auto, you can adjust the Flash Exposure Compensation (FEC) ±3 EV in 1/3-stop steps. When using Manual mode, adjust the flash output from 1/1 (full power) down to 1/128, also in 1/3-stop steps. You can repeatedly press Function button 2 to cycle through the settings, or you can rotate the Selector dial.

SB-900

To adjust the output of the Remote groups when using the SB-900 as a Master flash, do the following:

1. **Press Function button 1.** This highlights the group to be changed. Press it repeatedly until the specific group is highlighted. You can choose the Master (M), or groups A, B, or C.

2. **Once the desired group is high-lighted, press Function button 2 to adjust the output.** When the Flash mode is set to TTL or AA/A, you can adjust the Flash Exposure Compensation (FEC) ±3 EV in 1/3-stop steps. When using Manual mode, adjust the flash output from 1/1 (full power) down to 1/128, also in 1/3-stop steps. You can repeatedly press Function button 2 to cycle through the settings, or you can rotate the Selector dial.

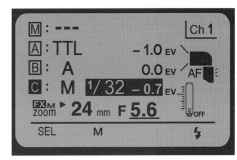

4.6 Adjusting the flash output using the SB-900 as a Master.

3. **Repeat Step 2 until all of the groups and the Master flash are set to the correct output level.**

4. **Press OK to save the settings.**

SB-700

To adjust the output of the Remote groups when the SB-700 is the Master flash, press Sel (Select). The group that is highlighted is ready to be adjusted. Next, use the Selector dial to adjust the output levels. When the Flash mode is set to TTL or AA/A, you can adjust the Flash Exposure Compensation (FEC) ±3 EV in 1/3-stop steps. When using Manual mode, you can adjust the flash output from 1/1 (full power) down to 1/128 in 1-stop steps.

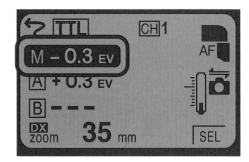

4.7 Adjusting the flash output using the SB-700 as a Master.

SU-800

To adjust the output of the Remote groups when using the SU-800 as a Commander, do the following:

1. **Press Sel (Select).** When the group is flashing, it is ready to be adjusted.

2. **Use the arrow buttons to adjust the group output.** When the Flash mode is set to TTL or Auto, you can adjust the Flash Exposure Compensation (FEC) ±3 EV in 1/3-stop steps. When using Manual mode, you adjust the flash output from 1/1 (full power) down to 1/128 in 1-stop steps.

3. **Repeat Step 2 until all of the groups are set to the correct output level.**

4. **When finished, press Sel (Select) until none of the settings is highlighted.**

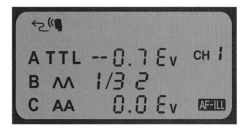

4.8 Adjusting the flash output using the SU-800 as a Commander.

Setting Up a Portable Studio

Given the recent advancements in digital flash technology, as well as the abundance of accessories created for working with flash, today's photographers no longer need to break their backs lugging around huge power packs, generators, and cabling. With a small to moderate investment, and careful planning, you can build a collection of gear that will enable you to create studio-quality lighting anywhere. Further, this portable studio will allow you to take what you need without first stopping by your local U-Haul.

There's no need to reinvent the wheel as far as what to buy and how to get it safely to your next shoot. Visit a few of your favorite photographers' websites and see if they mention the specific gear they use and how they transport it. If they don't mention it, contact them and see if they have any suggestions.

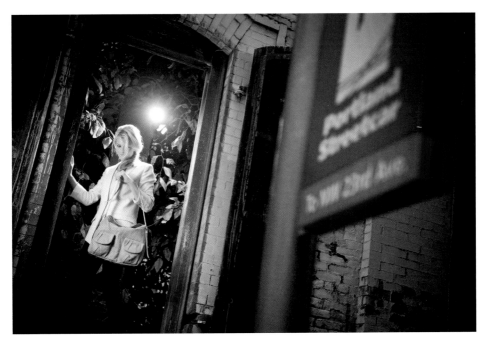

A portable studio allows you to get professional-looking images anywhere.

Introduction to the Portable Studio

Initially (and, perhaps, for the remainder of your time and interest in photography), it's easy to overdo it by purchasing and lugging around a store's worth of equipment when, in reality, you can capture amazing images with just a small amount of gear.

A portable studio gives you, at minimum, a main light source, a fill light or reflector to fill in shadows, a couple of stands, and a softbox or umbrella to soften lighting.

While it doesn't hurt to have an infinite amount of speedlight power at your disposal, being able to use at least three should help you achieve any look that you want. Keep in mind that these don't all have to be SB-910s. You also need a stand for each speedlight, at least two (but preferably three) modifiers, a reflector, and a way to carry your gear.

Equipment

This chapter covers some of the most practical equipment to use for a portable studio. However, the focus is on portability and ease of transport, and doesn't necessarily address all available equipment. The key is to get the maximum potential from your setup with the minimum amount of equipment. However, make sure that you have everything that you need.

Stands

Light stands are an underestimated part of any studio. Unless you have an army of human light stands (or interns) you need a stand to hold your speedlight. This allows you to place it anywhere, and also gives you the ability to make many micro-adjustments to its height and position.

There seem to be an endless number of light stands available. You should invest in a high-quality stand. This means you might pay more for it; however, after years of use, you'll be thankful that you did. If you plan on using only a medium-size umbrella, you don't need to buy a heavy-duty stand. However, if you plan on attaching a medium-size softbox, you should definitely buy a sturdier one. Stands run from simple and light-weight to extra heavy-duty — of course, the sturdier the stand, the higher the price. For most applications, you can purchase a medium-duty stand for about $40 to $50. For a simple background or accent light, a lightweight stand usually does the trick.

Light stands come in two varieties: Free-sliding and air-cushioned. Free-sliding stands are locked in place by a clamp that is usually a quick-release, lever-type (older stands may lock down with a screw mechanism). These stands (as the name implies) slide up and

down freely when the mechanism is unlocked. If the mechanism comes unlocked when your speedlight is attached, really bad things can happen. Air-cushioned stands are sealed at the bottom, creating a sort of pneumatic tube in which the air is compressed and then let out slowly when the locking mechanism is unlocked. This causes the light stand to collapse at a slower rate to help avoid a crash if it is accidentally unlocked.

Air-cushioned stands cost a little more than the free-sliding type, but the investment is worth it if you use heavier light modifiers (or if you're simply nervous about your speedlight crashing). I use free-sliding stands with my speedlights to cut down on weight (air-cushioned stands are generally heavier). My studio stands are air-cushioned because I typically put a lot more weight on them. Either way, take your time and make sure your stand is locked down and weighted just in case a gust of wind, or a curious child, comes along.

Light stands also come in different heights, ranging up to 6, 8, or 10 feet. An 8-foot stand is good for most applications.

Brackets and multiclamps

Another important piece of equipment you need to go along with your light stand is a bracket or multiclamp. These clamp to the top stud of the light stand and allow you to attach an umbrella or softbox to it. They also allow you to tilt the speedlight and modifier to angle the light. There are different types of brackets and multiclamps — some are made specifically for umbrellas and others are made to adapt to softboxes.

Shoe-mount multiclamp

5.1 A shoe-mount multiclamp attached to a speedlight stand.

Photoflex makes an adjustable shoe-mount that can be used to attach umbrellas and speedlights. Photoflex also makes LiteDomes in various sizes that can be used with a shoe-mount to attach a small softbox.

Umbrellas

Umbrellas are, by far, the lightest and most portable studio-type lighting modifier you can buy. They are used to soften and diffuse the light from your speedlight. If you are already familiar with studio photography equipment, you most likely know that umbrellas perform the same function as softboxes. What you may not know is that umbrellas are more affordable and easier to use with a speedlight than some softboxes.

The following are the three basic types of umbrellas:

▶ **Standard.** These are black on the outside to prevent light spill with a reflective (usually silver, but sometimes gold to add warmth, or white) surface on the inside. They are designed to bounce the light from the speedlight (which you point into the umbrella) onto the subject, resulting in a soft, nondirectional light source.

▶ **Shoot-through.** This is probably the most affordable type of umbrella. It is constructed of one-piece, translucent silver nylon. You can shoot through it to give the light a harder, more directional look. You can also use it for bouncing, but you will lose a substantial amount of light.

▶ **Convertible.** This umbrella has a removable black cover on the outside. You can use it to bounce light or as a shoot-through when the outside covering is removed.

Umbrellas come in various sizes, usually ranging from 27 inches all the way up to 12-1/2 feet. The size you need depends on the size of the subject and the degree of coverage you want. For standard headshots, portraits, and small to medium products, umbrellas ranging from 27 inches to about 40 inches supply plenty of coverage. For full-length portraits and larger subjects, a 60- to 72-inch umbrella is generally recommended; however, another option is to use two speedlights with two smaller umbrellas. This provides better coverage and allows you to set each speedlight on a lower setting for a faster recycle time.

The larger the umbrella is, the softer the light that falls on the subject from the speedlight. It is also true that the larger the umbrella, the less light that falls on your subject. Generally, small to medium umbrellas lose about 1-1/2 to 2 stops of light. Larger

umbrellas generally lose 2 or more stops because the light is spread out over a larger area.

 NOTE For umbrellas larger than about 32 inches, you may need to use a bracket that holds two speedlights to properly illuminate the subject.

Smaller umbrellas tend to provide a much more directional light than larger ones. As with all light sources or modifiers, the closer it is to the subject, the more diffused the light.

Choosing the right umbrella is, somewhat, a matter of personal preference. Some criteria to keep in mind when choosing one are type, size, and portability. You also want to consider how it works with your speedlight. For example, regular and convertible umbrellas

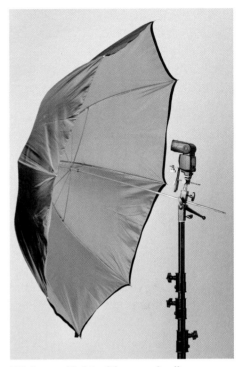

5.2 A speedlight with an umbrella mounted on a stand.

return more light to the subject when bounced, which can be advantageous because a speedlight has less power than a studio strobe. The less energy the speedlight has to emit, the more battery power you save (can you hear Mother Earth clapping?). On the other hand, shoot-through umbrellas lose more light through the back when bouncing, but they are generally more affordable than convertible umbrellas.

Softboxes

Softboxes, like umbrellas, are used to diffuse and soften the light of a strobe to create a more pleasing light source. Softboxes range in size from small, 6-inch boxes that mount directly onto the flash head, to larger ones that mount directly to a studio strobe. Softboxes also come in a variety of shapes, including square and octagonal to simulate an umbrella. I prefer to use an octagonal softbox due to the nice catchlights it produces and its ability to wrap light around the subject.

5

Flash-mounted softboxes

A small, flash-mounted softbox is economical and easy to use. Simply attach it directly to the flash head and use it with the flash mounted on the camera or on a flash bracket. You can also use it mounted on a stand, but it is less effective. This type of softbox is good for photographing events, informal portraits, wedding candids, or just plain old snapshots of your friends and family. You generally lose about 1 stop of light with these and should adjust your flash output level accordingly when using a speedlight in Manual mode. For shooting small, still-life subjects or simple portraits, this may be all you need to get started with your portable studio.

Stand-mounted softboxes

When photographing in a studio, you really need a larger softbox that is mounted, along with your speedlight, onto a suitable light stand. For a larger softbox, you need a sturdier stand to prevent the lighting setup from tipping over. Bogen/Manfrotto offers a basic 6-foot stand that works well for this application. To assist you in placing your softbox in exactly the right position, you may also want to invest in a boom pole and stand. A boom allows you to telescope your softbox out using a counterweight at the other end. This balances the weight of the softbox and the speedlight. While you can purchase a dedicated boom stand, there are aftermarket alternatives that attach to a typical light stand.

One reason you may want to invest in a softbox rather than an umbrella is that softboxes provide a more consistent and controllable light. Softboxes are closed around the light source, thereby preventing unwanted light from bouncing back onto your subject. More importantly, though, they reduce the amount of lost light, increasing the efficiency of the speedlight. The speedlight has to work harder to bounce light than it does to directly light a subject. The diffusion material on a softbox reduces the odds of creating *hotspots* on your subject. A hotspot is an overly bright area on your subject caused by uneven lighting (or someone who needs to make a trip to the powder room).

Softboxes are generally made for use with larger studio strobes. They attach to these strobes with a device called a speedring. Speedrings are specific to the type of lights to which they are meant to attach. Some companies manufacture speedrings that mount directly to a light stand. These allow you to attach multiple speedlights to the same stand. Just attach the softbox to the speedring, mount the speedring to the stand, attach the speedlight with the flash head pointed into the softbox, and you're ready to go.

Stand-mounted softboxes come in a multitude of shapes and sizes, from squares and rectangles to ovals and octagons. As with umbrellas, the size that you need depends on the subject you are photographing. Softboxes can be taken apart and conveniently folded up, and most of them come with a storage bag for easy transport. I usually leave mine set up, so I'm ready like a superhero.

Diffusers and reflectors

A multi-disk reflector and a good set of large diffusion panels, such as Photoflex Litepanels, are must-haves for today's photographer. These workhorses of the indoor/outdoor studio aren't just for reflecting light back on your subject and diffusing sunlight; when connected, they can make a huge wall of diffusion material through which your speedlights can shoot.

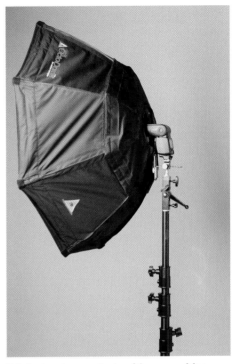

5.3 A stand-mounted softbox provides great lighting just about anywhere.

A *diffusion panel* consists of a translucent material attached to a frame that is usually made of PVC tubing or aluminum. Diffusion panels, like umbrellas and softboxes, soften or diffuse light. They are very easy to use: simply place the panel between the subject and the light source. It's generally preferable to place the diffusion panel relatively close to your subject.

You can easily control the quality of the light output from your speedlight when using a diffusion panel by moving the speedlight closer to, or farther from, the panel. Place the speedlight closer to the panel for a harder, more directional, light source. Move it farther away to achieve a softer, less directional light. Once you shoot your speedlight into the diffusion panel, the panel becomes the (much larger) light source.

5

Diffusion panels are available at most photography stores, but you can make one yourself for much less money if you're crafty enough. All you need is a bit of white rip-stop nylon and some PVC tubing and you're on your way. Type *homemade diffusion panel* into your favorite Internet search engine and you'll find many tutorials on how to build one of these.

Diffusion panels have a downside, however. Unlike a softbox, which is enclosed, a diffusion panel has no sides; therefore, a large portion of the light from your speedlight is lost. A softbox prevents the light from scattering around the room and is a more efficient way to control your light.

5.4 On its own, a diffusion panel can work wonders. Attach two or three together and you can build a huge wall of light for your subject.

Reflectors are another very important part of any studio. As mentioned earlier, reflectors are used in conjunction with your key light. The reflector bounces some of the light from your key light back onto your subject, which fills in the shadows. This reduces the contrast a little and ensures that you retain some detail in your shadow areas.

You can use any number of materials as a reflector. The most common is a piece of white foam core (available at any art supply store). You can also use white poster board or even the lid from a Styrofoam cooler. While you can do it yourself, keep in mind the image you're portraying to your clients. They may become concerned if you arrive with a van full of Styrofoam. I recommend buying a fold-up reflector. They are sturdier and last much longer than the alternatives listed earlier, which can easily get dirty, fold, tear, or break.

Professional reflector discs are available in a multitude of sizes — from about 2 to 6 feet — and are usually circular (the most common) or rectangular. They fold up to less than half their open size. I have a small, 22-inch reflector that folds up to 9 inches, fits perfectly in my camera bag, and is great for doing on-location portraits. These store-bought discs usually have a white side and a silver side for more reflectivity.

Many reflectors also have a gold side — however, it can often add too much of a golden colorcast to skin tones. Reflectors can also be used as a bouncing surface for your speed-light. Just as with the ceiling or wall bounce, this gives you a more pleasing and diffused light.

A 5-in-1 reflector disc is probably the single most versatile lighting modifier you can buy. The basic disc is a trans-lucent material that can be used as a diffusion panel. The 5-in-1 kit has five panels and comes with a cover that zips on over the top of the diffusion panel. The cover is reversible and each

5.5 Reflector discs fold up to a convenient, portable size.

side is covered with a different material: translucent white for bouncing; reflective sil-ver (which can be used to bounce flash or to reflect light from a constant light source, such as the sun); reflective gold (which is used in the same way as silver but adds warmth); and black (which is used to *flag* or block light from the subject).

Unless you have an assistant who comes with you on every shoot, I recommend buy-ing a reflector holder, such as the Photoflex LiteDisc Holder. It attaches to a light stand and has clamps to hold the reflector in position. This enables you to place the reflector exactly where you need it, leaving your hands free to operate your camera.

Backdrops

In photography, backdrops (also called backgrounds) are generally used to isolate the subject, allowing it to stand out without distracting elements in the background. Backgrounds can also be used to complement the color of an object or to accent a certain feature of the person whose portrait you are taking.

Backgrounds come in almost as many colors and materials as you can imagine. The following sections discuss some of the different types and applications.

Seamless paper

The most common type of background material is seamless paper. These backdrops are inexpensive and come in hundreds of colors. Standard rolls of background paper range in size from 3 to 12 feet wide and can be as long as 100 feet. The great thing

about using paper as a background is that if it gets dirty or torn, you can cut it off and pull more down from the roll. The not-so-great thing about paper is that this happens a lot.

5.6 A seamless paper background.

I recommend starting out with a roll of gray paper. This is a neutral color that you can use with almost any subject. You can easily change the color of the background by using color gel filters on your speedlight.

Vinyl

These backdrops are a little more expensive than paper, but they are far more durable and can be easily wiped down if they get dirty. The color selection is limited, with the most common being white, black, and gray. They are available in both gloss and matte surfaces. Be careful of the gloss surfaces as they can be difficult to light.

Muslin

Muslin is an inexpensive, lightweight cotton material. When used for backdrops, it is usually dyed different colors with a mottled pattern to give the background a look of texture. You can purchase muslin at most well-stocked photography stores or online.

If you have very specific needs, there are companies that dye muslin fabric to the color of your choice.

5.7 A muslin backdrop can provide a subtle, warm, and consistent look.

Muslin is very convenient to use. It's lightweight, stores easily by wadding it into a small bundle (to avoid patterned creasing), and durable. You can drape it over your background stand or you can easily tack it to a wall. For a portable studio, this flexibility is very advantageous because the muslin doesn't take up too much valuable space when traveling.

Backdrops by WHCC (http://backdrops.whcc.com) offers many unique backdrops. This company also uses an environmentally friendly, latex-based ink printer that prints directly onto the fabric. At this writing, it's not yet possible to design your own, but they do take suggestions.

Canvas

Canvas backdrops are very heavy duty. They are usually painted a mottled color that is lighter in the center and darkens around the edges, which helps the subject stand out from the background. These types of backdrops are almost exclusively used for portraits.

When considering a canvas backdrop, in addition to the weight factor, you should think about the cost — they are expensive. Although you can get them in lighter-weight, smaller sizes, I generally don't recommend using canvas backdrops for a portable studio as they are unwieldy and not very versatile. Also, you want to offer as many different looks for your clients as possible — most high school seniors probably wouldn't prefer having the same backdrop as their classmates.

Do-it-yourself

There are endless ways you can create your own backdrop. I've used designer curtains, built and painted my own walls, and used special-order wallpaper. Sometimes, doing it yourself ensures that no one else will create portraits that look just like yours — until they read the same book, that is.

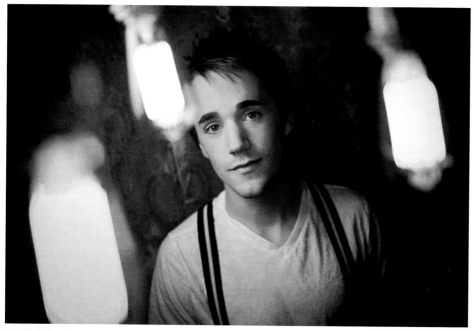

5.8 This background was created by layering two different designer wallpapers and sanding them.

Background stands

Background stands (are you ready?) hold up your backgrounds. Most background stand kits have three pieces: Two stands and a crossbar. The crossbar slides into a roll of paper (or other type of backdrop) and is held up by the stands. The crossbar has two

holes, one at either end, that slide over support pins on top of the stand. The crossbar is usually adjustable from 3 to 12-1/2 feet to accommodate the various widths of back-drops. They are adjustable in height up to 10-1/2 feet. Most kits also come with either a carrying case or bag for maximum portability.

5.9 This background stand comes with a handy bag (the cart was a separate purchase and is my primary portable studio hauler).

There are varying degrees of quality in background stands. The sturdier the stand, the more expensive it is. For a portable studio, a decent, medium-weight background stand kit will suffice.

Filters

Filters, sometimes referred to as *gels*, are pieces of colored acetate that are placed over the top of the flash head and change the color of light from your speedlight. There are two different kinds of color filters: Special effect and color correcting. These come in hundreds of colors. Color-correction filters are for matching the color of the flash output with the color of the ambient light.

Nikon offers a few filter sets for use with speedlights. The SB-900 and SB-700 both come with tungsten and fluorescent color-correction filters in the box. The filter kits include blue, red, yellow, and amber filters, as well as TN-A1 and TN-A2 filters, which are used when shooting flash in tungsten lighting, and FL-G1 and FL-G2 filters for shoot-ing flash under fluorescent lighting.

5

The following filter kits are available from Nikon:

▸ **SJ-2.** For use with the SB-R200 macro speedlights, this kit comes with one of each of the eight colors.

▸ **SJ-3.** This kit is for the SB-900 and SB-910. It includes 20 filters (4 blue, 4 red, and 2 each of the other colors). The filters for the SJ-3 include simple barcodes that are read by a sensor in the flash head so that the flash knows which filter is installed.

Attaching filters

The SB-900 and SB-910 come with the SZ-2 Color Filter Holder. As with the SJ-1 Filter Kit used on older speedlights, you fold this filter along the crease at the tab. You then place it into the filter holder. Be sure that the tab is on the bottom of the filter holder where you find a piece of black vinyl adhered. This is important as it allows the sensor on the SB-900 to read the code on the filter. Snap the SZ-2 over the top of the flash head, and you're all set. The SB-R200 also has a filter holder, the SZ-1. Simply place a filter in the filter holder and snap it into place on the speedlight.

5.10 Close-up of a filter used with the SB-900. Notice the positioning hole in the filter tab. This hole lines up with a projection in the filter holder, which ensures proper seating of the filter.

Settings

When using color filters, be sure to have your white balance (**WB**) set properly. These settings can differ, depending on the camera/speedlight combination you're using.

SB-910

The SB-910 is equipped with a sensor built in to the flash head. This sensor reads the codes printed on the tabs of the filters that come with it and the filters that come in the SJ-3 filter kit. The SB-910 then relays the filter color information to the camera body so a more accurate white balance can be achieved. Keep in mind that your camera must be equipped with filter detection. As of this writing, only the D3s, D4, D700, D800, D90, and D7000 use filter detection technology. When using one of these camera bodies, the camera adjusts the white balance for more accurate colors. You must set your camera's white balance (**WB**) to Auto (📷) or Flash (⚡) to take advantage of this technology.

For most other cameras, use the following settings for each filter:

▶ **FL-G1/FL-G2.** Set your white balance (**WB**) to Fluorescent (🔆). Since fluorescent lamps are available in different color temperatures, it's a good idea to shoot a few test shots and fine-tune the white balance setting as needed.

▶ **TN-A1.** Set your white balance (**WB**) to Incandescent (💡). Adjust the Flash Exposure Compensation (FEC) (🔲) to +1 EV and fine-tune the white balance setting to +3.

▶ **TN-A2.** Use the Sunlight (☀) white balance (**WB**) setting. Adjust the Flash Exposure Compensation (FEC) (🔲) to +0.3 EV, and fine-tune the white balance setting to +3.

▶ **Red, blue, yellow, amber.** With these filters, set your white balance (**WB**) to Auto (🅰), Flash (⚡), or Sunlight (☀). When using the amber filter, dial in +0.7 EV Flash Exposure Compensation (FEC) (🔲).

> The SB-910 manual states that the Fluorescent color-correction filters are not compatible with any cameras other than the D90, D3, and D700, and that none of the color-correction filters are compatible with the D50 or D1. Use the Fluorescent and Tungsten white balance (**WB**) settings with the respective filters to get around this. You may have to fine-tune your white balance setting for the best results.

SB-900

The SB-900 is equipped with a sensor built in to the flash head. This sensor reads the codes printed on the tabs of the filters that come with it and the filters that come in the SJ-3 filter kit. The SB-900 then relays the filter color information to the camera body so a more accurate white balance can be achieved. Keep in mind that your camera must be equipped with filter detection. As of this writing, only the D3s, D4, D700, D800, D90, and D7000 use filter-detection technology. When using one of these camera bodies, the camera adjusts the white balance for more accurate colors. You must set your camera's white balance (**WB**) to Auto (🅰) or Flash (⚡) to take advantage of this technology.

For most other cameras, use the following settings for each filter:

▶ **FL-G1/FL-G2.** Set your white balance (**WB**) to Fluorescent (🔆). Since fluorescent lamps are available in different color temperatures, it's a good idea to shoot a few test shots and fine-tune the white balance setting as needed.

▶ **TN-A1.** Set your white balance (**WB**) Incandescent (💡) setting. Adjust the Flash Exposure Compensation (FEC) (🔲) to +1 EV and fine-tune the white balance setting to +3.

▶ **TN-A2.** Use the Sunlight (☀) white balance (**WB**) setting. Adjust the Flash Exposure Compensation (FEC) (**⚡±**) to +0.3 EV and fine-tune the white balance setting to +3.

▶ **Red, blue, yellow, amber.** With these filters, set your white balance (**WB**) to Auto (**AUTO⚙**), Flash (**⚡**), or Sunlight (☀). When using the amber filter, dial in +0.7 EV Flash Exposure Compensation (FEC) (**⚡±**).

The SB-900 manual states that the Fluorescent color-correction filters are not compatible with any cameras other than the D90, D3, and D700, and that none of the color-correction filters are compatible with the D50 or D1. Use the Fluorescent and Tungsten white balance (**WB**) settings with the respective filters to get around this. You may have to fine-tune your white balance setting for the best results.

Using filters

As mentioned earlier, there are two types of filters available for use with color correction and special effects. This section briefly covers how and why you would use these.

Color correction

Different types of light sources have different colors. The two most common types of lighting are incandescent (also called tungsten) and fluorescent. Incandescent lights emit a light that is very amber in color, while most fluorescent lights cast a sickly green light. In recent years, color-corrected fluorescent lamps have become available that match daylight or a number of other colors (cool-white, warm-white, and so on). This discussion focuses on standard fluorescent lamps.

Your speedlight puts out a light that is about 5500K, which is *almost* the same as direct sunlight. This color temperature appears quite blue when compared to the color temperature of an incandescent or older fluorescent lamp.

When using flash indoors, you run into a situation that photographers call *mixed lighting*. This is because you're mixing two types of light — usually flash and incandescent. What happens with mixed lighting is that the output from your flash lights the main subject with a color temperature of 5500K, but the ambient light in the background is at a different color temperature. This causes your subject to look blue and your background to appear orange or green (depending on the light source).

The way to overcome this problem is to place a filter over your flash head to change the color of the flash output to match the ambient light. Problem solved.

Sticky Filters

One of my favorite tools is my set of Sticky Filters. These simply stick to your speed-light flash head and can assist you either with color correction or having some fun with your light. One technique is to put an amber (incandescent) filter on your main light and then turn the camera's white balance (**WB**) to Incandescent (💡). By doing this, other speedlights that are not gelled appear bluer.

5.11 **Sticky Filters are, well, sticky.**

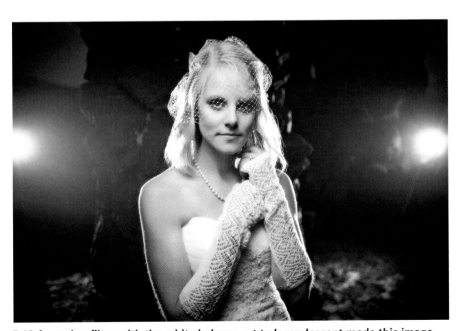

5.12 **An amber filter with the white balance set to Incandescent made this image sing the blues.**

Transporting Your Portable Studio

Now that you're geared up with the basic supplies, you need to make sure that you can actually transport your *portable* studio. Even with the basics, that's still a good deal of gear to carry around. How do you do it?

Well, it's safe to say you already have a camera bag, so I won't cover those. Some light stand kits and background stands come with their own bag (see Figure 5.9). However, these aren't always the best solution, nor do they seem to last as long as other options. Some products don't even fit in the bag that comes with them.

I frequently travel to different countries to shoot for various organizations, and I'm still trying to find the perfect bag for various pieces of equipment. I use a Calumet light stand bag at present, but I might switch to something a bit roomier with more padding, such as the Tamrac 328. Don't feel limited to shopping from camera product manufacturers — the perfect solution may come from elsewhere. The bottom line: use what works for you.

While on location, it's great to have a bunch of handy bags, but how are you going to move them around? For a few years I used a giant plastic tub with wheels, which was completely ridiculous and probably didn't look very professional. Thankfully, my sweet wife spotted (and made me buy) a handy little ride at a local discount store. This particular cart is made for hauling soccer balls, picnic supplies, and general family items from the minivan to the garage. With a maximum capacity of 150 pounds, it's perfect for all of my gear and it even has cup holders for my latte.

I've found that having a dedicated bag for my speedlights and accessories is a must. It allows me to quickly find what I need and doesn't take up too much additional space. I pack my speedlights, diffusion and color filters, sync cables, Pocket Wizards, and extra batteries in this bag.

 Just like a car battery, the contacts on the speedlight battery chamber door can become corroded if the batteries start to spew. To combat this, I keep a small battery-terminal cleaner tool in my bag, just in case.

5.13 This cart saved my back and even has a spot for my beverage.

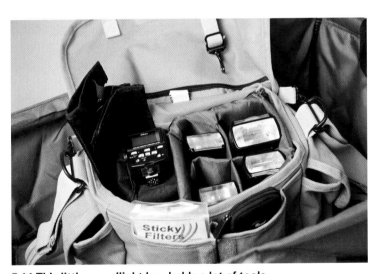

5.14 This little speedlight bag holds a lot of tools.

Of course, these solutions might not be ideal for your portable studio equipment. You may want to put everything in Pelican cases, and that's great if it works for you. Regardless, there are many different types of containers for lighting equipment — from simple, unpadded roll-up light stand bags to partitioned hard cases that can hold any number of stands, umbrellas, and speedlights. You are sure to find something that works for your setup. Your choice depends on your budget, size requirements, and the level of protection you need.

Advanced Flash Techniques

his is where the fun really begins. Armed with the knowledge of what function each button performs on your speedlight, it's time to light up the world. As you become more familiar with advanced flash techniques, you'll start to see endless possibilities for lighting your subjects.

In the following two chapters, I cover some of the most common reasons for using a speedlight in photography. While I can't include all of the possibilities, I provide some tips and tricks on how to use the CLS in your own photography.

In most cases, there is no *wrong* and, as such, I encourage you to experiment with light placement and how it interacts with your subject. Whether you're photographing an athlete or the macro world, it's my hope that you will walk away with some creative ways to approach your next photo shoot.

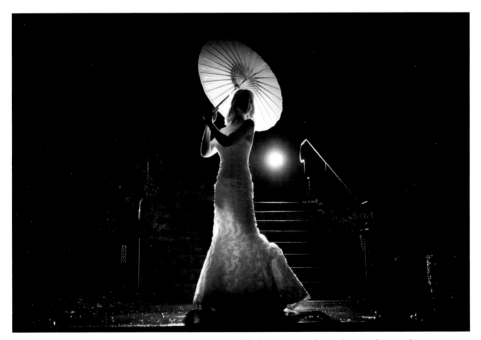

Balancing existing light at night with a speedlight can produce dramatic results.

Action and Sports Photography

Incorporating flash into sports photography is becoming increasingly popular. With the ability to fire a speedlight from a great distance, more photographers are embracing the creative possibilities. While some sporting events, such as car racing and football, have yet to see dramatically lit flash images, sports such as basketball, biking, and skateboarding have benefited from the little extra punch provided by the speedlight. While you may not be able to mount a speedlight inside your child's football helmet (or can you?), you can still take advantage of fill flash to fill in any shadows created by harsh sunlight.

The Line of Sight Conundrum

The Nikon CLS is amazing technology, but it's not perfect. Using your pop-up flash, speedlight, or SU-800 as a Commander only works if the separate devices can *see* one another. The CLS relies on pulsed flashes to communicate between Commander and Remote(s). These pulses, for the most part, are imperceptible to the human eye.

So what do you do when you need to place a Remote speedlight around the corner or inside a softbox, where it cannot receive a pulse flash from the Commander? Enter, Pocket Wizard. The TT1 Transmitter and TT5 Transceiver make it possible to place your Remote nearly anywhere.

The TT1 Transmitter slides into the camera hot shoe. To gain CLS control, you must then slide an SB-700, SB-900, SB-910, or SU-800 into the shoe-mount atop the TT1. The Remote speedlight must be set to TTL and slid into the TT5 shoe mount.

Rather than controlling your channels via the SU-800, you manually set them on the TT5 receiver, A, B or C. You are then able to change the Remote speedlight's operation mode, as well as output from the SU-800 just as you did before.

How does this work? In short, the TT1 Transmitter receives the information from the Commander, and then translates and sends it to the TT5 Transceiver. The TT5 then translates the information back to Nikon's proprietary language and the function is performed.

This all happens faster than you can say, "Wow!" A bonus of using the SU-800 atop the TT1 is the added feature of focus assist. You'll also be using less power from the expensive CR123 battery in the SU-800 because it's no longer needed to send flash pulses. Purchasing the Pocket Wizard devices is an added expense, but the benefits far outweigh the cost.

6

Your speedlight is going to work best if you can get fairly close to the subject. If it is any farther than 15 to 20 feet away, then you may want to try getting the shot without using a speedlight, or try a different vantage point or angle.

Setup

Two sports that are increasingly photographed with speedlights are biking and skate-boarding. In fact, most of the images you find in magazines devoted to these sports are shot with some sort of artificial light. While visiting a local skate park, I wanted to provide a young boarder with a memorable image.

I wanted to try to freeze him in mid-air and realized a shutter speed of 1/250 second would give me just enough stop action to do so. To do this, it was also necessary to pre-focus on the general spot where he would be when I hit the shutter. Pre-focusing reduces the risk of a completely out-of-focus image while the camera hunts for a focus. I also wanted to ensure, because he was a moving target, that I had a slight margin for error in terms of exact focus, so I opted for an aperture (⊛) of 5.6 to provide enough depth of field.

Initially, I used an SB-900 set to 1/4 power, on an adjustable speedlight mount with an extra-small OctoDome softbox. The SB-900 was set to Remote and was controlled by the SU-800, which was atop a D7000. After a few runs, I found that this setup wasn't working.

Because of where I wanted the SB-900 placed, it couldn't sufficiently communicate with the SU-800 Commander. When the speedlight fired, the light looked very flat and made the subject appear to be skating in a cave. The remedy was to place a TT1 Transmitter on the D7000 hot shoe, and then mount the SU-800 atop the TT1. After sliding the SB-900 (now set to TTL but in Manual mode via the SU-800) into the TT5 Transceiver, I manually switched the TT5 to group A so it could be independently controlled.

I added an SB-700 (in manual mode) attached to a TT5 and set to group B on the deck of the bowl to give some depth to the shot. Using the SU-800, I was able to remotely set the SB-700 to 1/2 power. With a reliable way to fire each speedlight, I was able to produce the image shown in Figure 6.1.

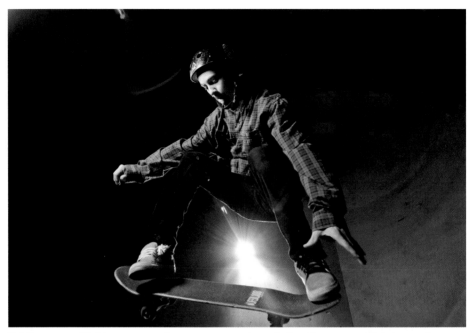

6.1 Two speedlights were used to overpower the existing fluorescent lighting and capture this skateboarder.

Tips and tricks

In addition to using a speedlight to add some punch, you can add interesting elements to your action photography with the use of *Slow Sync flash*. Slow Sync flash combines the use of the flash, which freezes the subject, and a slow shutter speed, which captures some of the ambient light. This allows you to capture some of the movement, conveying a sense of action.

For this mountain bike shot, I found a nice hill for the rider to bomb down. As it happens with many shoots, this was the final photo in a progression of images. For this shot, I wasn't too concerned with soft light, so I used both the SB-700 and SB-900 bare-bulbs. Using a flash without a modifier can more accurately reproduce sunlight.

To convey a sense of motion, I used a slower shutter speed so the background would appear blurred while I panned the camera, which was focused on the rider. After a couple of test shots, I decided that 1/40 second would provide a sufficient motion blur. I also wanted the image to have a shallow depth of field. In order to keep my aperture (⊚) at f/3.2 and my shutter speed at 1/40 second, I had to use a neutral density filter on my 28mm lens to darken the ambient exposure.

After a few trial images, I discovered that the light looked flat. To fix this, I used an SB-700 triggered by a TT5. I used a clamp to attach them to a tree directly behind the rider's approach. The resulting image, shown in Figure 6.2, looks as though the sun is shining through the trees, illuminating the subject.

6

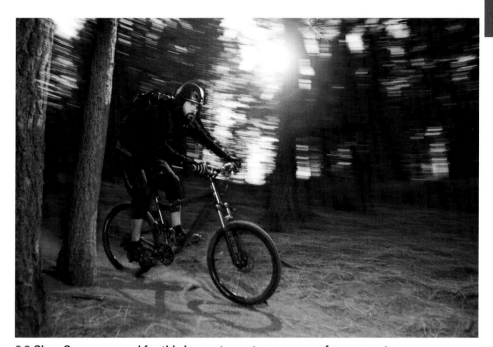

6.2 Slow Sync was used for this image to capture a sense of movement.

When you set your camera to Shutter Priority (**S**) or Manual (**M**) mode, you can only use Slow Sync in conjunction with Rear-curtain sync. In either of these modes, you choose the shutter speed so you are, in effect, in Slow Sync mode by default. The camera flash info displays *Rear*, not *Slow*.

Some other handy tips for shooting action include the following:

▶ **Scope out the area to find out where the action is.** Getting a great action shot involves being at the right place at the right time. Before you break out your camera and start shooting, take some time to look around and see what's going on.

▶ **Stay out of the way.** Make sure you're not in anyone's way. It can be dangerous for you and the person doing the activity. Also, be sure your speedlight isn't going to blind the athlete.

▶ **Practice makes perfect.** Action photography is not easy. Be prepared to shoot a lot of images. After you get comfortable with the type of event you're shooting, you will be able to anticipate where the action is going to occur and you'll start getting better shots.

▶ **Pocket Wizards.** Don't miss the perfect shot — go radio!

Macro Photography

You can open a whole new world of photographic opportunities when you experiment with *macro*, or close-up, photography.

By definition, macro (the more commonly used name for micro) photography reproduces the image on the sensor at exactly the same size or larger than the actual object. The magnification of a macro lens is often referred to as a ratio, with 1:1 being life size, 1:2 being half size, 2:1 being twice the size, and so on. Most lens manufacturers have blurred the distinction of micro/macro and label most lenses with a magnification of 1:2 or 1:4 as macro lenses.

Nikon offers a wide variety of equipment for photographers interested in macro photography. I use the Af-Micro Nikkor 60mm lens, as well as the Nikon R1-C1 Speedlight kit. The kit comes with an SU-800, two SB-R200 Speedlights, a mounting ring, and an assortment of accessories that will have you singing, *It's a Small World*. However, don't be fooled into thinking that you have to have a close-up kit to light up the tiny world of macro photography — just about any speedlight will do the trick. While the R1-C1 can also help you achieve a very flat light, which is sometimes useful in the macro world, you can still set up your speedlight team to create drama that more closely replicates how we light scenes in the larger world.

Technically speaking, macro photography can be difficult. The closer you are to an object, the less depth of field you have. When your lens is less than an inch from the face of a bug, just breathing in is sometimes enough to lose focus on the area that you want to capture. For this reason, usually, you should use the smallest aperture your camera can handle and still maintain focus. I say usually, because a shallow depth of field can sometimes be useful for bringing attention to a specific detail. Tired, rather than freshly caffeinated, bugs are also helpful.

Setup

For the image in Figure 6.3, I wanted to demonstrate that it's possible to light a macro shot with a traditional speedlight or, in this case, three.

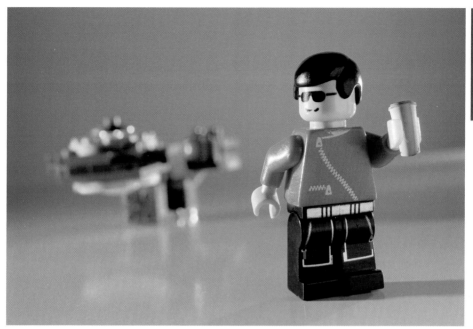

6.3 I created this image for my son, who is a big *Star Trek* and Lego fan. I convinced him that even the captain of a starship has to land at his favorite coffee station from time to time.

I purchased a small piece of bath board, also known as Masonite, at the hardware store. This product (often used in bathrooms) usually has one side that is highly reflective, as well as water resistant. I put it down on a folding table, near my *cyclorama wall* (a concave wall typically used in photography for its seamless look). The table gave the image a sense of having a horizon.

I knew I'd be shooting in a small area, so I was confident I could position each speedlight in a way that it could communicate with the SU-800 Commander atop the D7000. I set my shutter speed to 1/160 second and settled on an aperture (⊚) of f/10. To enlarge the main subject enough to fill the frame and still see his ship behind him, I used one of my favorite lenses, the Sigma 28mm f1.8 macro. While this lens doesn't produce a true 1:1 ratio (rather, a 1:2.9), I find it very fun to use because I can shoot wide angle with a large aperture (⊚) and still achieve very close magnification.

I wanted a main light for my subject, a background light, and a rim light that would *rake* (or skim at an angle) both the starship and Captain Java. First, I started fine-tuning the background light. Because the cyc wall and Masonite were white, I knew they would take color well. I chose to place a blue gel filter on my SB-800 to give the wall and Masonite a blue wash, reminiscent of the backgrounds found on distant worlds in

the original *Star Trek* series. When working with gels, it's easy to overpower them with the light source and wash out too much of the color. Underexposing a bit (just like when shooting slide film) produces a deep, rich color from a gelled speedlight. With a final power setting of 1/8 second, and the SB-800 set to Remote, I moved on to the rim light.

I've encountered several happy accidents that prove that a rim or edge light can, with some reflector work, serve as a terrific main light. This, however, was not one of those times. I wanted the edge light to be very focused, so I zoomed the SB-700 to 120mm and added a FlashBender to narrow the beam even further. I wanted this light to be whiter than the main one, so I elected not to gel it. Set to Remote and with a final output of 1/16 second, I moved on to the main light.

Because I wanted the bluest background possible, I used a warm gel on the main light (SB-900) and adjusted the D7000's white balance (**WB**) to incandescent (☀). This made the warm-gelled speedlight appear more neutral while punching up the blue tone in the back. You can zoom the SB-900 head to 200mm — this is a very tight beam of light and it worked perfectly to rake across Captain Java's right side. The position of the SB-900 didn't wrap enough light around the captain's face and torso, so I used a white, empty filter holder to act as a reflector and open up the shadows. With a final output setting of 1/8 second and set to Remote, the SB-900 was ready to contribute to the shot. The coffee cup was shot afterward and composited in.

6.4 While not a beautiful scene from afar, you can see the details that make up the tiny world of Captain Java.

6.5 The R1-C1 Close-up Kit gives you the option of using two SB-R200 Speedlights in a ring light configuration. For a more dramatic scene, use one as the main light and the other as an edge (or rim) light.

6.6 Setup shot for Figure 6.5.

I often use macro photography at weddings when shooting many of the details, such as the bride and groom's rings. Figure 6.7 shows a detailed shot of the bride's ring, incorporating other elements from the day.

This shot was very simple to create and took only a minute to set up. I had my assistant hold an SB-900 Speedlight with an extra-small softbox on a stand, just above and to the left of the ring. An aperture (⚙) of f/4 provided a nice, shallow depth of field. The SB-900 was triggered by the TT1/TT5 system with the speedlight set to channel 3 and group A.

Tips and tricks

Most of the same lighting principles that apply to portrait or general photography also apply to the macro world. Unless your goal is a flat light to evenly illuminate your subject, you can use a main light, edge or rim light, and a backlight to provide your image with depth. Here are some tips and tricks that can further enhance your time in the tiny world:

6.7 For wedding photographers, a macro lens and a way to light the subject are absolute necessities.

▶ **Add on.** Having a macro (or micro) lens is a great start, but for the ultimate depth of field, add an extension tube or a teleconverter. It's just money, right?

▶ **Experiment.** Like any kind of photography, getting used to the macro world can take some time, and trial and error. Don't beat yourself up if you walk away with a bunch of bug photos with only the mouth or ear in focus.

▶ **Get colorful.** Don't be afraid to use color gel filters and share the color love.

▶ **Kindness.** If you're shooting bugs or animals that are still breathing, please treat them with respect.

▶ **Tripod.** Even the smallest amount of camera shake in the tiny world can cause big focus issues. Lock it down.

Night Photography

In a nutshell, photography is capturing light. It's what is bathed within that light that defines what kind of photography is taking place. Just because the light is low or night has fallen doesn't mean you can't make fun, creative imagery.

When using flash photography at night, it's important to remember the quality of light you are trying to achieve. A speedlight is a smaller light source and must be softened to generate a pleasing light. While a single speedlight may leave an empty feeling in an image, that same speedlight combined with a slow shutter speed to capture ambient light can open a whole new world.

Setup

Figure 6.8 features a playful couple during an engagement session. Due to work schedules, part of this session had to take place at night. This was a simple, straightforward image to create and was made possible by using a slow shutter to capture the light coming from the vehicle's headlights.

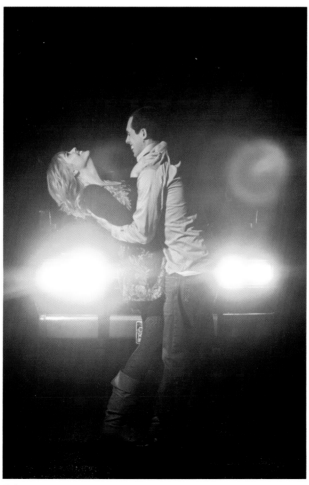

6.8 Pop that speedlight at night, but don't be afraid to
slow down the shutter speed to capture the ambient light.

The main light for this image came from an SB-800 firing through an Octobox at camera left. The speedlight, set to Remote, was fired by the pop-up flash on a D90. To ensure that the D90 flash wouldn't add to the exposure of the image, I set the output of the pop-up flash (which was in Commander mode) to +3 EV. The resulting flash from the pop-up was still enough to communicate with the Remote speedlight.

The image in Figure 6.9 holds a special place in my heart. Tired of all the usual locations for high school senior portraits, I decided to try something a bit more outside-the-box (or, in this case, under-the-ground). However, keep in mind that outside-the-box may not be for every client. As always, take great care and communicate with your clients so that you always meet, and hopefully exceed, their expectations.

This image was easily created with two speedlights. The main light, an SB-800, was softened with a softbox and triggered by a TT5. The background light (an SB-700, also triggered by a TT5), was pointed directly at the camera lens, creating a dramatic starburst effect. I used a shutter speed of 1/100 second to allow some ambient light to add to the exposure. An f-stop of 4.5 ensured enough depth of field to keep the subject in focus, while preventing the background from being too distracting.

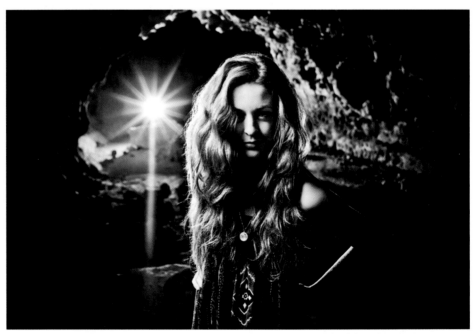

6.9 While it wasn't taken at night, this senior session got a dose of cool when we ventured into a cave.

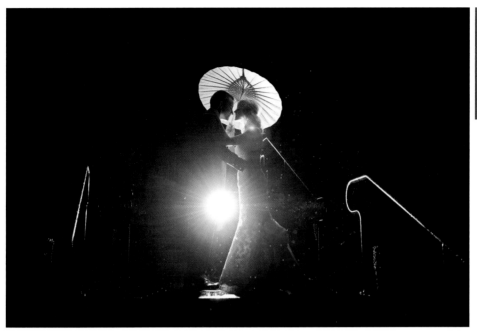

6.10 You may only need one speedlight at night to get the shot. Here, a TT1 and an SU-800 firing an SB-700 attached to a TT5 gave me the freedom to create.

Tips and tricks

Photographing a subject at night presents its own set of issues, but there's no reason why you can't walk away with a masterpiece. Here are some tips and tricks to help you along the way:

▶ **Be a drag.** Don't be afraid to drag your shutter to let the ambient light aid your speedlight in exposure.

▶ **Model light.** Bring a flashlight to help you accurately acquire focus. You or your assistant can turn it off just before the shot so it doesn't lend to the exposure.

▶ **Tripod.** If you're really dragging the shutter (or have had too much caffeine), you may want to lock down your camera.

▶ **Zoom.** During a longer exposure, try zooming the lens in slowly to give a sense of motion to your image. You may want to do this from a tripod.

▶ **Be safe.** If you're on (or near) a road, make sure that oncoming traffic can see you.

Flash Techniques for Portrait Photography

Two of my favorite settings in which to use a speedlight and the CLS are portrait and wedding photography. Creating a portrait can be as simple as raising your smartphone, pressing the shutter button, and swiping on a few filters. However, I've found that the best portraits come from a well-thought-out plan and solid execution.

It's beneficial to have an understanding of your subject to determine the best way to capture his personality. Consider what the client wants to communicate, what you want to convey, and what tools will help you accomplish both.

Also, think about the mood you and the client want displayed in the image. Would something bright work best or are you going for something more somber? Deciding these factors beforehand will help you place your subject in the scene and light it accordingly.

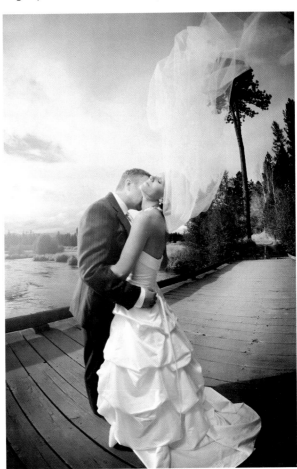

A single speedlight used in conjunction with the sun as ambient light can yield adramatic effect.

Indoor Portraits

The beauty of an indoor portrait is having a controllable environment. This means no puffy clouds constantly changing the ambient exposure, no wind gusts to topple over your softbox, and no dogs mistaking your light stand for a fire hydrant. Often when shooting indoors, you'll be met with low and/or mixed lighting. While you may be able to simply position your subject next to a large window and use a diffuser or reflector, using the CLS will give you more creative options.

Setup

I often approach the setup of a portrait as if I'm the director of an epic film in which my subject is the star. However, whereas a film might take thousands of frames to communicate the nature of the piece, I have only one.

When setting up a portrait, consider the following:

- ▶ **Location.** Is the desired location safe for your subject and crew? Do you need a location permit or permission to shoot there?

- ▶ **Time of day.** Is there a better time of day for this particular location? If the windows face east and west rather than north or south, perhaps midday might work best.

- ▶ **Props.** Does the location provide the necessary props or do you need to bring your own?

- ▶ **Equipment.** What gear do you need to achieve the look that you want? Do you need to bring anything, such as a sandbag, to ensure safety?

- ▶ **Framing.** What is the best way to frame the subject? Does anything need to be moved into or out of the frame?

- ▶ **Light positioning.** Where do you want your main light source and rim lighting? How will these interfere with the ambient light? Do you need someone to hold the light stand or make sure passers-by don't trip on the equipment?

- ▶ **Color correction and gel.** Do you need to use color filters to match the color temperature of your speedlight to the ambient light? Do you want to add color to the scene?

- ▶ **Posing.** What pose works best for the subject's body type? Does it convey the mood that you want?

▶ **Post-production.** It's never too early to think about what you'd like to do with your image in post-production. For example, will the image eventually be in black and white?

Take a look at Figure 7.1. This image was conceived as part of a commercial shoot, but it also serves as a fun Facebook portrait for the subject. I wanted a location that had an after-hours feel with a fun vibe. I finally settled on a local bar.

It was important that I be able to move around in the space and not be in the way of the bar's patrons. To accommodate this, I settled on a midmorning shoot time just before the bar opened. When a business allows you to use its space, it's important to respect that space and not disrupt customers, the employees' routines, or the furniture placement. Always be

7.1 With the help of two speedlights, an OctoDome, and the Nikon CLS, I was quickly able to control the ambient light.

careful, respect the staff, and put things back where you found them. This ensures that you'll remain in good standing with the establishment (and not give a bad name to photographers in general).

Once I found the framing I wanted for this image, I began to set the stage. I first positioned the subject where I wanted her and then slid the back of the green chair into the upper-right side of the frame to give dimension to the shot. I learned this technique from Kevin Kubota, which he appropriately calls *shooting through*. To add authenticity to the image, the model needed a drink. We settled on something that would add a splash of color.

The next step was to decide where the light should come from, and how to soften and balance it with the ambient light. I generally like to light images with the main light on the camera's left side. The main light, in this case an SB-900, was on a light stand attached to an adjustable speedlight mount and softened with a small OctoDome. A second speedlight (an SB-700), also on an adjustable speedlight mount, was positioned on a light stand camera right and pointed at the back wall. Both the SB-700 and

the SB-900 were in Remote mode and controlled with the SU-800. In most situations, I prefer to work in Manual (**M**) mode on both my camera and the speedlight. With a shutter speed of 1/160 second, I was able to dim the ambient light to a point where the speedlights could overpower it. This enabled me to avoid any color balance issues with the scene.

Tips and tricks

Here are some helpful tips and tricks for shooting indoors:

▶ **Drag the shutter.** By using Slow or Rear-curtain sync, you can bring out the ambient color of an indoor location so that your subject doesn't appear to be in a cavern.

▶ **Color filters.** Avoid unwanted colorcasts or white balance issues by using the appropriate color filter to balance the color temperature of the speedlight.

▶ **Pocket Wizard.** If you're having line-of-sight problems with your CLS, use the Pocket Wizard MiniTT1 and Flex TT5, which provide full CLS operation with the reliability of a radio signal.

▶ **Movement.** Create a small breeze with a portable fan or leaf blower, or by fanning a reflector on the subject. A small amount of blowing hair can add realism or drama to an image.

Outdoor Portraits

For all of the cons that can present themselves when shooting in the great outdoors, there is one big pro: you can shoot in the great outdoors. Shooting outdoors means that you are at the mercy of Mother Nature. Keep in mind that this is the same Mother Nature who can peek into your speedlight bag and see if you're using rechargeable batteries. Don't overlook the fact that being outside means you are shooting in whatever weather may present itself. Do you or your subject need sunscreen? Will your gear get too hot or cold? Is it windy? Overlooking any of these questions can damage your gear or, worse, you or your subject. This might be a good time to download a weather app to your smartphone.

Perhaps the most challenging part of shooting a portrait outside is controlling the ambient light. Previously, one needed an expensive, back-breaking battery pack and head-type strobes to overpower sunlight. Recent technological advances, such as the Nikon CLS, the Pocket Wizard TT1 and TT5, and the Singh Ray variable neutral density filter, have leveled the playing field.

Setup

You should approach the setup of an outdoor portrait in the same way that you would an indoor portrait. Previously, photographers wanting to use the best light were restricted to shooting only during the magic hour — either early morning or late afternoon/evening. While the magic hour is certainly my preferred time of day to shoot a portrait, this leaves me with a large portion of the day when I'm not shooting. When a professional photographer isn't shooting, he isn't making any money. Shooting in midday light needed to become a option.

I recently tried an experiment and booked a good number of high school senior portraits throughout a Wednesday, understanding that most of them would be photographed during the dreaded harsh light of 11 a.m. to 2 p.m. As shown in Figure 7.2, it is possible to achieve acceptable light from the midday sun.

7.2 This was shot when the sun was just past mid-sky (usually the worst time of day to shoot a portrait). However, with the correct gear, I was able to manufacture enough soft light to create a beautiful image.

I approached this shot like any other. I first found a location that worked for both the client and myself and, upon arrival, looked for my opening shot. I'm a sucker for tall grass and knew instantly that I wanted to place my subject in the center of it. I also wanted to be sure that the background wouldn't overwhelm the shot while, at the same time, adding a bit of natural texture to it. Keeping the background darker meant the attention would immediately be drawn to the model's face.

The setup for this shot was fairly simple: One SB-900 on an adjustable speedlight mount with an attached Octobox Small. I wanted to shoot with a shallow depth of field with nice lens compression, so I attached my workhorse Nikon 70–200mm 2.8 VR to my D700, and set the aperture (⊛) to 2.8 and the lens to 200mm. Knowing that my camera, at best, flash syncs at 1/250 second, I opted for 1/200 second. Normally, this aperture and shutter speed combination wouldn't be enough to overpower direct sunlight.

In this case, I chose to use a variable neutral density filter attached to the front of the 70–200mm lens. This brought the ambient exposure down enough so that the background would be sufficiently dark, while maintaining enough flash output to correctly expose the subject. I triggered the SB-900, set to 1/2 power in Remote mode, with an SU-800. In order for the pulsed light communication sent from the SU-800 to be seen by the SB-900, I made sure that the light sensor window for Remote flash on the SB-900 wasn't covered by my assistant's finger, or the Octobox.

The light source was placed at camera left and feathered slightly to rake across the subject's face, providing perfect little catchlights in her eyes, as well as a soft light for her skin. Notice the beautiful rim and hair light above and to her back. While I could have done this with an additional speedlight, I chose to place her so that the sun would act as an additional light source.

Tips and tricks

Here are some helpful things (and people) to bring when shooting outdoors:

▶ **A neutral density (ND) filter.** This gem can work wonders to bring down the ambient light, darken the background, or aid in motion blur. Don't go cheap when purchasing one of these.

▶ **A light stand.** Don't bring a wimpy light stand to a location shoot if you can help it. Something sturdy you can wrap a sandbag around is preferable.

▶ **An assistant.** I can't stress the benefit of this enough. Whether you pay the hand holding the stand, or bribe him with an evening or morning beverage, he's invaluable.

▶ **A leaf blower.** You can find a battery-powered leaf blower at most home improvement stores. These work great for adding a touch (or blast) of wind when Mother Nature is napping.

▶ **A Pocket Wizard.** If you're having line-of-sight problems with your CLS, use a Pocket Wizard MiniTT1 and Flex TT5. These give you full CLS operation (including high-speed sync) with the reliability of a radio signal.

Pet Portraits

One of my favorite subjects to photograph is pets. While our (sometimes) furry companions can be challenging to photograph, the rewards of capturing each pet's personality far outweigh the troubles that can arise (and, occasionally, end up on the backdrop).

Whether you're shooting indoors or outdoors, many of the same principles you use when working with people also apply when photographing pets. If you're photographing a client's pet, make sure that you communicate the look you want to achieve, as well as whether the pet is prone to any misbehavior.

Setup

Angus, shown in Figure 7.3, is a confident and energetic Jack Russell Terrier who came to visit the studio one afternoon while his (human) mom was on other business.

A relatively simple shot, Angus was lit with a Nikon SB-700 in Remote mode, controlled by an SU-800 atop my D700. I found 1/32 second to be the appropriate output setting on the SB-700 to

7.3 This guy is ready for anything.

give an accurate exposure. Breaking my rule of lighting from left to right, I placed an Octobox on a boom pole and lit from camera right without the use of a reflector to open up the shadows on Angus's right side. I felt the shadows left by the feathered softbox lent a mischievous feel to his portrait. In this case, using the CLS — aided by the SU-800 — saved a great deal of time because the speedlight was placed in a precarious position that would have required me to go up and down a ladder to adjust it. Being able to make adjustments to the speedlight via the SU-800 gave me just enough time to make the portrait before Angus got bored and abandoned me for something more exciting.

Many animals may feel uncomfortable in the studio, making the outdoor portrait a better option. Again, many of the same principles you use with humans also apply when photographing pets outside. Safety, communication, and gear are all important considerations. Pets, like children, like to move around.

Hoover, shown in Figure 7.4, decided he wasn't really into the photography thing and slunk around the pasture for a bit. In this case, having a speedlight on a stationary stand would have been ineffective. My assistant and I kept inching along with the subject.

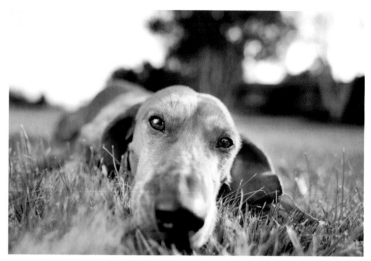

7.4 The family Dachshund bathes himself in the morning sunlight.

Although it was a bright autumn morning, I knew I wanted to darken the background enough that the dog would really pop in the image. I also wanted to use a shallow depth of field so any items in the background, such as the house or cars, wouldn't be a distraction. Given these conditions, I knew that I needed to use high-speed sync. The SU-800 works great in a controlled environment; however, using pulsed light communication outside with a moving subject (and light source) prompted me to use a TT1 and TT5, in conjunction with the SU-800.

I set my aperture (⊚) to f/3.5 to give me a shallow depth of field but also allow for some minor movement on Hoover's part as I focused on his nearest eye. After checking the ambient exposure, I knew that my shutter speed would have to be 1/1250 second, well beyond the typical 1/250 second sync speed to which most cameras adhere. The Pocket Wizard's Hyper Sync technology allowed me to use this higher sync speed.

With the SB-900 set to TTL and attached to the TT5, and the SU-800 attached to the TT1 atop my D700, I was ready to belly crawl. The SU-800, with its infrared signal now being converted to the more reliable radio frequency via the Pocket Wizard, enabled me to get a nearly accurate Through-the-Lens exposure. After dialing in a +0.7 Flash Exposure Compensation (FEC) (⚡ᴶᶻ), I had the shot.

Tips and tricks

Here are some things I've found helpful when photographing pets:

▶ **Through-the-Lens (TTL).** While I usually advise shooting in Manual (**M**) mode, TTL is the way to go when it's more important to just get the shot. Minimal exposure variances can be corrected in post-production.

▶ **Food.** While pet treats have little to do with the CLS, they can make your life much easier by keeping your subject focused. This may also work with people.

▶ **Activity.** What does the animal like to do? Try incorporating that into the shoot.

▶ **Move around.** If you're incorporating an activity, be prepared to move your feet and the light source, or pre-plan and pre-light the area where you'll be shooting.

▶ **Tummy time.** Just as you might do when photographing children, don't be afraid to get down on their level and see the world from their point of view.

▶ **Pocket Wizard.** If you're having line-of-sight problems with your CLS, use a MiniTT1 and Flex TT5. They provide full CLS operation, including high-speed sync, with the reliability of a radio signal. You don't want to miss the shot because your speedlight didn't fire.

Still Life and Product Photography

Some of the most fun and creative shots are those of things that do not move and have no personality. Just because still life and product photography don't involve a lot of movement on the part of the subject, you can still take advantage of the features offered by the Nikon CLS. Although, in this case, you may not be photographing a subject's eye or trying to capture the essence of her soul, you still need to do your homework. Understanding the product, including where it shines (and where it doesn't) is important for determining what needs to be highlighted or hidden.

You should approach a product or still life shoot in the same way that you would a portrait session. Ask yourself what gear you need to correctly illuminate the product, what kind of location best suits it, and if you need any assistants to pull it off.

Setup

I often use a macro lens when shooting products. Being able to fill the frame with the subject makes it appear larger than life, which is something most of us appreciate when looking at a plate of fine food, such as the one shown in Figure 7.5. Books could be filled (and, indeed, they have been) with the tips and tricks, and ins and outs of

photographing food. Luckily, this dish neither melted nor needed to steam.

Armed with a trusty assistant to hold an SB-700-powered softbox in the correct position, I found the angle at which I wanted to shoot and began to adjust my settings. I wanted a relatively shallow depth of field and, given the amount of ambient light, an f-stop of 3.5 was my aperture (⊚). The 3.5 f-stop with the macro lens provided a shallow depth of field. Depending on your subject, this may be too much or too little.

For Figure 7.5, I wanted to sync my flash at 1/160 second to provide the cleanest image possible. Armed with an SU-800 atop my D700, I dialed in a manual (**M**) exposure of 1/64 power and had my assistant hold the softbox as close to the dish as possible to create the softest light. The greatest part about photographing food is that you usually get to eat it afterward.

7.5 Getting in close and keeping the image bright make the subject appealing.

 While many camera manufacturers claim a sync speed of 1/250 second, shooting a white wall convinced me that 1/160 second is more accurate, as I saw no sign of the shutter curtain in the image.

When photographing an object, it's a good idea to include other items around it to lend meaning and substance to the final image. While a bride would certainly love an image of just her ring, in the case of Figure 7.6, I chose to incorporate table décor from the wedding, and the groom's ring, as well.

This shot was fairly straightforward — I used a simple bounce technique. As light from the onboard speedlight (which was pointed straight upward), bounced off of the metal ceiling, the ceiling became the light source and acted as a giant softbox.

With an aperture (⊙) of f/3.5, I set my shutter speed to 1/100 second. This slower shutter speed allowed for the warm glow of ambient light to add to the exposure. The onboard SB-900 was set to TTL.

Tips and tricks

Here are some helpful hints for shooting product and still life images:

▶ **Get in there.** Don't be afraid to get macro on your subject.

▶ **Work the scene.** Try an interesting angle. Walk around and see what angle looks best for your product.

▶ **Bounce cards.** You may need to use a bounce card or reflector for smaller items to open up the shadows. Even a small 3-inch × 5-inch card can work well.

7.6 This shot incorporates other elements close to the bride's heart.

▶ **Stuff.** I don't like to be a pack rat; however, having a number of roach clips, make-up sponges, bottle caps, and spray bottles can come in handy for elevating a product.

▶ **Implement.** If you're on location, such as at a wedding, use items that have some meaning and will benefit the final image.

Wedding and Engagement Photography

Nowhere is the benefit of the Nikon Creative Lighting System more evident than in wedding and engagement photography. In these situations, photographers (and their subjects) are constantly on the move, and missing the shot just isn't an option. Gone are the medium-format days where static images of perfectly posed people more closely resembled statues; now, it's about fun and candid imagery. More couples are seeking artistically lit images that can timelessly hang on their wall.

Setup

If at all possible, you should approach wedding and engagement sessions with two words in mind: Mobility and flexibility. I suggest using a belt (I use one from Think Tank) that enables you to quickly change lenses, as well as carry a couple of speed-lights and enough rechargeable batteries to last the day. Having a cart that can haul your speedlight bag and a couple of light stands is also a good idea.

During an engagement or wedding portrait session, I most often use one or two speedlights on stands (or monopods) to get them high enough or into hard-to-reach places. When possible, I use the sun as a back- or fill light to decrease my setup time.

When photographing groups at a wedding, it's easiest to use two speedlights — one on either side of the group. Firing each speedlight into an umbrella is a good idea because it bounces a nice, soft light onto the group. This is also a great time to use the SU-800 to fire your Remote speedlights, as well as take advantage of Through-the-Lens metering. I've found that I also sometimes need Flash Exposure Compensation (FEC) (⚡️). If I'm feeling frisky, I'll also set a speedlight behind the group to give them a bit of backlight if the sun is taking a break.

The engagement image in Figure 7.7 was taken in the afternoon; however, because of the settings I chose, it looks like it was made at night. I wanted the image to feel as if the couple were about to kiss secretly under a streetlight. For a shallow depth of field (but enough to keep the focus on the subjects), I chose a 3.2 aperture (⊚). With a shutter speed of 1/100 second, my exposure, even without the speedlight, was very bright. To bring my ambient exposure down far enough for my speedlight to be the sole source of light (and mimic a streetlight), I used a variable neutral density (ND) filter dialed all the way down. By using it at its darkest setting, I brought my ambient exposure down 8 full stops. Awesome!

It's possible that I could have used high-speed sync to achieve the same effect. However, high-speed sync limits the output of the speedlight no matter its operating mode. A neutral density filter does not limit the flash power, per se, but it does reduce the amount of light hitting the sensor from the speedlight. In his book, *Kevin Kubota's Lighting Notebook: 101 Lighting Styles and Setups for Digital Photographers,* Kubota points out that by using a neutral density filter rather than high-speed sync, you can achieve about a 2-stop increase in the speedlight's contribution to the exposure, which is huge.

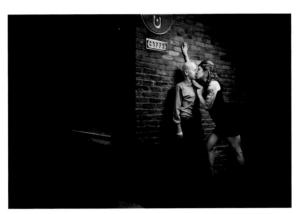

7.7 A variable neutral density filter was used to make this image appear as if it were shot at night.

7

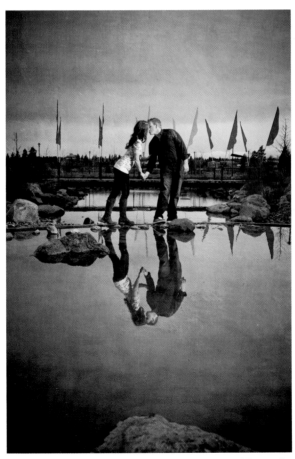

7.8 An engagement session benefits from an SB-900 fired bare-bulb at full power. I rarely do this, but it can work.

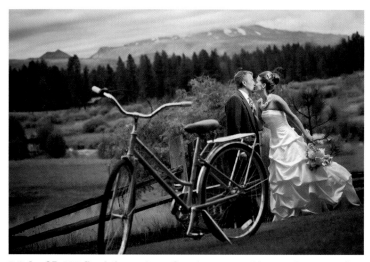

7.9 An SB-900 fired through an Octobox gave this couple some nice, soft light. The softbox was later cloned out.

7.10 Place a speedlight directly behind your subjects during a dance. Depending on the couple's position, the bride's dress can often act as a soft white reflector and help illuminate the couple's faces.

Tips and tricks

Here are some hints for using the CLS during engagement or wedding sessions:

- **Come prepared.** Bring enough batteries to last the day, light stands, and a way to haul things.

- **Gaffer's tape.** If you're planning on putting a light stand in a precarious place next to the wine table, make sure that you tape it down and mark out a safety area.

- **Get set up.** Have your light on a stand or stick (monopod), ready to go.

- **Through-the-Lens (TTL).** If you're bouncing flash into the ceiling or off of a wall, TTL is still a great way to go.

- **Flash Exposure Compensation (FEC) (⚡).** Using Through-the-Lens and things look dark? Just like photographing snow, the camera meter can be fooled when evaluating a bride's white dress. Don't be afraid to up the Flash Exposure Compensation (⚡) +1 or +2 EV.

- **Soft light.** Get that softbox close to your subject! Sometimes, you may have to later clone a softbox or assistant out of the winning shot, but the result is well worth it.

- **Pocket Wizard.** If you're having line-of-sight problems with your CLS, use a MiniTT1 and Flex TT5. They give you full CLS operation, including high-speed sync, with the reliability of a radio signal.

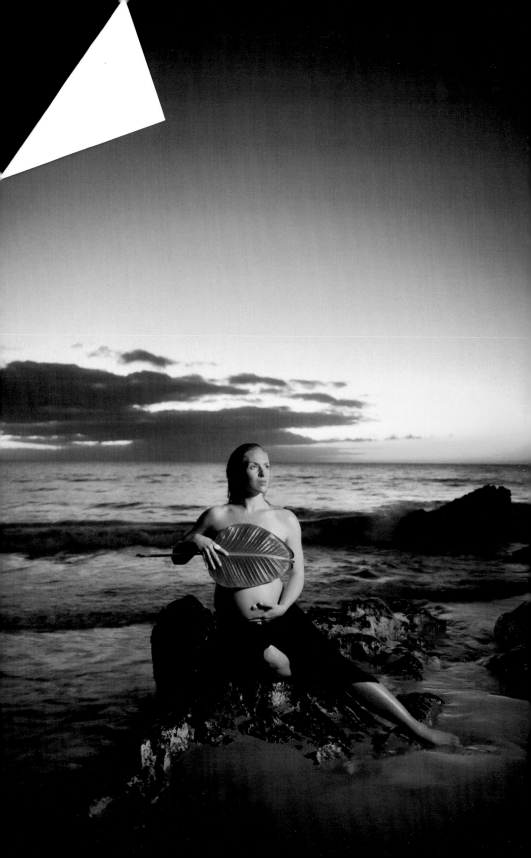

Creative Lighting System Gallery

If you were to sit down with any songwriter, composer, or artist, you would likely find that they were influenced or inspired by another person. As a photographic artist, I believe in the importance of finding what it is that inspires and influences your images. By understanding from where you draw your inspiration, you're less likely to lose sight of what you're creating and why.

However, your inspiration should compel you to create new work, rather than simply recycling someone else's vision. I encourage you to search out your source of inspiration so you have a place to which you can return should your process become jaded.

This CLS Gallery shows you how I've incorporated CLS into my own photography. It also includes setup diagrams, technical information, and details about the postproduction process.

The Swan Sings the Blues

Partnering with others on projects has resulted in some of my most cherished images and experiences. A friend of mine was the perfect model for collaboration between myself and another friend, who is a make-up artist. I wanted to show that you could effectively create a high-fashion look with just two speedlights and modifiers.

The initial image in this series, *The Swan Sings the Blues,* was fairly straightforward and easy to set up. I first placed a 7-foot OctoDome directly behind the subject and pointed it at her back to wrap some light around the subject. Inside, a single SB-700 was directed at the back of the OctoDome to reflect and fill the box with blue light, made possible by a blue filter attached to the head of the SB-700. I keep an adjustable speedlight mount attached to the OctoDome so I have the option of using two speedlights if necessary for additional output. In this case, because we were in the controlled environment of the studio, I was able to use just one side of the dual mount.

While the backlight of the 7-foot OctoDome proved interesting by itself, the subject required front light to bring some life to her eyes. I used a 3-foot OctoDome on a

boom stand positioned right above the model's head and angled down at, roughly, a 45-degree angle, making sure that it was low enough to create a catchlight in her eyes. Powering the 3-foot OctoDome was an SB-900 with an amber filter. Setting my white balance (**WB**) on the camera to incandescent (*) made the warm light from the front SB-900 more neutral and punched up the blue from the SB-700 behind.

With one speedlight completely inside the 7-foot OctoDome, moving directly under the 3-foot OctoDome for several shots made it difficult for the Remote speedlights to see the pre-flash communication from the SU-800. To solve this problem, I used the SU-800 in conjunction with a TT1 Transmitter to fire the Remote speedlights, each of which were attached to a TT5 Transceiver. Both the SB-700 and SB-900 were set to Through-the-Lens (TTL) on their LCD screens, but they were set to Manual mode on the SU-800.

AA.1 Two speedlights with OctoDomes were used to create this dramatic image. Taken with a D700 at ISO 200, 1/160 second, 85mm, and f/3.5. Triggered by a Pocket Wizard TT1/TT5 system with an SU-800 as a Commander.

AA.2 A setup shot for Figure AA.1.

Initially, it can be confusing to see TTL on the speedlight LCD screen, but rest assured, what you see on the SU-800 is what's being communicated to the Remote speedlight. For ultimate control, I set each speedlight on a separate channel by simply changing the channel on each speedlight's TT5 Transceiver. By using the SU-800 and TT1 combination to trigger the party, I was able to quickly and easily make necessary changes with no misfires.

My D700 was set to ISO 200, 1/160 second, and I used a Nikkor 85mm 1.4 lens at f/3.5. I performed basic adjustments on the digital file in Lightroom using a combination of presets from my own library, as well as Kubota Image Tools (KIT). In Photoshop, I smoothed the model's skin with a plug-in from Imagenomic called Portraiture. To further enhance the colors of the image, I used a selection of actions from KIT, including Pow Wow, Fashion Passion, and Radiance Landscape. I highly recommend the use of actions and presets to save time in your workflow process.

After achieving the look I wanted in the first image, I began to experiment with softbox placement. Figure AA.4 demonstrates the clamshell technique, which provides a soft, nearly shadow-free beauty light that was perfect for the subject. Using two, 3-foot OctoDomes in the shape of (you guessed it) a clamshell, provided stunning catchlights in the eyes and a flawlessly lit face.

SB-700

7-Foot OctoDome

3-Foot OctoDome with SB-900

Camera position

AA.3 A setup diagram for Figure AA.1.

A

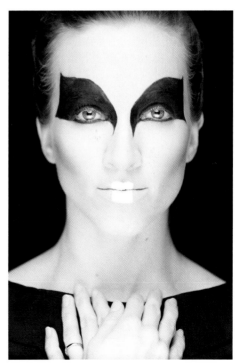

AA.4 The clamshell technique worked perfectly for this close-up.

Boxing Ring Bride

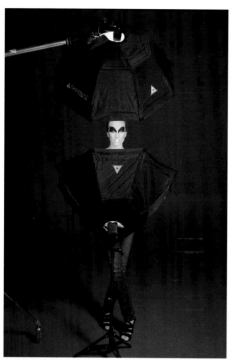

AA.5 Setup shot for Figure AA.4. Taken with a D700 at ISO 200, 1/160 second, using a 70–200mm Vibration Reduction, focal length 120mm, at f/4.5. Triggered by a Pocket Wizard TT1/TT5 system with an SU-800 as a Commander.

This is one of my favorite image sets. It has partly to do with the image series itself, but more to do with the manner in which the images were created: collaboration. The bride is on the U.S. national boxing team, which proved to be an enticing concept for her bridal session; hence, the series title, *Boxing Ring Bride*.

Overall, the setup for this image wasn't extremely difficult. By far the hardest part was setting up the boxing ring in the hot central Oregon sun. I decided to use a three-speedlight setup — two lit the subject from behind and gave the image a little pop from the corners. The model's main light came from camera left and was balanced with the ever-lowering sun.

Each rear corner of the boxing ring received a speedlight: An SB-800 camera left and an SB-700 camera right. Each speedlight was also inserted into a Pocket Wizard TT5 receiver. I used a multi-clamp to attach the speedlights to the rope, making sure they were tightly locked down to avoid any expensive tumbles. The model's main light came from an SB-900 on a boom pole fired through a 3-foot OctoDome, held up by one of my buff assistants. My D700 was set to 1/125 second and ISO 200, while the 28mm lens was set to f/3.2 to soften the background. Puffy clouds can lend drama to an image, but they can also prove frustrating because they change your exposure every few seconds. To help balance the existing ambient light and to make quick changes, I used a Singh-Ray Variable Neutral Density filter, without which I wouldn't have been able to shoot with such a shallow depth of field.

First, I processed the image in Lightroom with custom presets. I applied several KIT actions in Photoshop and finished with a KIT texture. Texture is a great way to add depth and a timeless feel to your image.

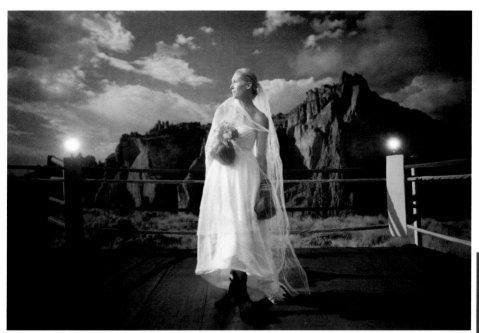

A

AA.6 *Boxing Ring Bride* benefited from a collaborative photo shoot. An SB-700, SB-800, SB-900, and TT1/TT5 system were used to light this scene in the setting sun. Taken with a D700 at ISO 200, 1/125 second, using a 28mm lens with attached neutral density filter, at f/3.2.

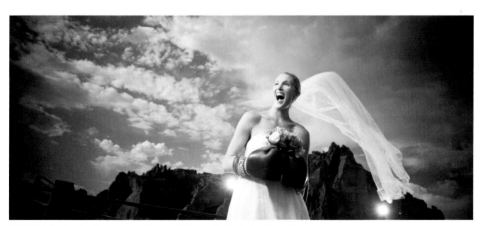

AA.7 Relatively the same shot with a whole lot of smile.

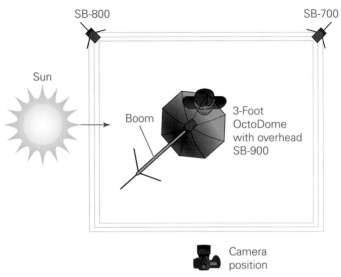

AA.8 A setup diagram for *Boxing Ring Bride.*

Pink Shoes Amongst the Moss

While photographing a book cover the week before this shoot in the same location, I decided it would be the perfect fairy tale spot for a bridal session. A lot of bridal sessions are shot before the wedding and, often, they are done outdoors. I believe that every wedding and bride is unique, so I do my best to scout out a new location that lends itself to the bride's personality and wedding theme. These sessions have been a good tool for getting me to think outside the box; I've even photographed a bride in a cave with a chainsaw — why not?

The setup for this shot, *Pink Shoes Amongst the Moss*, was quite easy. I backlit the subject with the rising sun, as well as an SB-600 on a Pocket Wizard TT5 Transceiver, set to group B. I always have my main light, which, in this case, was an SB-800 on a TT5 shooting through a 3-foot OctoDome, set to group A. I triggered the speedlights with a Pocket Wizard TT1 and an SU-800, which enabled me to make adjustments on the fly. My D700 was set to ISO 200, 1/160 second, and my 70–200mm Vibration Reduction (VR) was positioned at the 160mm focal length with a 3.2 f-stop. I love the compression of the longer lens and, in combination with a shallow depth of field, it really made the subject pop in this image — well, that and the pink shoes.

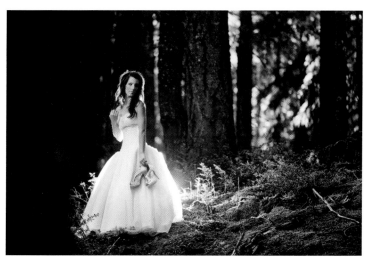

AA.9 A couple of hours in the car and strategically placed speedlights helped create this pre-wedding bridal portrait. Taken with a D700 at ISO 200, with a 70–200mm Vibration Reduction at 160mm, and f/3.2. Triggered by a TT1/TT5 system.

Initially, I made basic adjustments to the RAW file in Lightroom. In Photoshop, I applied the Pow Wow and Fashion Passion actions from KIT to the whole image, as well as painting in Radiance Landscape to the mossy areas to make them pop. I finished the image off with a bit of sharpening courtesy of KPD Magic Sharp (also from KIT).

The Castle's Keep

For this session, the bride needed something epic, and I wanted to capture her more serious side. The Dee Wright Observatory is just such an epic location — it often reminds me of a scene from *The Lord of the Rings*.

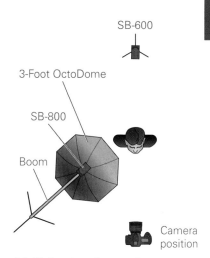

AA.10 A setup diagram for Figure AA.9.

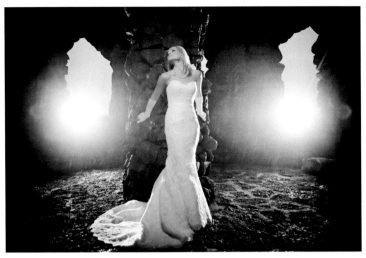

AA.11 The Dee Wright Observatory in Oregon looks as though it's straight out of the land of Mordor. An SU-800 triggered an SB-700 main light, and SB-800 and SB-900 Remotes. An OctoDome was used to soften the main light. Taken with a D700 at ISO 200, 1/200 second, using a Nikon 17–55mm at the 28mm setting, and f/2.8.

For my main image, which I call *The Castle's Keep*, I wanted to use three speedlights, with two from behind to provide some dramatic flair and illuminate the lava rock structure. An SB-900 was placed camera left and an SB-800 camera right. An SB-700 was mounted on an adjustable stand and fired through a 3-foot OctoDome.

Due to the placement of each speedlight, I was able to successfully fire each Remote with the SU-800 by itself. Each speedlight was in Remote mode, with the main light on group A and each backlight on group B. While the output of the SB-900 may differ from that of the SB-800 at the same output setting, the difference in this case was negligible, so it did not warrant having each backlight on its own independent channel.

I set my workhorse D700 to ISO 200 and 1/200 second to bring down the ambient light. I used the Nikon

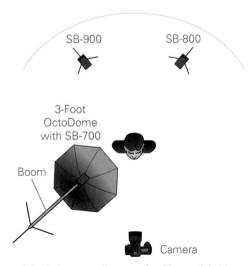

AA.12 A setup diagram for Figure AA.11.

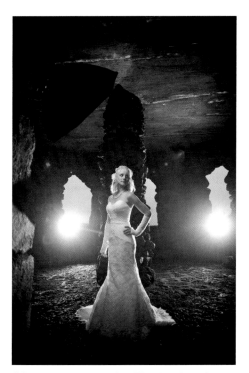

AA.13 A setup shot for *The Castle's Keep*.

17–55mm lens at the 28mm setting to avoid the extreme vignetting caused by using a crop sensor lens (DX) on a full-frame (FX) body. To keep my depth of field fairly shallow, I used a 2.8 f-stop.

In postproduction, I began with initial edits in Lightroom, applying custom presets and adjusting the brightness level a bit. Once in Photoshop, I used the Portraiture plug-in from Imagenomic to soften the subject's skin, a Pow Wow action, and a texture from KIT to finish it off.

LaChureca

My favorite way to use my photography is by shooting for organizations that, day in and day out, change the world. I was asked to help document the work of Forward Edge International in Managua, Nicaragua, where many people live, literally, in a dump called LaChureca. The task was to document, as quickly as possible, the dichotomy of life inside and outside the dump.

I needed to travel fairly light on this trip. I dislike checking equipment through any airline and try to keep the majority of my gear in my Airport Security carry-on roller from Think Tank. It's also difficult traveling to a location like LaChureca with a ton of gear. Word of any visitor's arrival travels quickly, and having extra baggage is tempting to thieves.

I brought two speedlights, the now-discontinued SB-600 and SB-800. To keep things moving quickly on the trip, I rarely used a two-light setup if the sun could be my second light source. This image was shot before I had the TT1/TT5 system. In order to achieve a high-speed sync-type shot, I used a neutral density (ND) filter. This allowed my speedlight and camera to sync up to 1/250 second with my older transceivers and still shoot wide open in the bright daylight.

Operating my D700 at 1/250 second with apertures (⊛) on my Nikkor lenses ranging from f/1.4 to f/4.5, I was able to capture an emotional collection of images of some of

the girls rescued from LaChureca. I culled and sorted the RAW file image collection in Lightroom, and made some minor adjustments. In Photoshop, I applied an assortment of actions from KIT to punch up the color and draw attention to the subject.

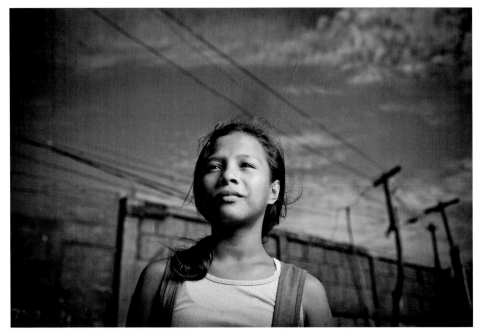

AA.14 One of the girls rescued from LaChureca. An SB-800 speedlight was triggered by a Pocket Wizard Transceiver. A 3-foot OctoDome was used for diffusion. Taken with a D700, at ISO 200, 1/250 second, and using a range of Nikkor lenses.

AA.15 A setup diagram for the technique I used most often in Nicaragua. While the position of the sun changed from shot to shot, the overall concept remained consistent.

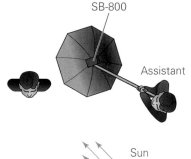
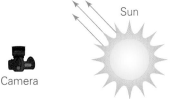

SB-800

Assistant

Sun

Camera

Georgia On My Mind

When photographing children, you never know what you're going to get. Parents are often horrified at the behavior of their kids and watch their portrait investment drown in a fit of tears. I have found that most children have a fairly short attention span and, unless you can dish out a lot of excitement or candy, the clock is ticking. That, however, was not the case with my model for this series, called *Georgia on My Mind*.

The setup for this indoor session was very simple. I wanted a large light source to create the softest light possible and give my subject a bit of room to move around. While there are other ways to produce a large light source (such as joining two litepanels), I opted to use a 7-foot OctoDome. This is a mammoth softbox, but it's easy to use and set up. Inside the OctoDome's two layers of diffusion, you can reach the DualFlash Adapter (see Figure AA.19), which enables you to use two speedlights. This decreases the power of each speedlight, providing a faster recycle time or twice the power, depending on your needs.

A

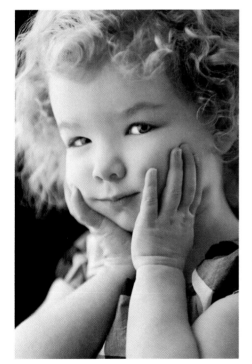

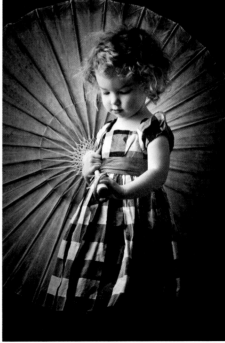

AA.16 For this shot, an SB-700 and SB-900 were triggered by a TT1/TT5 system and softened by a 7-foot OctoDome. Taken with a D700 at ISO 200, 175mm, and f/2.8.

AA.17 By zooming out to 135mm and adding a prop, I was able to get an entirely different image with the same lighting setup. I later darkened the edges in Photoshop with the Starburst Vignette effect from KIT.

To light the 7-foot OctoDome, I used the SB-700 and SB-900, both attached to their own TT5 Transceiver. Both were also set to Through-the-Lens (TTL) to allow the TT1 and SU-800 to communicate with them. My D700 was set to ISO 200 and 1/160 second. I used a Nikon 70–200mm Vibration Reduction at the 175mm lens setting with an aperture of f/2.8.

After importing the images to Lightroom, I made basic adjustments to the RAW files. In Photoshop, I used an assortment of actions and textures from KIT to punch up the colors, soften the skin, and draw attention to the subject.

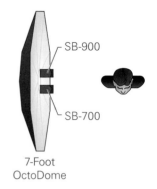

SB-900

SB-700

7-Foot OctoDome

Camera

AA.18 A setup diagram for Figures AA.16 and AA.17.

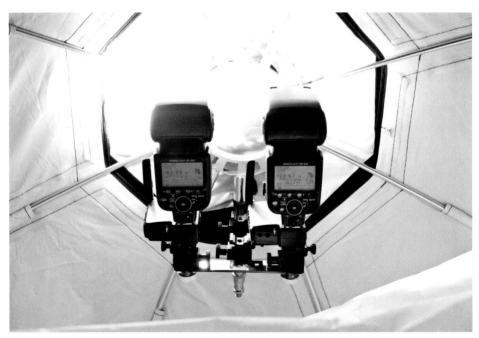

AA.19 The Photoflex DualFlash Adapter inside a 7-foot OctoDome allows the light from each speedlight to bounce off the back of the softbox and then travel through two panels of diffusion. This provides a huge amount of soft light for your subject.

Triple Take

One of the most creative functions of the Nikon CLS is Repeating flash. It is often showcased in sports, such as skateboarding or biking. In the case of *Triple Take*, I used it to highlight the movement of a master black belt.

Repeating flash can be a difficult technique to master and, I admit, I'm still working on it. Much of the outcome of your final image depends on the existing light, location, and subject. During test shooting for this image, the subject had to act as if he were dancing to a beat — in this case, the beat of the flash.

To have complete control over the Remote speedlights, I needed to have a Repeating flash-equipped Commander on the camera's hot shoe. I chose to use the SB-900 atop my D7000 as a Commander for the Remote SB-700 and SB-800. The SB-700 was set to group A and served as my main light, softened by a 3-foot OctoDome. The second speedlight was an SB-800 zoomed to 120mm with a FlashBender attached to further narrow the output beam. I set the SB-800 to group B for separation control. The Commander atop the D7000 was set to Off, so its output did not contribute to the final exposure. However, setting the Commander to Off still allows it to communicate with the Remote groups. I chose to use the highest output available for Repeating flash on a Nikon speedlight — 1/8 power.

A

After my speedlights were placed, I concentrated on focus. When using Repeating flash, it's a good idea to determine your point of focus before shooting. Whether you're in a studio or out on the sidewalk, having relatively low (or non-existent) ambient light can be beneficial for this technique. However, asking your camera to focus in pitch black is asking a lot. If possible, ask an assistant to shine a flashlight on your subject, and then lock the focus or switch to Manual (**M**) to ensure that the focus doesn't drift. In a studio, you can simply focus with the lights on and, once you've acquired your target, ask an assistant to turn them off. It's also a good idea to stop your lens down a bit to allow a margin of error should your subject drift. In this case, I chose an f-stop of 5.6 to ensure that the subject was within the focal plane.

The subject needed enough time to complete three stances (or moves) — any more than that and the image would be mottled with movement. I decided to use an exposure of f/5.6, and 2-1/2 seconds would be enough time. With the SB-900 set to Master, I made sure that the Repeating flash (RPT) mode was enabled in the speedlight's Custom Settings Menu. After deciding on three bursts from each speedlight (each to freeze a particular movement), I then needed to determine the Hertz setting for the flashes, which determines how quickly the flash bursts fire. After some testing, I found that 2 Hz allowed enough time for the subject to move between flashes.

Initially, I processed the RAW file in Lightroom, making basic adjustments to brightness and tone. In Photoshop, I applied the Pow Wow, Warm Wishes, and KPD Magic Sharp actions from KIT.

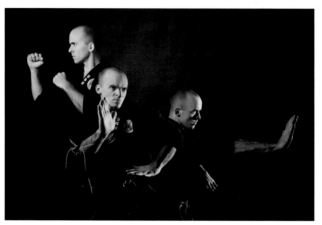

AA.20 No Photoshop blending here. Taken using a 2-1/2 second exposure with a D7000 and a 12–24mm lens. An SB-900 was used on-camera to fire two Remote speedlights (an SB-700 main light and an SB-800 rim light). The Commander fired a repeating flash series containing three bursts at 2 Hz.

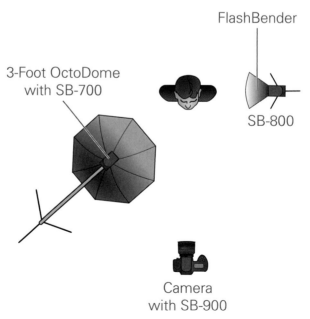

AA.21 A setup diagram for Figure AA.20.

All About the Shoes

All About the Shoes is a basic, commercial-style image that's very easy to set up using the Nikon CLS. Both the SB-900 and SB-910 allow the photographer to zoom the flash head to 200mm. This can create a dramatic edge light for many different applications, including the image shown in Figure AA.22.

I placed two SB-900 Speedlights, set to group B, just behind and to the right and left of the model on their respective floor stands. I chose to use each SB-900 without a modifier to create a hard edge light. My main light came from an overhead SB-700 set to group A and fired through a Photoflex 3-foot OctoDome — my workhorse modifier. Groups A and B were controlled by the SU-800 Commander. My D700 was set to ISO 200, 1/160 second, and I chose a focal length of 35mm on my 17–55mm Nikkor lens, which was also set to f/4.

I applied basic edits to this image in Lightroom. I then took the final RAW file into Photoshop where I softened the skin with the Imagenomic Portraiture plug-in, and ran a few Kubota Image Tools actions, such as Pow Wow, Golden Delish, and Bring It On.

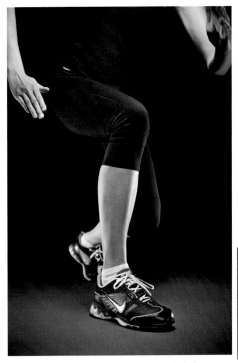

A

AA.22 This style of three-point lighting is common with commercial sports photography. Taken with a D700 at ISO 200, 1/160 second, and a 17–55mm lens set to 35mm at f/4. Remotes were fired using the SU-800.

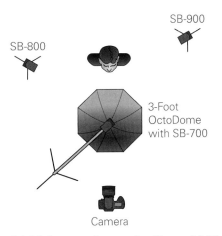

SB-900

SB-800

3-Foot OctoDome with SB-700

Camera

AA.23 A setup diagram for Figure AA.22.

Romulan Ale

Whether you're shooting a portrait or commercial image, like Figure AA.24, don't overlook the possibility that one speedlight may be all you need to accomplish the task. *Romulan Ale* was a very easy image to set up. The outcome for an image of this nature can be achieved in multiple ways, so I'll walk you through what I've found works well.

Because of its transparency, photographing a backlit glass makes a liquid — in this case, blue food coloring in water — really pop. Because there is no light coming from either side of the glass, the edges go black, reflecting the dark environment and giving shape to the subject. This effect can also be reversed, and it works well either way when shooting liquids, wine bottles, or glasses.

For this image, I attached the wine glass to a boom pole with a rubber multi-clamp. The swivel of the boom and multi-clamp head allowed me to tip the wine glass a few degrees to give the liquid a higher slosh factor. After I squirted a few drops of blue food coloring into my water bucket, I set a paint tray under the glass to ensure any spills wouldn't travel far. I also had a small container to scoop up the water for my perfect pour.

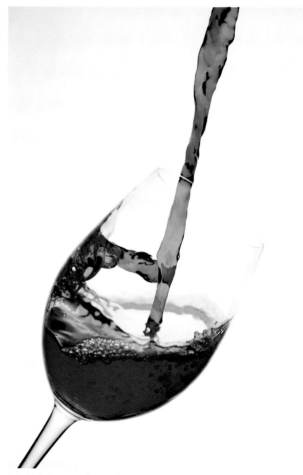

AA.24 It's amazing what you can do with one speedlight, water, blue food coloring, and a glass. An SB-900 was used through a 7-foot OctoDome. The speedlight was triggered with a TT1/TT5 system, with an SU-800 atop the TT1. Taken with a Nikon D700 at ISO 200, 1/160 second, using a Micro Nikkor 60mm lens at f/6.3.

To light the image, I chose to use a 7-foot OctoDome. This massive softbox created a very uniform, soft light — perfect for filling the frame when using it to backlight a subject. The speedlight is attached inside the softbox, making it necessary to use the TT1/TT5 system. I used one speedlight for this image — an SB-900 — set to Through-the-Lens (TTL) mode. To achieve a bit more of a highlight behind the glass, I chose to rotate the speedlight to fire directly though the softbox, rather than bounce into the rear of it.

The D700 was locked down on a tripod, and set to ISO 200 and 1/160 second. To fire the SB-900, I used the TT1 with the SU-800 attached to give me full control. I chose the 60mm Micro Nikkor lens with an aperture (⊚) of f/6.3 to provide enough depth of field for the glass and liquid. Once everything was set up, I pre-focused my D700, and turned off the AF and studio lights. I poured the liquid with my right hand and fired the camera with my left.

After some minor tweaks in Lightroom, I made several color adjustments in Photoshop and brought up the highlights a bit in the background.

A

7-Foot OctoDome
with SB-900

Camera

Boom
with multi-clamp

AA.25 A setup diagram for Figure AA.24.

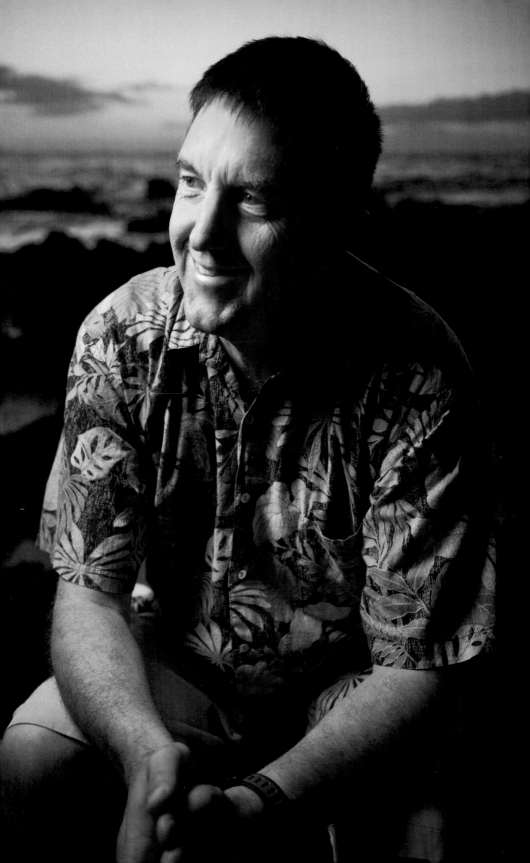

Resources

There is an abundance of information available to today's photographer. From on-line resources to equipment and workshops, the information below is a great starting point to increase not only your knowledge of off-camera lighting, but of photography in general.

Informational Websites

Here are a few websites that you can visit to receive encouragement, constructive criticism, and detailed technical information on your equipment, or to encourage others.

Pimp My Speedlight

Kevin Kubota and I show you the ins and outs of speedlight shooting here: http://pimpmyspeedlight.com.

Digital Photography Review

A community of photographers discussing a wide range of topics, including speed-lights. It's also a great place to visit when a new product is announced: www.dpreview.com.

Strobist

An informative blog containing the how-tos and DIYs of speedlight photography: http://strobist.blogspot.com.

Nikonians

A forum with over 150,000 users where you can ask questions and discuss topics with other Nikon users on a range of photography-related topics: www.nikonians.org.

Photo.net

A large website with everything from equipment reviews and forums to tutorials, and more. If you are looking for specific, photography-related information and aren't sure where to find it, this is a great place to start: http://photo.net.

Kevin Kubota's Lighting Notebook: 101 Lighting Styles and Setups for Digital Photographers

This book features dozens of Kubota's unique lighting and postproduction recipes and techniques. Check out the website for the book here: http://kubotaimagetools.com/lighting-notebook.

Benjamin Edwards Photography

My blog is an ever-growing resource for photographers, and I invite you to visit. Don't be afraid to leave comments, fill out a contact form, or ask any burning questions: www.benjaminedwardsphotography.com/blog.

The Nikon Creative Lighting System Digital Field Guide, Third Edition Facebook page

If you enjoyed this book, please stop by and let me know here: https://www.facebook.com/pages/Nikon-Creative-Lighting-System-DFG-Third-Edition-Benjamin-Edwards/198425486913005.

Workshops

There are a multitude of different workshops that offer training for photographers. Browse the list below to find one that's right for you.

Kubota Digital Photography Bootcamp

http://kubotaimagetools.com/events.html.

CreativeLIVE

www.creativelive.com.

The Ansel Adams Gallery Workshops

http://anseladams.com.

Brooks Institute Weekend Workshops
http://workshops.brooks.edu.

Mentor Series Worldwide Photo Treks
http://mentorseries.com.

Photo Quest Adventures
www.photoquestadventures.com.

Summit Series of Photography Workshops
http://photographyatthesummit.com.

Santa Fe Photographic Workshops
http://santafeworkshops.com.

Online Photography Magazines and Other Resources

Some photography magazines also have websites that offer articles and other information not included in the print versions. The list below includes some of these, as well as other photo-related websites with content you may find useful.

B

Rangefinder
www.rangefinderonline.com.

Digital Photographer
http://digiphotomag.com.

Digital Photo Pro
http://digitalphotopro.com.

Outdoor Photographer
http://outdoorphotographer.com.

Photo District News

http://pdnonline.com.

Popular Photography and Imaging

http://popularphotography.com.

Shutterbug

http://shutterbug.net.

Flickr

http://flickr.com.

Equipment

Need to know where to get the equipment mentioned in this book? Look no further.

Nikon

When you want to access the technical specifications for Nikon speedlights, cameras, or lenses, visit the Nikon website: http://nikonusa.com.

Pocket Wizard

Visit this site to learn more about the TT1 and TT5 — must-have additions to beef up your CLS: www.pocketwizard.com.

Photoflex

You can have all the flash output in the world, but if the light isn't pretty, it isn't usable. Visit Photoflex and check out the many options for helping you get your speedlight where you need it: www.photoflex.com.

How to Use the Gray Card and Color Checker

Perfect and consistent color doesn't happen by accident. Knowing how to use your included gray card and color checker could save you a lot of postproduction hassle. While they aren't tools I would often use at a wedding, they are a must-have for studio or product photography.

The Gray Card

The color temperature of light varies and is dependent on the source from which it comes. You may even see variances in color temperature from the same light source, such as a speedlight or studio strobe, when the power settings are changed. Color temperature changes can also occur as the light source ages or, in the case of the sun, as it moves across the sky. Although you may believe that you have a neutral item in your scene from which you can select a custom white balance (**WB**), the best way to know for sure is to use a gray card. A gray card is designed to reflect the color spectrum neutrally, providing a standard (or baseline) from which you can measure white balance in other images taken within the same scene and with the same light source. By taking a test shot that includes the gray card, you guarantee that you have a neutral item against which you can adjust colors later if you need to. Make sure that you place the gray card in the same light as the subject for the first photo, and then remove it and continue shooting.

 When taking a photo of a gray card, de-focus your lens a little to ensure that you capture more even color.

My software of choice for cataloging, culling, and editing images is Lightroom. In the Develop Module, Lightroom allows you to use the White Balance Selector to select an area of the image that is completely neutral, thereby eliminating any unwanted color-casts. By placing and photographing your gray card in the first image of your series, you can refer to it later in Lightroom (or your preferred image-editing program) to apply the correct custom white balance.

If you prefer to make adjustments during a shoot (and if the lighting conditions will remain mostly consistent while you shoot), use the gray card, or a tool called an ExpoDisk, from ExpoImaging, to set a custom white balance (**WB**) in your camera. You can do this by taking a photo of the gray card or ExpoDisk and filling as much of the frame as possible. Then, use that photo to set the custom white balance (**WB**) in the Custom Functions menu (✐) of the camera.

The Color Checker

A color checker contains 24 color swatches that represent colors found in everyday scenes, including skin tones, sky, and foliage. It also contains red, green, blue, cyan, magenta, and yellow, which are the colors used in most printing devices. Finally, and perhaps most importantly, it has six shades of gray.

The process for using a color checker is very similar to using a gray card. You place it in the scene so that it is illuminated in the same way as the subject. Photograph the scene once with the color checker in place, and then remove it and shoot away. You should create a reference photo each time you shoot in a new lighting environment, or when you change power output settings on your speedlight or studio strobe.

In Lightroom, open the image containing the color checker. Measure the values of the gray, black, and white swatches. The red, green, and blue values in the gray swatch should each measure around 128; the black, around 50; and the white, around 245. If the camera's white balance (**WB**) was set correctly for the scene, your measurements should fall within the range (deviating by no more than 7 points either way). If so, you may rest easy knowing that your colors are true. (Isn't there a song about that?)

If your readings are more than 7 points out of range either way, you can use software to correct the image. You can also use the levels adjustment tool to bring the known values back to where they should be (gray around 128, black around 50, and white around 245).

If you prefer to shoot JPEGs rather than RAWs, and your camera offers custom styles, you can also use the color checker to set (or adjust) them. Simply take a sample photo and evaluate it using the on-screen histogram (preferably, an RGB histogram if your camera has one). You can then choose that custom style for your shoot — perhaps even adjusting it to better match your color expectations. This will have no effect on your RAW image.

Glossary

Active D-Lighting A camera setting that preserves highlight and shadow details in a high-contrast scene with a wide dynamic range.

AF-assist Illuminator An LED that emits light in low-light or low-contrast situations. The AF-assist Illuminator provides enough light for the camera's autofocus to work in low light.

ambient lighting Lighting that naturally exists in a scene.

angle of view The area of a scene that a lens can capture, which is determined by the focal length of the lens. Lenses with a shorter focal length have a wider angle of view than lenses with a longer focal length. The angle of view of a specific focal length changes depending on the image format (such as DX or FX). See also *DX* and *FX*.

aperture The physical opening of the lens, similar to the iris of an eye. The designation for each step in the aperture is called the f-stop. The smaller the f-stop is, the larger the actual opening of the aperture. Higher-numbered f-stops designate smaller apertures, letting in less light. The f/number is the ratio of the focal length to the aperture diameter.

Aperture Priority mode A camera setting in which you choose the aperture and the camera automatically adjusts the shutter speed according to its metered readings. Aperture Priority controls the depth of field. See also *Auto exposure mode* and *Shutter Priority mode*.

aspect ratio The proportions of an image as printed, displayed on a monitor, or captured by a digital camera.

Auto exposure mode (AE) A general-purpose shooting mode in which the camera selects the aperture and/or shutter speed according to the built-in light meter. See also *Aperture Priority mode* and *Shutter Priority mode*.

autofocus The capability of a camera to automatically determine the proper focus for the subject.

backlighting A lighting effect produced when the main light source is located behind the subject. Backlighting can be used to create a silhouette effect or to illuminate translucent objects. See also *frontlighting* and *sidelighting*.

barrel distortion An aberration in a lens in which the lines at the edges and sides of the image are bowed outward. This distortion is usually found in shorter focal-length (wide-angle) lenses.

bounce flash Pointing the flash head in an upward position or toward a wall so that it bounces off of that surface before reaching the subject. Bounce flash softens the light that is illuminating the subject. It also often eliminates shadows and provides a smoother light for portraits.

bracketing A technique in which the photographer varies the exposure of the subject over three or more frames. This ensures a proper exposure in difficult lighting situations in which the camera meter can be fooled.

broad lighting A type of lighting in which the main light illuminates the side of the subject that is facing the photographer.

Butterfly lighting A lighting style in which the main light is placed above a model and directed toward the face, creating a butterfly-shaped shadow under the nose.

camera shake The movement of the camera, usually at slower shutter speeds, which produces a blurred image.

catchlights Highlights that appear in a subject's eyes.

Center-weighted meter A light-measuring device that emphasizes the area in the middle of a frame when calculating the correct exposure for an image.

color gel filters Translucent color filters that are placed over a flash head or light to change the color of the light emitted on the subject. Color gels can be used to create a colored hue of an image. Gels are often used to change the color of a background or to match the flash output with the ambient lighting by placing the gel over the flash head.

Continuous Autofocus (AF-C) A camera setting that allows the camera to continually focus on a moving subject.

contrast The range between the lightest and darkest tones in an image. In a high-contrast image, the shades fall at the extremes of the range between white and black. In a low-contrast image, the tones are closer together.

Crop factor The ratio of a 35mm frame's diagonal measurement (43.3mm) in relation to another imaging device, such as a digital sensor.

dedicated flash An electronic flash unit (such as the Nikon SB-400, SB-700, SB-900, or SB-910) designed to work with the autoexposure features of a specific camera.

default settings The factory settings of a camera or speedlight.

depth of field The portion of a scene from foreground to background that appears acceptably sharp in the image.

diffused lighting A soft, low-contrast lighting.

digital single lens reflex (dSLR) A single lens reflex camera with interchangeable lenses and a digital image sensor.

DX The Nikon designation for digital single lens reflex cameras (dSLRs) that use a 23.6 × 15.8mm APS-C–sized sensor. See also *angle of view* and *FX*.

equivalent focal length A DX-format digital camera's apparent focal length, which is translated into the corresponding values for 35mm film or the FX format.

exposure The amount of light allowed to reach the film or sensor. It is determined by the intensity of the light, the amount admitted by the aperture of the lens, and the length of time determined by the shutter speed.

exposure compensation A technique for adjusting the exposure indicated by a photographic exposure meter, in consideration of factors that may cause the indicated exposure to result in a less-than-optimal image.

exposure mode Camera settings (such as Aperture Priority, Shutter Priority, Manual, Programmed Auto, and Scene modes) that determine how the exposure settings are chosen.

fill flash A lighting technique in which a speedlight provides enough light to illuminate the subject and eliminate shadows. Using a flash for outdoor portraits often brightens the subject in conditions where the camera meters light from a broader scene.

fill lighting The lighting used to illuminate shadows. Reflectors, additional incandescent lighting, or electronic flash can all be used to brighten shadows. One common technique used outdoors is to use the camera flash as a fill.

flash An external light source that produces an almost instant flash of light to illuminate a scene. Also known as electronic flash.

Flash Exposure Compensation (FEC) An adjustment to the flash output. If the flash portion of the images are too dark (underexposed), FEC can be used to increase the flash output. If images are too bright (overexposed), FEC can be used to reduce the flash output.

flash modes Modes (such as Red-Eye Reduction and Slow Sync) that enable you to control the output of the flash by using different parameters.

flash output level The output level of the flash as determined by the flash mode being used.

Front-curtain sync A camera setting that causes the flash to fire at the beginning of the period in which the shutter is completely open in the instant that the first curtain of the focal plane shutter finishes

its movement across the film or sensor plane. This is the default setting. See also *Rear-curtain sync*.

frontlighting The illumination coming from the direction of the camera. See also *backlighting* and *sidelighting*.

f-stop See *aperture*.

full-frame sensor A digital camera's imaging sensor that is the same size as a frame of 35mm film (36mm × 24mm).

FX The Nikon designation for dSLRs that use a sensor that is equal in size to a frame of 35mm film. See also *angle of view* and *DX*.

histogram A graphic representation of the range of tones in an image.

hot shoe The slot where the flash connects on top of a camera. It is so named because it has electronic contacts that allow communication between the flash and the camera.

ISO sensitivity The level of light sensitivity on a camera, indicated by its ISO (International Organization for Standardization) setting. Digital cameras can use any available setting. Lower ISO settings provide better-quality images with less noise; however, they require more exposure.

Kelvin A unit of measurement for color temperature based on a theoretical black body that glows a specific color when heated to a certain temperature. For example, light emitted from the sun is approximately 5500K.

lag time The length of time between when the Shutter Release button is pressed and when the shutter is actually released. The monitor pre-flash can cause shutter lag, which may make it unsuitable for shooting some action scenes.

LCD (liquid crystal display) screen A screen on the back of a speedlight or camera that displays its settings.

leading line An element in a composition that leads a viewer's eye toward the subject.

lighting ratio The proportion between the amount of light falling on the subject from the main light and the secondary light. An example would be a 2:1 ratio in which one light is twice as bright as the other.

Loop lighting A lighting style similar to Rembrandt lighting, with the exception that the shadow under the nose doesn't fully reach the shadow on the other side of the subject's face. See also *Rembrandt lighting*.

macro flash A flash specifically made for use in close-up and macro photography.

manual exposure A feature that allows you to bypass a camera's automatic exposure system in favor of setting the shutter and aperture manually. Manual exposure is beneficial in difficult lighting situations in which the camera meter doesn't provide correct results. When you switch to manual settings, you may need to review a series of photos on the camera's LCD screen to determine the correct exposure.

Matrix metering A metering system that reads the brightness and contrast throughout an entire image frame. It then compares them against a database of images (over 30,000 in most Nikon cameras) to determine the best metering pattern to use to calculate the exposure.

metering Measuring the amount of light by using a light meter.

noise Pixels with randomly distributed color values in a digital image. Noise in digital photographs tends to be more pronounced in low-light conditions and with long exposures, particularly when a camera is set to a higher ISO setting. Noise can also be caused from heat build-up on the sensor due to long exposures and the amplification of signal processing to reach a higher ISO.

noise reduction A technology used to decrease the amount of random information (usually caused by long exposures and high ISO settings) in a digital picture. See also *noise*.

pincushion distortion An aberration in a lens which causes the lines at the edges and sides of an image to bow inward. It is usually found in longer focal-length (telephoto) lenses.

Programmed Auto mode (P) An exposure mode in which the camera determines both the shutter speed and the aperture.

Rear-curtain sync A camera setting that causes the flash to fire at the end of the exposure an instant before the second (or rear) curtain of the focal plane shutter begins to move. With slow shutter speeds, this can create a blur effect from the ambient light. This effect appears as a pattern following a moving subject, with the subject sharply frozen at the end of the trail. This setting is often used in conjunction with longer shutter speeds. See also *Front-curtain sync*.

red eye An effect from flash photography that appears to make a person's eyes glow red and an animal's eyes glow yellow. It is caused by light bouncing from the retina of the eye. It is most likely to occur in dimly lit situations (when the irises are wide open), as well as when the electronic flash is close to the lens and, therefore, prone to reflect the light directly back.

Red-Eye Reduction mode A flash mode controlled by a camera setting that's used to prevent the subject's eyes from appearing red in color. The speedlight fires multiple flashes just before the shutter opens, causing the subject's iris to contract and, therefore, reflect less light from the retina to the camera.

Rembrandt lighting Named after the painter who made it famous, this lighting style produces a triangle of light on the side of the subject's face furthest from the light source.

self-timer A mechanism that delays the opening of the shutter for several seconds after the Shutter Release button has been pressed.

shooting through Placing an object in the foreground of an image to create a sense of depth or texture.

short lighting A situation in which the main light illuminates the side of the subject facing away from the photographer.

shutter A camera mechanism that allows light to pass to the sensor for a specified amount of time.

Shutter Priority mode A camera mode in which the desired shutter speed is set by the photographer and the camera automatically sets the aperture. It's best used when shooting action shots to freeze a subject's motion by using fast shutter speeds. See also *Aperture Priority mode* and *Auto exposure mode*.

Shutter Release button The button pressed on a camera to take a picture.

shutter speed The length of time the shutter is open to allow light to fall onto the imaging sensor. It is measured in seconds or, more commonly, fractions of seconds.

sidelighting Lighting that comes directly from the left or right of the subject. See also *backlighting* and *frontlighting*.

Single autofocus (AF-S) A focus setting that locks the focus on the subject when the Shutter Release button is half-pressed. This allows the photographer to focus on the subject, and then recompose the image while retaining focus settings as long as the Shutter Release button remains half-pressed.

Slow Sync A Flash mode that allows the camera shutter to remain open for a longer time to allow the ambient light to be recorded. The background receives more exposure, which gives the image a natural appearance.

speedlight A Nikon-specific term for its dedicated flash units.

split lighting A lighting style in which half of the subject is lit and the other half is in shadow.

Spot meter A metering system in which the exposure is based on a small area of the image; usually, the spot is linked to the autofocus point.

Through-the-Lens (TTL) A metering system in which the light is measured directly through the lens and then processed by the camera's metering module.

tungsten light The light from a standard incandescent light bulb.

Vibration Reduction (VR) A function of the lens in which the lens elements are shifted to reduce the effects of camera shake. This can also be done inside the camera by moving the image sensor to increase stability.

white balance A setting used to compensate for the differences in color temperature that are common in different light sources. For example, a typical tungsten light bulb is very yellow-orange. To remedy this, the camera adds blue to the image to ensure that the light looks like standard white light.

Index

Index

Index